THE ARTIST'S STUDIO BOOK

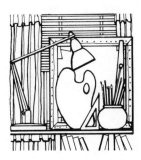

Books by Richard Seddon

The Academic Technique of Painting (The Artist Publishing Co., Ltd, London & New York, 1960)

A Hand Uplifted: Memoirs of a War Artist (Frederick Muller, Limited, London, 1963)

Art Collecting for Amateurs (Frederick Muller Limited, London, 1965 and Barnes & Noble, New York, 1968)

An Illustrated Dictionary of Art Terms (with Kimberley Reynolds), (Ebury Press, London, 1981)

THE ARTIST'S STUDIO BOOK

Studio Management for Painters and other Artists

Richard Seddon

BEAUFORT BOOKS, Inc.
New York / Toronto

Library of Congress Cataloging in Publication Data

Seddon, Richard Harding, 1915-
 The artist's studio book.

 Includes index.
 1. Artists' studios. 2. Artists' materials.
 3. Artists' tools. I. Title.
N8520.S4 1983 706'.8 83-21558
ISBN 0-8253-0210-2 (pbk.)

Published in the United States by Beaufort Books, Inc., New
York. Published simultaneously in Canada by General
Publishing Co. Limited

Printed in the U.S.A.

10 9 8 7 6 5 4 3 2 1

Contents

Part Three – The Presentation of Work

Line drawings in the text

A selection of photographs of artists at work

Acknowledgments

The author gratefully acknowledges the help unfailingly received from many specialists in the preparation of this book; notably that of Miss Irene Briers, Managing Director of the Artist Publishing Company, Limited, in whose magazine *The Artist* much of this material first appeared in the form of articles; and the editors of that journal, Kimberley Reynolds, Jill Whittle and Carolyn King for continual patience and support.

It is not permitted to mention by name the staff of the national art museums in London who supplied invaluable specialist information and discussion; and so, in this connection, sincere collective thanks are offered to the National Gallery, London (Restoration Department) for discussion of framing and gilding; the National Portrait Gallery, London, for help in tracing pictures and photographs of artists in their studios; the Tate Gallery Archives for help in the same search, and the Restoration Department of that Gallery for discussion of the cleaning of prints and drawings; also the Department of Paintings of the Victoria and Albert Museum, London, for information on the sealing of the frame of J. M. W. Turner's oil painting *Venice* in the Nettlefold Collection.

To the many artist and craftsmen friends and colleagues of the author who responded to queries, only collective thanks can be offered; but a particular debt is acknowledged to Alfred Reardon, wood-machine specialist, for advice on the spring loading of the DIY routing jig for frame moulding; to cabinet makers Gordon Clark, Sidney Lord and Bernard Marshall for much information and advice; to the fire prevention officers, petroleum officers, librarians and many other specialists who gave freely of their knowledge.

Special thanks are also due to Rosemary Stevenson, textile specialist, for information on that subject; and to the late Bill Chugg, materials specialist, for discussion of plastics and other materials; and to Michael Doran, Book Librarian of the Courtauld Institute of Art, London University.

Introduction

Every artist has to have somewhere to work; which can vary from a corner of a bedroom to a purpose-built accommodation, perhaps involving several different rooms. Thousands of busy and serious artists – from the professional to the dedicated amateur, with all the semi-professionals in between – need work-space. Many – if not most – artists start by using any spare space they can find; a corner of the student digs during art-school training, or the spare bedroom at home during the vacations. The keen amateur cannot, at first, set aside space for art alone, in the family house; and has to make do with a space in the lumber room, or an unused bedroom; or even less than that; perhaps occasional use of the kitchen table with the art materials and equipment stored in the cupboard under the stairs or some similar place, when not in use.

A professional artist, and to a great extent the amateur who has reached the stage of regular exhibiting and, perhaps, the sale of a number of works every year, reaches a stage when something better is called for. Just what form this might take is governed by a number of considerations; all of which can affect how the studio accommodation finally takes shape.

Firstly, very few artists, however successful, do art all the time. Many – perhaps most – of the well-known professionals do some art teaching; perhaps one or two days a week in the 36 weeks of the art college teaching year. Such an artist may very well do also a certain amount of writing for publication; and is very likely to be involved in the committee work of art societies and art groups. Then, there is always a considerable amount of business appointments with art dealers and galleries. In such ways, the dealers, the editors, and the artist's other customers and clients, take up quite a lot of time from the

working week. This all means that the studio space is not in use all the time, by any means.

One result of this is that it is not economic to set aside very considerable space – whether in the family house, or elsewhere in rented or purpose-built accommodation – if it is to be empty for part of the week. It has to be borne in mind that space in a building has to be paid for in rateable values, as well as in heating, lighting, cleaning and maintenance; and a careful appraisal of the costs of producing the artwork includes a lot of hidden costs, a degree of which is a necessary part of the studio over-heads; but it has to be kept within limits, if the artist's financial returns for his or her work are not to be eroded.

Whatever the artist's personal situation, this is a problem that has to be solved sooner or later in his or her career. Most art students leave art college intending to work as studio artists at least for a part of the working week; and, if possible, for the whole of their time. Few manage to become entirely free of other working commit-ments that interrupt studio work – teaching, lecturing, writing, framing, packing and despatching, and involve-ment with art dealers and art societies, and even jobs that have nothing to do with art but which help to pay the rent. Let us not forget that Chaucer was a customs officer, Christopher Wren was a university astronomer, Shakespeare was a theatre manager, Joseph Conrad was a merchant seaman, and both Conan Doyle and Somerset Maugham were doctors of medicine, Van Gogh worked for art dealers as a salesman and also as a school teacher in Ramsgate, and even Rubens was a diplomatic courier.

All these circumstances make it far from easy to conceive of the ideal studio accommodation for an artist's personal requirements and pocket. I have, in my time, known and worked as a teacher with many young stu-dents of art and design; few – if any – of whom had the slightest idea of how and where they would carry out the fine artistic ambitions with which they were due to leave college. In consequence, I suspect that many of them, in common with many other artists, spent years working in unsuitable conditions that were uncongenial to their requirements, at high expense, much of it in hidden costs; with either too much space, (costing a lot in light and heat) or not enough; with equipment bought at high prices when they could easily make much of it them-

selves; in ill-considered conditions that have an adverse effect on their work, that is often unrealised.

I spent ten years studying in three famous art colleges[1]; and later taught in two others over some twenty years. I cannot recall at any of these famous colleges a moment's advice or tuition ever being given on the topics discussed in this book; nor have I ever come across any other book that provides any. Often, I talked to a newly qualified art or design student about his or her future plans. Whenever I asked where the hoped-for freelance work would be done, I met blank incomprehension of a topic that had never been given any thought. To those with rosy images of framing their own pictures, printing their own prints, modelling and casting their own sculpture and so on, such sympathetic queries as 'How much space will you need?' had never been considered; and the vague replies usually omitted any thought of such things as storage space and loading access, for large canvases or heavy objects.

'How much do you expect it to cost?', 'Which floor will it be on?', 'Are you in a position to get a mortgage?' and the like were questions I soon ceased to ask, as they caused alarm and despondency.

It is hoped, therefore, that this book will offer some advice and information of a kind that is not readily available elsewhere to artists setting out to provide and equip a studio; not only with regard to the choice of premises, or the best use of available space, but the least-expensive way of equipping and using the studio for all those skills that are ancillary to art – such as framing, mounting, packing and transit – for which an efficient studio should provide.

The book does not aim to offer advice on the production of the art itself; whether oil painting, water colours, prints or whatever it may be; but discusses many of the other things that a working artist should know in addition. Though written primarily for the interest of painters – who often also make prints or do illustrations – I refer in passing, from time to time, to the studio needs of sculptors, designers and other artists whose creative needs in a studio are much the same as those of the painter; though their production areas may differ in equipment.

Metrication is still a thorny subject. Most art materials are supplied in metric measurements and in general I

think it is time we adopted them. I have not usually given both metric and imperial measurements since this becomes cumbersome, but I have done so occasionally, where I think a measurement may be hard to visualise. Only with traditional items like 'a 4-inch nail' or 'a 1-inch chisel' have imperial measurements been used; suppliers of such goods are apt to return a blank stare when asked for the metric equivalents. You may also find that timber merchants are leery of metrics, and the metric and imperial equivalents of the wood measurements you are most likely to need are given on page 123. A useful tool to combat confusion is a retractable steel rule or a folding box-rule which gives metric measurements on one side and imperial the other.

The term 'drawings' includes all types: pencil, crayon and pastel, pen and ink and water colour. These subdivisions of drawings are only mentioned specifically when that medium alone is being referred to. The term 'prints' includes all graphic media in which the design is printed in editions: lithography, etching, engraving, silkscreen and their allied media. 'Paintings' refers to works in oil paint, tempera, acrylics, PVA and mixed media.

The equipment, materials and methods described are among those which the author has used with success for many years; and all the studio equipment for which specifications and designs are given have been made by him and used over a long period, in which they have proved their efficiency.

The emphasis on making the most of limited space, and the use of inexpensive equipment made by the artist, is aimed, primarily, at the art school leaver and the amateur who has had enough success to consider setting up, for a limited financial outlay, a studio in which fully professional work may be produced.

NOTES

[1] 1932–36 Sheffield College of Arts and Crafts
1936–39 Royal College of Art, London
1943–46 University of Reading, Department of Fine Art

Part One
The Studio Environment

Chapter 1

The Studio

The need for a studio

Artists – like other people – are not all alike; and they pursue different types of art employing quite different media. In the workshop space of a studio, this means that very different types of equipment have to be accommodated; and such factors as studio lighting, access and floor stability will vary according to the type of work carried on.

However, every studio has to have an area for the production of the creative – usually graphic – origins of the work that is later finalised by one or another of the processes involved; which are, at that later stage, largely – though not entirely – a matter of craft rather than of art.

It may well be helpful, to begin with, if I summarise the various sections into which art-studio work can be divided; each of which calls for accommodation and equipment different from the others.

In the first instance, every artist begins his conception of the desired work of art by a kind of contemplative sketching and sometimes painting. In this way, sculptors such as Henry Moore and Barbara Hepworth, like Michelangelo before them, produced a quantity of distinguished graphic work that was closely related to their sculpture. Indeed, before the Second World War, Henry Moore earned most of his income from his art by producing drawings and water colours for his sculpture; these were, at the time, more regularly bought than the sculptures themselves. It is no coincidence that he is now an Honorary Member of the Royal Society of Painters in Water Colours.

After the production of preparatory drawings and sketches – often works of art in their own right – the

concept is transferred to the workshop area of the studio. Thus, a painter in oils will have a drawing or water-colour table, and, in another part of the studio, equipment for oil painting, including painting trolley or table, oil painting easel and so on. A sculptor will have an area – usually in a quite different place, perhaps outside – where the modelling and carving will be done. A print-maker will have, perhaps, an engraving bench in the same area as his drawing space, but will have his etching baths (if any) and his printing press in another part of the studio complex. A lithographic artist will have litho stones or plates, and a printing press in a special area.

The workshop space, involving heavy equipment and materials will advisedly be on the ground floor – or even in a cellar – or outside. Each different medium demands its own type of equipment and, in consequence, its special kind of spatial environment. Most of the working areas for sculpture, print-making and the like, demand strong floors, and ground-floor accommodation with proper access for loading and unloading. A painter in oils, on the other hand, may or may not do the finished art in the same studio as his water-colour and drawing preparation of his pictorial concepts. A water colourist will, usually, do it all in the same room.

Even so, both the oil painter and the water colourist, like the print-maker, will possibly frame their own work for exhibition and sale; and thus make a considerable saving on the costs of professional framing. This calls for yet more space to itself; in the form of a framing work-shop; in which, additionally, the packing of works of art for transit to exhibitions and dealers may be done.

The one thing that is common to most, or all, of these different types of artistic production according to medium, is the *creative area*, where that work is done that only the artist himself or herself can perform. Outside this area, the work largely takes on a craft character; and can be – and often is – delegated by a busy artist to a specialist craftsman or team of craftsmen. In this way, a successful sculptor such as Henry Moore or my old friend, the late Sir Charles Wheeler, PRA, would employ skilled assistants to carry out a lot of the later stages of the work. Similarly, a print-maker will engrave, etch or draw his plates and will have them printed by a specialist crafts-man.

I recall the late Sir Gerald Kelly, who at the time was President of the Royal Academy, once taking me to task for publishing the fact that Sir Francis Chantrey, RA, the famous early-nineteenth-century sculptor, used to ask a sitter to breakfast, to be observed during conversation. After that, an assistant, through a *camera lucida*, made an outline profile and a full-face drawing of the sitter, from which a second assistant built up a clay model. Chantrey himself then worked on the clay for a short while; after which it was translated into marble by means of a pointing machine worked by yet another assistant. Sir Gerald felt that this was 'giving the game away'. At the same time, he readily agreed that it is unlikely that Henry Moore makes all the bronze castings of his sculptures on his own.

It is, of course, quite beyond the scope of this book to describe in detail all the different equipment and spatial problems arising in such varying workshop conditions; even if any single person were qualified to do so. What I wish to concentrate upon the most is the creative studio, where art is evolved by the artist, regardless of whether he or she later hands over any of the later craft processes to others. In the case of many artists, this is the only studio accommodation they require; and with water colourists and oil or tempera painters, this is usually the case. It is, therefore, for the painter that I write in particular; though all other artists, of whatever medium, will find something of value, I hope, in what I have to say; for all artists, whatever the particular art pursued, need creative work-space; where, usually, the artist works alone, in a contemplative and creative solitude, on the images and ideas that are embodied in the later stages of the work.

Another factor that conditions the artist's choice of work-space is that, at the present time, many artists – whether professional or amateur – have their studios accommodated in space that is devoted to this purpose from areas that are part of – or closely linked with – their living accommodation. This work-space can range from one room or, a series of rooms in a house or flat, to an outside stable, barn, or wooden hut for the country artist. In my experience, very few artists buy or lease studio accommodation outside the confines of the family home and garden.

Today, few artists in the country can find, or afford, spacious accommodation; and, in cities, it is expensive even in the rare cases when it is to be found. An exception in London is found in such projects as the Wapping Artists scheme. In the 1960s, when New York artists were forced by the property market to move downtown into the unfashionable 'garment' district of Soho, a similar exodus down river occurred in London for similar reasons; and the artists looked to the empty docklands for suitable studio-space. The transition to the area was gradual, but was sufficient by 1978 for Wapping Artists to hold their first Open Studio Exhibition, in two nineteenth-century warehouses overlooking the Thames, when 4,000 visitors came to see their work in the spaces in which it was created.

In this book, I attempt to suggest some of the ways and means by which an artist can create an efficient and agreeable working studio for drawing and painting, without access to such opportunities as Wapping Artists; whether or not it is the sole studio space or is associated with ancillary workshop space for sculpting, casting, printing and so on.

If the artist is only working in a small way, the equipment and materials can be taken from storage for use, and put away again afterwards; and there are few artists who have not had to work in this way at some stage in their careers. In between, the working space can be used for some other purpose. This procedure, however, is not only time-consuming, but is disruptive; taking the cutting edge away from the artist's start to the day, and interrupting the continuity of the work.

A serious artist, therefore, has to face the problem at some time or another, of providing working space that, for some of the time, will not be in use for producing art. This did not matter so much in the past, when houses were large, due to the availability of cheap servants; but today, with no help employed in the vast majority of homes, the houses themselves have become smaller, and the space within them is much more costly to buy and to maintain.

This book attempts to provide answers to many of the questions that face the artist in the acquiring of studio space and making the best use of it, not only regarding the studio space itself, but the furnishing and equipping of it to the best advantage.

Artists to whom it may be of assistance are likely to be fairly young, perhaps not long out of art school and wondering how and where to start; or, if older, they are perhaps likely to be semi-amateurs who have been sufficiently encouraged and successful to be considering better working space. In both these instances, the artist will, perhaps, be fairly well experienced in whatever art is pursued; but may well have little, or no, experience of the matters of accommodation, equipment and the related business knowledge of such things as district surveyors, income tax allowances, employers' and public-liability insurance, British Standards dimensions and similar matters. An added and very important advantage of this knowledge is that, through a proper working ambience, the quality of their art will be improved.

Types of studio

Artists, like other people, differ also in the kind of working atmosphere or ambience in which they can work best. Turner, for example, worked in untidy and dusty squalor, in which, after his death, many of his rolled-up oil paintings were found to have suffered from dirt, vermin and leaking rainwater. Picasso preferred an unholy mess and when his first wife, Olga, the daughter of a general, objected, he moved it all to the floor above their flat and shut her out. Earlier, in the old wooden building in the Place Ravignan, Paris, called the 'Bateau-Lavoir', his studio merely had a rusty iron stove, a rickety table, and a wash basin. A single window also revealed the dust and the cobwebs, the two ramshackle chairs and the white mouse that lived in the table drawer.[1]

In contrast to this, I well recall, as a student and occasional studio assistant of Paul Nash, in London before the War, his elegant studio on the ground floor of his large, detached white house in Hampstead; with its French windows looking on to his garden; his books and bookcases, elegant fireplace, his water-colour table and oil-painting easel; furnished partly as a drawing room; though nothing was allowed to get in the way of the working equipment. On his large, flat desk in the window, his pens and pencils were laid out in parallel rows, with his blotter, brush pots and other things precisely squared up on the desk top.

The only artists of my acquaintance who had purpose-built studios in London were all portrait painters or sculptors: Sir Gerald Kelly, Henry Carr, Feliks Topolski, Sir Charles Wheeler, Sir Jacob Epstein and others. It seems as if a professional portrait painter is influenced by the presence of the sitters to require a lot of space, in height as well as floor space. They all used Victorian or Edwardian studios in various parts of London; Kelly's, Epstein's and Wheeler's being incorporated into houses; while Topolski's and Carr's were built mainly as studios with no particular emphasis on domestic provision.

In comparison with these, the landscape painters like Paul Nash appeared to prefer rooms in ordinary domestic houses, equipped for studio purposes; but with no specially built features like skylights, studio windows, large access doors and so on. Paul Nash's brother, John Nash RA, the landscape painter, with whom I once stayed, took me into his studio, through the attics of his small country farmhouse, to a very small room at the far end, in the gable; which was about 2½ metres by 3½ at the most, and hardly big enough to stand back from the drawing table. It was quite an adventure to get into it through the rafters of the intervening lofts.

Like Picasso, some artists seem to prefer muddle; but most of those I have known liked things to be orderly and efficient; and the layman's idea of the artist as a bohemian and untidy individual is largely a myth.

Whilst sculptors, and print-makers with their presses, naturally set up their heavy equipment on the ground floor – preferably a stone or concrete floor with no space beneath, a painter can work on any level in a house, with no risk of everything going through the floor. This is a bigger advantage than at first it might seem. It not only widens the artist's scope of choice in finding premises, but also means that, if the studio is part of the family house, it can be upstairs out of the way of other inhabitants; and free from interruptions.

Victorian, or even older, houses seem to be the best for part-use as artists' studios. Not only are the main rooms larger than in most modern houses, but, more important still, they are higher. Indeed, it is not often possible to use the traditional kind of oil-painting easel in a modern house; as the centre stay of the easel, when wound up to

its full height, is too high for the modern ceiling. Quite often, if one sees such an easel for sale second-hand, it can be seen that the centre stay has been shortened by sawing off the top metre or so. The artist has to use a tripod easel, which is really designed as a sketching easel. This will hold canvases up to around a metre in height or length; but is not really stable over those limits. If an artist wishes to paint bigger pictures than that, it is needful to seek a Victorian house with high ceilings, and which still may have its stable and coach house with hayloft above – there are many such in London and other towns with Victorian houses. These can be adapted, and if necessary (and with the approval of the District Surveyor) the hayloft floor can be partly removed, the windows enlarged and so on. Conversely, the artist may decide to paint smaller pictures.

Another way in which artists differ is in their various postures when working, and their idiosyncratic working methods which are, frequently, quite unusual. Vasari relates how Luca della Robbia (1400–82) the Florentine sculptor used to work in the studio all day and late into the night, with his feet in a basket of shavings to keep them warm.[2] Donatello (c.1386–1466) kept all his money in a basket hung by a cord from his studio ceiling, and his friends could lower it down and take what they needed to save interrupting Donatello when he was at work.[3] Leon Battista Alberti (1404–72) had in his studio an enlarging and diminishing machine of his own invention[4]; whilst Canaletto worked in the street, painting views of Venice from a portable cabin with ventilation worked by foot pedals.[5] Vasari, pupil of Michelangelo, also describes how his master would take a wax figure and immerse it in a big tank in the studio, gradually raising it out of the water to study the contours of the forms as it emerged,[6] as a guide to cutting back the layers of marble in carving.

It is not only the old masters who had very personal approaches to their studio work. Matisse, when he was old, used to lie in bed and draw on paper stuck to the ceiling, using charcoal on the end of a long stick. This is not as eccentric as it sounds, for Vasari in his *Technique*[7] describes how, in his day, the painters of frescoes used to draw the designs on paper on the wall or ceiling, with a long rod, having a piece of charcoal on the end. At the same time, Braque, in a photograph[8] can be seen to be

painting with his palette on the floor and the canvas leaning against the legs of a chair. Van Gogh used a kitchen chair, outside the back door, when painting his famous *Sunflowers* at Arles.[9]

Goya painted the frescoes of the cupola of S. Antonio de la Florida in Madrid with sponges, in dabs and wipings of colour[10]; whilst Titian painted a lot with his fingers, and in final passages, he used his fingers more than his brushes according to the description by Palma Giovane (1544–1628), who completed Titian's painting *The Entombment*, which is now in the Accademia, Venice.[11] Indeed, as with charcoal on a long stick, the use of a sponge for painting is not unique to one artist. Leonardo da Vinci is recorded as having evolved creative images by throwing a sponge loaded with paint at the wall; and Alexander Cozens, the English water colourist, made 'blot pictures' by dabbing ink on paper and pressing it with another sheet of paper used rather as a sponge. Henry Moore, as a water colourist, has produced 'blotting paper watercolours' with very delicate effect. Painting with a sponge is, indeed, recommended by Doerner, who suggests applying egg-and-water medium with a sponge as in gilding[12]; and elsewhere he describes how some old masters varnished tempera pictures with a warm-tinted varnish rubbed on with the hand[13], and how, when a glaze was put on over an underpainting heightened with white, it was put on by the old masters with the fingers and/or the ball of the hand, and not with a brush.[14]

Matisse was not the only elderly artist who painted in bed. When Turner lived in Mrs Booth's cottage on the Chelsea riverside, he painted some of his final oil paintings sitting up in bed; according to her account.[15]

I quote these few examples of artists' idiosyncracies to emphasise that there is no single way to produce art; and no one type of studio that is better than all the others. However, whatever individual features a studio may possess, to suit the artist who works in it, there are distinct factors governing the efficiency of a studio which should be understood. Not all of these factors will be found to be present in every studio; but any particular studio should satisfy as many of them as possible within the circumstances concerned. Within these parameters, any artist has plenty of scope for freedom of arrangement and method.

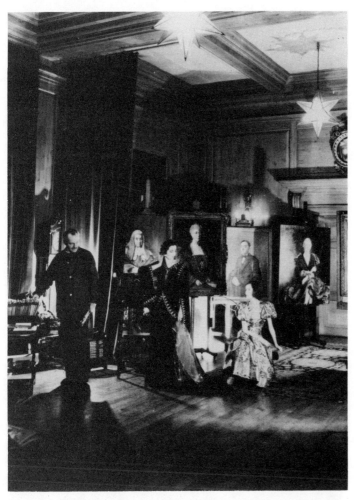

Plate 1. Sir Oswald Birley (1880–1952) the society portrait pain-
ter in his studio. The 'drawing room' character of the sitter's
accommodation is at one end; the working area of sparse simplic-
ity is at the other; with an absence of strong lighting. *Photo by Cecil
Beaton, reproduced by kind permission of Sotheby's, Belgravia.*

In this way we sometimes find the drawing-room
studio, with elegant appointments, as favoured by many
successful portrait painters; and also the work-
shop-studio, filled with equipment and tools, and some-
times not to be recommended to visitors who do not wish
to get paint, oil, acid or any other materials, on their fine
clothes. Also, there is the studio that contains nothing but
a bare floor and walls, a paint table and an easel.

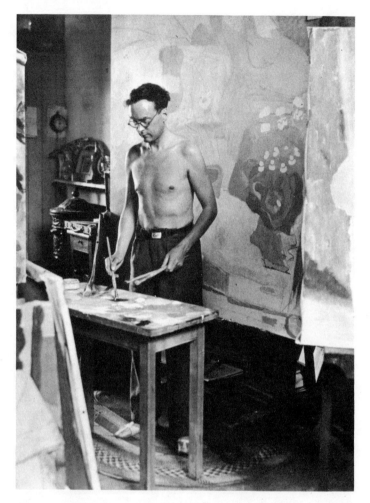

Plate 2. The English landscape and flower painter Ivon Hitchens in the working area of his studio, a small space with only the bare essentials, about 1933. *Photo by J. Somerset Murray.*

The functions of a studio fall roughly, as I have indicated, into four categories. There is the *creative area* where preparatory sketches, water-colour studies and other preliminary works are carried on. If the artist has assistants, or is liable to friendly interruptions, this part of the studio should be closed away and private, with the possibility of keeping people out.

The second area is the *production area* where the finished work goes through its different stages; and this

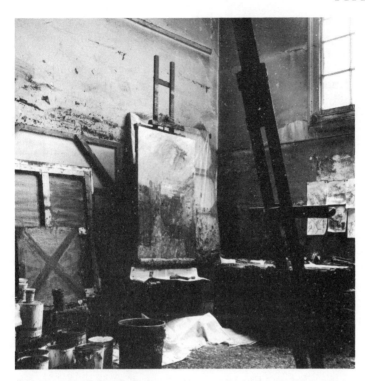

Plate 3. The studio working area of the portrait, figure and landscape painter Frank Auerbach, who lives in London. *Photo by Marc Trivier, reproduced by kind permission of Marlborough Fine Art Ltd.*

part of the studio is more of a workshop; whether it produces oil paintings, sculptured models and casts, stone carvings or prints from printing presses and silk-screen equipment and the like. For a sculptor or a print-maker this area will take up a larger part of the space; but, conversely, a water-colourist will not need anything like this, unless he or she also does mount-cutting and framing.

Thirdly, whether the latter uses the ready-made frames of easy assembly supplied on the market today, or makes frames from the wood mouldings onwards, a workshop is needed for mounting, framing and packing to high standards, in the *presentation area*

Fourthly, there is the *storage area*. Every studio needs this, just as every kitchen needs a larder or pantry. A painter stores oils and essences, canvases and frames,

packing cases and wrapping paper and the like. A sculptor stores clay and plaster, lead pipe for armatures and spare modelling or carving stands.

Ideally, each of these areas will be quite separate; in different rooms. Yet, this is not always possible; and a painter has to consider having the creative area together with the storage area in the same room; together, if need be, with the production area. However restricted the available space may be, the mounting and framing area should always be separate and on its own, for the sake of immaculate cleanliness of the finished mounting and framing. I have too often seen grubby mounts and even fingermarks on the white areas of abstract paintings, from the studios of eminent artists who should set a better example.

A perfect description of a typically frenzied creative area is in the catalogue of the one-artist exhibition by Jennifer Durrant, the abstract painter, held at the Nicola Jacobs Gallery, London in November and December, 1982:

'At the beginning of the summer, she had no teaching commitments for several weeks and a clear space to work on new paintings and on a commission for a hospital . . . the two immediate triggers were several sheets of paper lying among a pile of books and postcards in the area of the studio used for drawing, and the summer flowers she saw on the walks with the dog . . . she saw . . . the chance to make works . . . beginning with small sketches, simply outlining areas shading them and annotating the sheets with basic colours.'[16]

From this creative area the artist has instigated paintings which are now in the Tate Gallery, the British Council, the Neue Gallerie, Aachen and the Museum of Fine Arts, Boston, USA, among others.

Studio installation – the finance and the paperwork

Setting up a studio, for the painter of mature years will, as described, most often take place within the artist's existing home; a flat, bungalow or house; but a younger artist cannot begin until something of the sort has been either rented or bought.

A mortgage is always easier to obtain and is more likely to be granted if the applicant is already a subscriber, or investor, in the building society concerned. A young artist, with premises to find sooner or later, cannot start too soon placing some money, however small an amount, regularly into a building society account. If it is not going to be called upon for several years, until the artist has enough money to put down the deposit, the money can be kept in one of the accounts bearing higher rates of interest, and hopefully, left undisturbed.

The artist should also consider very carefully whether to operate in the capital city, a regional city or in the country. The chief thing that will influence this is the location of any other job that the artist may have; such as art teaching, university extra-mural lecturing, or some work not connected with art at all. If an appointment as a part-time lecturer at a metropolitan art school has been obtained, the artist will be earning the weighted income, giving useful additional cash; but this is likely to be swallowed up by the greater cost of property in the capital city to which salary weighting relates. There is a great difference in cost for example of a house in London and the same sort of house elsewhere.

Clearly, it is better for the young artist to buy a small place as soon as possible; it will grow in value (in 1980–81 the increase was 3 per cent for older properties and 5 per cent for new; and for 1982–83 the forecast is an increase of up to 8 per cent, perhaps still more the year after). Is it better to save money at interest of decreasing percentage; and make do in temporary accommodation; or buy sooner a house that will perhaps gain by some 8 per cent? Naturally, nothing can be bought until the money is available; but with houses today, it may appear that 'the sooner the better' is the best policy. Having said which, it is still the position today in Britain that a summary by the Nationwide Building Society revealed that a new detached house in Greater London costs on average £60,790 and the same house in the East Midlands sells for an average of only £33,470.

Why hesitate, then, about living away from the capital and saving several thousand pounds? Once again, it depends what kind of painting the artist does. For a portrait painter it is usually preferable to have a fairly big studio in London, because that is where many of the

sitters are to be found. However, it must be remembered that a great many good portraits are painted by artists who are prepared to travel anywhere and paint the sitters in their own homes; and that even London-based portrait painters are quite prepared to travel to wherever the sitter may be, if the sitter's house is at all suitable for painting in.

Mortgage finance is almost impossible to find for the purpose of buying small workshops or factory-type accommodation. The best that is available from the banks at this time is about fifty per cent of the price; with repayments spread over about seven years, on a simple interest basis, which puts a heavy load on to the early years of a loan.

Twenty years or more ago, there were not very many art dealers' galleries outside London; and it was so expensive in time and money to take work to London, that many artists were hampered in their career development for this reason. Today, so many small and excellent art dealers' galleries have opened all over the provinces, that an artist can sell his or her work quite well without ever showing in London. If an artist's work sells fairly well, it is quite enough to try to keep up with one dealer. I have, in my time, tried to keep up with one West End dealer and one outside, on the fringe; and had no time to seek a third.

For some reason, many artists prefer to exhibit with art societies; and in England all the principal ones – with a few exceptions – are in London; where they sell a lot of work for their members. I recall the Royal Society of Marine Artists, showing a few years ago at the Guildhall Art Gallery in the City, selling some £30,000 of work in the first two or three days of their annual show. An artist who is intending to exhibit with several such societies will have to be in London, because of the cost of sending work to-and-from the provinces. Indeed, I have observed that most of the painters showing in London societies live in London or the Home Counties; except the miniature painters, who, due to the smallness of their work, can send it from a distance without much trouble or expense. For a sculptor, it is even more difficult to show in London from any great distance outside. To get a half-sized figure, or even a portrait head from the North or the Midlands to the Summer Exhibition of the Royal Academy, of the annual

shows of the Royal Society of British Sculptors, or the Portrait Sculptors Society, is a major undertaking.

It seems that, for an artist who wishes to take advantage of the much lower cost of buying premises outside London, it is best to aim to show with a gallery in the regions, of which there are many; whether doing landscapes, still-life, flower pieces or portraits; supplementing this, if necessary, with teaching part-time at one of the many provincial art schools. To do the same sort of thing in London will cost very much more, for the same financial return.

Having, at last, acquired premises, these will, ideally, be part of the domestic or family home; for the reason that banks only lend grudgingly on workshop premises; whilst they do lend on domestic accommodation, of which a part can quite properly be used as a studio.

If you are a tenant, it is wise to ascertain without any doubt that there is no restriction on the carrying on of professional painting or the like, in the rented accommodation; and, if rented, to read the small print in any lease before commitment. If there is no obstacle, it is still important not to make any installation that can be regarded as a landlord's fixture; otherwise on wishing to leave the premises and live elsewhere, it may be found that the installation has to be left behind. This can include not only alterations to studio windows, that are, naturally, part of the building thenceforth, but could conceivably, if the landlord insisted successfully, apply to shelving, storage racks, fitted worktops, sinks and similar things. Many of these things can be installed in such a way as not to become landlord's fixtures.

It is absolutely needful, whether tenant or owner, to scrutinise the tenancy agreement or the title deeds, to see whether there are any of what are known as 'covenants'; these being restrictions and undertakings that you become bound to when you sign the tenancy agreement of the purchase contract and which are embodied in the deeds. These can take all sorts of forms; from forbidding the erection of outhouses to a prohibition against carrying on any kind of business on the premises. It does not matter that you may own the land and premises freehold, you may – and very likely will – have covenants just the same.

If you wish to make any alterations to walls, doors, windows and so on, it is essential to contact the local

authority. You may have to do this even to put up a wire fence. Details of the structure or alterations have to be supplied in several copies – probably five copies – together with drawings and all other information to enable the authority to decide whether the proposal is safe and sound or otherwise. It is illegal to proceed without approval; and an official may come along to the site for a prior discussion; and will also come along every few years to see if it is still alright. There is nothing to worry about in this; indeed, if you give the officials full and clear details of the project, they will be found very helpful; perhaps, from experience, making some good suggestions as to methods, ways and means. The District Surveyor will be prepared to discuss these with your builder or whoever is professionally doing the job, all for a very nominal and statutory fee.

Under the laws relating to town and country planning, you may have to seek permission for projects that are likely to alter the appearance of your premises and thus affect local amenities. You can find out whether you need planning permission, by asking at your local town hall. The Citizen's Advice Bureau of your local district – probably stationed at your local borough library – will advise you where to apply and whom to ask; or, if you feel like it, ask your solicitor. Projects such as building a dormer or picture window in an attic may well come under this restriction, as it could affect the appearance of a whole street.

If you have a large tree that cuts off some of the studio daylight, you cannot legally top it, lop it, prune it or fell it, without proper planning permission; and as it is likely to be a local amenity, anyone, who likes it as it is, can object. You could even have a successful objection for cutting or severely cropping a standing hedge, without permission; even if the objector lives a mile away. The artist who is buying the house through a building society mortgage – or intends to seek to do so on the basis of the purchasing cost of the house in its state at the time of purchase – must notify any proposed alterations in detail to the building society, so that the mortgage, and the basis on which it is calculated, are not impaired. It must be remembered that alterations that may be to the advantage of the artist occupant may be regarded as drawbacks by an estate agent and valuer, a building

society or an intending purchaser. For example, two small rooms may have been knocked into one large room by the removal of a partition wall. This reduces the number of rooms – in most cases they are potential bedrooms – which can be a drawback for a family with growing children who would prefer several small bedrooms rather than one or two big ones.

THE TREATMENT OF THE WALLS

If the artist follows only a part of the advice I offer later in this book, the walls of the studio will be so covered with shelves, bulletin boards, unstretched canvases, and so on that there will be little wall left to worry about. In any case, the colour of the walls is best deferred until Chapter Three when I discuss studio lighting; upon which the colour of the walls has a considerable effect. The type of wall covering can be plain, such as emulsion paint, or it can be vinyl wallpaper which is washable and waterproof. It depends whether you are happiest in a factory atmosphere, an office situation or a domestic ambience. My own studio takes on a little of each and is wallpapered by vinyl waterproof paper (which is really paper-backed plastic). It is patterned in a broken, abstract design, of medium-dark browns, greens and dark reds, with black and white. I find an empty wall surface makes my paintings seem over elaborated and fussy; and I empty the composition accordingly; only to feel later that I need not have done so. A patterned repeat design or flower motif has its own style and it interferes with my independence of creative compositions; so that it is not allowed. A surface filled with broken, irregular patches of moderate, unchallenging colours has just the right non-committal texturing and tone, whilst being lively enough to prevent my doing any 'sleepy' paintings which betray their lassitude in contrast with it and are accordingly livened up.

FLOORING TREATMENT

The treatment of the flooring is important. Because a painter is likely to splash and spill a certain amount of water colour, inks, oil paints, varnishes and similar things, on to the floor, it is not wise to have carpeting in the painting area, as it is difficult to keep it clean. My

own studio has been floored with tropical hardwood (teak) parquet, which I find entirely successful; and a blob of paint spilled on to it can be easily wiped up. Otherwise, plastic floor tiles are very good and are equally easy to clean. Cork floor tiles are very good also and are quieter to walk on than hardwood parquet or plastic floor tiles. As my own studio is on the first floor, I always wear rubber-soled shoes when working; otherwise the rest of my family downstairs are disturbed by my footfalls across their ceiling, for hours at a time.

I recall that Paul Nash, in his Hampstead studio had a strip of stair carpet about three metres long, leading up to his oil-painting easel; and he found it useful when backing away from the painting as a guide to prevent him backing into the furniture, or walking backwards into his painting trolley, or wearing out the large carpet.

If the artist favours a semi-domestic character in the studio, as do many portrait painters, it is best to have the social part at one end and the painting area at the other. The former can have rugs and carpets, coffee tables and easy chairs and so on, on carpet; but the floor of the painting area should be of hardwood, plastic tiles or linoleum.

Quite reasonably, a young painter might point out that things like parquet floors, and even plastic or cork tiles, or linoleum, are expensive. To this I would suggest turning a necessity into a virtue by having bare floor boards. After knocking down all nail-heads with a punch, an electric floor-sander should be hired from a tool-hire shop, and the floor boards sanded completely smooth. Then they should be varnished with polyurethane varnish, in two coats at least. They can be water stained before varnishing with very attractive effect, if it is well done. The stain must be water stain; as varnish stain may not be compatible with whatever varnish is painted on top, and can leave a sticky surface like an old-fashioned fly-paper. Of course, there are varnish stains in a variety of tints that can be painted on to the sanded floor boards, to stain and varnish at the same time. It is related that the artists of the Aesthetic Movement of the 1880s preferred the studio floors to be pale green, for some reason.

For the ground-floor production area of a sculptor or print-maker solid flooring is desirable; which will be of concrete with cement finish, or of asphalt. Both of these

floors can be painted with deck paint, for cleanliness and smartness. A floor of a studio where much water is used, or corrosive acids like those used by etchers, should not have floorboards through which such fluids can leak when spilled. If such a studio be on the ground floor on solid concrete or the like, it should be covered with strong, old-fashioned linoleum, protected by two or three coats of polyurethane varnish, finished with a beeswax polish; which resists corrosion and staining and does not let fluids drain through, as would plastic floor tiles, for example.

NOTES

[1] Antonina Valentin, *Picasso*, (Cassell, 1965), p. 49.

[2] Vasari, *Lives of the Artists*, (B.Burroughs, ed.), (Allen & Unwin, 1960), p. 49.

[3] *Op.cit.*, p. 91.

[4] *Op.cit.*, p. 103.

[5] *Oxford Companion to Art*, (Clarendon Press, 1979) p. 194.

[6] Vasari, *op.cit.*, p. 293.

[7] Vasari, *Technique*, (Thames & Hudson, 1954), p. 213.

[8] Françoise Gilot and Carlton Lake, *Life with Picasso*, (Nelson, 1965), p. 136 ff.

[9] Seen thus in a drawing by Van Gogh on one of his letters. Van Gogh painting *Sunflowers* is also seen in a painting by Gauguin, completed in 1888; *cf.* Dillian Gordon, *100 Great Paintings* (National Gallery, London, 1981), p. 208.

[10] Peter & Linda Murray, *A Dictionary of Art & Artists*, (Penguin, 1968), p. 177.

[11] P. & L. Murray, *op.cit.*, p. 414.

[12] Max Doerner, *The Materials of the Artist*, (Granada, 1979), p. 327.

[13] *Ibid.*, p. 325.

[14]*Ibid.*, p. 336.

[15] Jack Lindsay, *J.M.W.Turner, his Life & Work*, (Cory, Adams & Mackay, 1966), p. 216.

[16] Richard Francis, Introduction to the catalogue of the *Jennifer Durrant* exhibition (Nicola Jacobs Gallery, London, 1982), page 2.

Chapter 2

Working conditions

The cleaning of the studio

Not many people today have housemaids; but quite a lot of people have 'treasures' in the form of cleaning ladies who 'come in to oblige'; and who happily dust and vacuum-clean their way around the house in a remorseless sequence of well-meant wear-and-tear. It is quite fair to state, I think, that these gallant ladies constitute as big a threat to the conservation of paintings, sculptures and other works of art such as fine furniture, as all the Commissioners of Henry VIII in his dissolution of the monasteries, and the despoiling of art treasures by Cromwell's troops, and the well-meant devastation by Victorian restoration all added together.

Having long ago regretfully dispensed with the services of such ladies, in order to prevent any further breaking off of pieces of sculpture and furniture, ripping out of inlay, and scouring of the fine glazes from paintings, and the banging of the corners of antique furniture by heavy-handed wielding of vacuum cleaners akin to the effects of stock-car racing, I feel it worth while to offer a few tips to artists and others, to pass on to the 'cleaning lady'.

Firstly and, perhaps, most important, she should get rid of her beloved duster. Generations of housemaids and mothers' helps have hooked the corners of their dusters round ormulu, fine marble carving, gesso ornamentation and the like and broken it off with the vigour of their 'dusting'. I have had an inlaid Persian cigarette box in ebony and ivory practically stripped of its parquetry inlay by a cleaning lady who gripped it firmly and rubbed it hard with a duster, tearing away the small pieces of inlay, week by week. Dusters should be firmly 'out'.

The traditional and correct implement for dusting is that used in great houses for generations; the feather

duster, made of hens' feathers bunched on a cane. Such a tool is used in all the properly conducted museums of furniture and similar arts and the great historic country-houses. Even so, in art galleries, I have seen, and sometimes had to deal with, old masters lent from such country houses, which have evidently, for generations, been briskly wiped over by conscientious housemaids; removing in the process all the thinly applied surface glazes that, once upon a time, had given the painting the quality intended by the artist. Such pictures are sometimes referred to as having been 'over cleaned'; when it is not the poor restorer who removed the glazes, but a couple of centuries of successive housemaids with dusters.

A characteristic of many varnished surfaces on paintings is that friction with cloth will set up strong static electricity all over the painting. This attracts dust like iron filings to a magnet; so that the harder the housemaid 'dusted' the painted surface, the dustier it became. In addition, much of the dust constitutes a fine abrasive, which aggravates the effect of wearing away the glazes.

Artists of today do not use glaze very much (which I think is rather a pity, as if modern organists no longer used the top keyboard, or orchestras no longer employed viola players – with comparable loss of character and quality). It may be, therefore, that modern paintings will not suffer so badly, under the ministrations of the duster-wielding cleaner. However, sculpture and furniture can suffer just as much as before, as the surface quality of sculpture is almost equally fragile.

See also page 261 for advice on the correct cleaning of framed pictures.

Health and safety in the studio

At first sight it would seem, perhaps, that nothing could be safer and healthier than an artist working away in the studio in peace and quiet; proceeding at a steady and contemplative pace to pursue an acceptedly therapeutic form of harmless self-expression. To declare that nothing is farther from the truth would, perhaps, be overstating the position; bearing in mind that many artists have lived to a very ripe old age, even in difficult times; so that Michelangelo died aged 89; Leonardo da Vinci at 67 and

Titian at 89; Tintoretto at 76 and Paolo Uccello at 78; to name a few long-lived artists at random from times when the expectancy of life of most people was about 45. Raphael, tragically dying at only 37, was very much the exception among artists rather than the rule.

Yet, among the wealth of published writings on health and safety in factories, schools and other places of work, it has, seemingly, been worthwhile for a special study to be published on *The Impact of Hazards in Art on Female Workers*, as an important piece of research in preventive medicine. The advice and warnings that I offer in this chapter, apply, in fact, to both male and female artists; and my main concern is not that art is so safe that one need not take any care, but rather that I will not frighten anyone into giving art up altogether and taking up something safer such as mountaineering, big-game hunting or deep-sea diving.

Hazards to health in any environment can take the form of the immediate effects of accidents, or the slower and more gradual appearance of symptoms that take a long time to develop. The recognised effects of accidents – which, of course, can happen anywhere – are: crushing, fractures, lacerations, bruising, burns, dermatitis and back injuries. Of these, the ones most likely to happen in the artist's studio are: lacerations, dermatitis and back injuries.

The lacerations can occur in trimming paper and card, and in cutting mounts; the dermatitis can arise from the use of volatile spirits in conditions of bad ventilation; and back injuries can be caused by lifting cumbersome things like heavy paintings in too confined a space or other awkward circumstances.

Of the four types of main hazards to health to which all workers are exposed; the first category – heat or cold, glaring or poor lighting, noise and radiation – are not very likely to occur to any great extent in an artist's studio. The second type, however, in the form of toxic substances, such as chemicals, fumes and fibres, is a very real and ever-present risk in a studio; to such an extent that I devote the following section entirely to these. The third area of risk, from hazards such as trailing wires, hidden pitfalls, broken stairs and the like are no more or less likely in a studio than anywhere else; whilst the fourth group of risks, in the form of unsafe and unhealthy

working conditions, overcrowding, long and irregular hours and lack of sanitary and welfare provision, are all entirely in the artist's own control in a studio.

Stress is an insidious cause of illness; and whilst it might be claimed that an artist in a studio would not suffer stress arising from the work, yet those artists who teach at art schools, like those working in their own studios, can suffer from the effects of stress-causing factors: such as bad lighting, poor ventilation, noise from outside, lack of proper work-space and so on. At the art school, these things are not under the artist's control; but in his or her own studio they should be given careful attention as very likely to cause hidden irritation, frustration and therefore, stress; with the usual consequences to health in the form of headaches, colds, nervousness, sleeplessness and muscle cramps among others.

Bad organisation of the work can cause stress; due to fluctuations between periods of comparative inactivity and idleness and other times of definite overwork. One of the most insidious and expensive results for an artist of this kind of hidden stress is loss of tranquillity required for the work, and distraction of a proportion of the artist's concentration.

No one engaged in any activity involving high skill can give 100-per-cent concentration to the focal work area; which in the case of a painter is the small area of the painting or drawing that is being worked on at any given moment. During World War II, I trained in the interpretation of intelligence photographs and the use of camouflage. The use of camouflage usually succeeded because the pilot of a reconnaissance aeroplane, flying sometimes low and fast in enemy territory, could only give about one third of his attention to studying the ground; another third was engaged in flying the aeroplane and the remaining third was taken up with an alert look-out for enemy aircraft. Thus the camouflage had only to be just above one-third efficient to succeed.

Like the pilot, the artist who is unconsciously distracted (by using wrong posture due to working at the wrong height, or by outside noise, or the fact that the studio lighting is not entirely satisfactory) will only give about 50-per-cent concentration to the area of work; the rest of the concentration and faculties being drained off by the distractions of which the artist may be hardly aware.

In my following chapter dealing with studio lighting, I hope I convey how important this factor is to the successful completion of high-quality work. The question of good ventilation is equally important. A painter is, of course, quite familiar with the strong smell of paint that fills the studio whilst painting is in progress. This is an indication of high levels of volatile spirit vapours arising from the work; of which only one of the possible health hazards is the effect on the respiratory system through breathing the fumes for long periods. Poor ventilation can be the cause not only of infections, dry skin, throat and respiratory infections and the like but potentially serious heart conditions. Benzine and toluene can cause blood disorders. When the studio and the production area are in part of a house, the effects of these toxic substances with poor ventilation can also affect the artist's family and cause contamination or pollution in the kitchen and nursery.

Some of the adjuncts to studio production in the home also cause pollution: such as pottery glazes, photographic chemicals and processes, and the processes for making plans and blueprints in design studios, such as photocopiers (with ozone, toners and selenium in dry copiers and ammonia in wet copiers) and acids in etching studios.

It goes without saying that among the equipment in the studio there should always be a first-aid cupboard or box. This is very important if an assistant is employed; when a proper accident book should be kept, in which any mishap should be carefully entered as soon as possible. Failure to do this could affect the assistant's entitlement to Industrial Injuries Compensation, or considerations under Employer's Liability Insurance. If outside noise – perhaps from nearby factories, the neighbour's radio or overflying aircraft – is a distraction, you should consider whether to install double-glazing, the benefits of which, in quiet work areas, are not confined to greater warmth but also to a reduction of noise nuisance.

There is little danger in the creative area of a studio, if the artist avoids toxic pigments and ensures that the desk lamps and other electrical apparatus are properly wired and earthed. In the production area, the variety of techniques and media available poses a wide range of dangers. Painting and etching studios, with their volatile oils and acids need adequate ventilation and care in handling and

storage of these materials; and pottery work, like pastel drawing, can hold risks involved in the breathing of powdered pastels or glazes. The artist working on the mounting and framing of pictures and drawings incurs the risk of serious injuries from edge tools, power tools and the handling of heavy objects in confined spaces. The storage area has, also, dangers of its own.

The bulk storage of liquids, especially of volatile and flammable spirits, should never be undertaken without care. If storage of large quantities of turpentine, acetone and similar liquids is contemplated, the advice of the local Fire Prevention Officer should be sought. He is an expert in what starts fires, and his services in advising how to prevent them in the first place are entirely free on request at your local fire station. A good rule to start with is never to store such liquids in plastic or glass containers, which are liable to injury or breakage, but, where possible, to use metal containers with screw tops, clearly labelled and stored in the proper sort of place, detached from the house and securely locked. Preferably, do not store volatile liquids in bulk. If you do, forbid smoking nearby.

Corrosive liquids should never be carried in the wrong sort of container; for example a shallow etching dish full of acid should never be carried or even moved a slight distance.

Premises where dangerous or fragile objects have to be carried should always have a small glass pane in the door, so that anyone liable to push the door open and rush in, will see that there is someone on the other side who is carrying something. In any area that functions as a workshop, proper footwear should be worn. In art schools I have often seen girls working at benches using sharp edge-tools, and wearing open-toed sandals. In a later chapter on the tools and equipment for the small studio, I advise against the use of power tools; but if the studio does have static power tools, such as a small drill, lathe or grinding or buffing wheel, people of either sex with long hair should wear something to hold it in check, so that it does not hang loose close to revolving machinery. When using such equipment, I have observed people to hold the head very close to the revolving part; and the results of a scalping can be horrific.

Toxic art materials

Let me say right away that artists' materials as supplied by the artists' colourman are no more dangerous than any other familiar household product, in the form in which they are supplied; and, if used sensibly in the way they are intended, they are completely harmless. Along with many artist friends and colleagues, I have used them constantly for over 40 years and am none the worse.

All the same, like many seemingly harmless household products, they can be dangerous, if not used with care and respect. I have only known three cases where I was fairly sure the artist concerned was poisoned by his materials; none of them being of fatal consequence, but causing considerable discomfort and inconvenience for all that.

The first case was at art school many years ago when a fellow student had severe stomach pains in the afternoon. After he had retired, I could not help noticing that his palette was liberally covered with bright yellowish-green pigment containing Emerald Green; it was all over his painting table, his paint rags and his overall. He was only 16, and probably had never heard that some pigments are toxic. He ate his sandwiches at lunch-time, on his painting table, and I believe that, after a perfunctory wipe, he had used his palette knife to halve a large sandwich. As far as I recall, he was back with us in a day or two; and, if the pigment was the cause of his stomach ache, he must have only ingested a very small amount of the arsenic compound that was in the paint in those days.

The other two cases both involved the prolonged use of highly volatile solvent – I forget which – in a restoration studio to remove old varnish from elderly paintings. In both cases, two very experienced art restorers, working without glove protection, spent many hours with the right hand holding the swabs in tweezers, within a cloud of the volatile vapour from the picture surface. After many days of this, the skin became inflamed, and tended to erupt and peel; and, on different occasions, each walked around with a heavily bandaged right hand, for several uncomfortable weeks.

Whilst, as stated above, I have no criticism whatever of artists' materials as supplied and made up by the artists' colourmen, nevertheless, even the firms concerned cannot help the fact that a number of pigments and a variety of

volatile spirits are toxic. But then, ordinary household bleach, washing-up powder and metal polish are all toxic if misapplied. Even talcum powder is toxic if inhaled too much; and many cosmetics are toxic in nature. Even familiar home remedies like aspirin and cough mixtures are toxic in excess, as is the whisky on the sideboard, if misused.

As many artists have a studio in the home, there is a particular responsibility to keep potentially toxic studio materials where children cannot reach them. In a survey conducted by the Consumer Safety Unit of the Department of Prices and Consumer Protection, in 1975–76, 100 household products and materials were listed as potentially dangerous; and the number of hospital cases of accidental poisoning of children up to 14, needing in-patient treatment is higher in this respect than *any other* broad class of accident, including road accidents.

Which product was to blame in the survey for the highest percentage of cases of child poisoning? None other than our old studio standby – turpentine! It scored 12 per cent of cases in six representative hospitals. This was in spite of the finding that turpentine substitute, surgical spirit, paraffin and the like are notably more likely to be kept in locked storage than all the other products; and, in most cases, had been in the house for less than a week. Compared with turpentine, the figures for other studio materials included: paraffin 5.8%, paint-brush cleaner 2.2%, glue 0.9%, petroleum 0.7%, methylated spirits 0.7%, thinners 0.5% and acetone 0.2%. At the six hospitals, involving 100 products, 1,723 cases were followed up. The annual total of such cases in the UK is 10,500 up to four years old and 1,000 from five to 14 years old.

One moral is that the more familiar and seemingly harmless the substance is, the more poisonings it causes. Thus, apart from the case I mention above, I have never known another case of poisoning from the lurid and dangerous-looking Emerald Green; and that one was many years ago. Toxic substances can act quickly; and others are cumulative in effect over a period of misuse; as in lead poisoning, where the lead builds up in the system; or in the skin damage caused by volatile spirits in bad conditions. A substance is 'toxic' if it damages tissue or health, or destroys life; either quickly or over a period. There are probably many instances of do-it-yourself diag-

nosis of 'upset tummy', 'backache' or 'nettle-rash' that might be traced to misuse of materials. If there is serious ground for suspicion that someone's sudden sickness, skin trouble or stomach cramps are linked to the fact that they have been using toxic materials in a foolish way, they should be taken to hospital, together with a sample of the suspected material, and its packaging, to give every help in identifying the cause.

Many pigments are toxic in powder form but are harmless in suspension in drying oils as supplied by the colourmen. They should always be handled in the mixed state, and not inhaled. It is dangerous to try to mix your own pigments for economy unless you know the composition of the substance. Flake White (basic lead carbonate) should be treated with respect; and also the various grades of Naples Yellow, a very old colour, which can contain lead, Emerald Green which used to contain arsenic compound, and Cobalt Violet and the Chrome Yellows which can also contain lead.

Colourmen have done much research to eliminate toxic pigments from their ranges and to introduce harmless equivalents; and most childrens' and students' ranges of colours omit them. However, they are retained in the lists of pigments for professional use; but in such cases are invariably marked with a warning. Messrs. Rowney, for example mark with a dagger the toxic items in their list of Rowney Artists' Oil Colours; including the grades of Naples Yellow, Chrome Lemon, Chrome Yellow, Chrome Orange, and Flake White; totalling only seven out of 81 pigments; and their Georgian Oil Colours give the dagger to: Chrome Lemon, Chrome Yellow, Chrome Orange, Chrome Orange Deep, Chrome Green, Flesh Tint and Flake White.

Messrs. Reeves, who cater specially for educational materials, state that to the best of their knowledge, all products in their catalogue which are included in Appendix A(i) to A(vi) of the DES Administrative Memorandum No. 2/65 dated 1/2/1965 concerning poisonous substances, conform to the requirements stated and are classified as non-toxic unless otherwise stated. Messrs. Winsor and Newton signify toxic character of a pigment by a © mark in their catalogue lists (used elsewhere as the International Copyright sign); including the Chromes, Mauve Blue, Mauve Red, Naples Yellow, Zinc Yellow, Flesh Tint,

Geranium Lake, Lemon Yellow, Manganese Blue, the Cadmiums, Carmine, Cremnitz White, Flake White, Silver White, Foundation White and Underpainting White.

Pastels should not be used by young children, who spread the dust around, breathe it in and lick it off their fingers. Those with a tendency to asthma, bronchitis or dust allergies should use pastels with caution.

Volatile solvents are all potentially toxic without good ventilation, and surgical gloves should be worn if using them for a long time. The hardeners for plastic resins, and solvents like acetone, ethyl alcohol or carbon tetrachloride should never be used in closed conditions; and the user should avoid inhaling them, or getting them on the skin. Genuine turpentine is only dangerous if you mistake a glass of it for your gin-and-tonic.

All the polyester and epoxy resins are hazardous in pigments and adhesives over long periods except in extremely well ventilated conditions; and the hardeners are bad for the skin. Methanol (wood alcohol) is very toxic though a useful solvent. Acetone and benzol are risky, as well as being, like all other volatile spirits, very flammable. Alkyds and acrylics and the (so-called) polymers are safe if used as intended; but varieties of all these substances, if not clearly identified, are hazardous; as are the raw materials for anyone tempted to experiment in his or her own mixtures.

Artists cannot avoid the toxic volatile spirits, but should use them with understanding (see also page 91). As for the toxic pigments, it is not difficult to choose a palette that is not only of fully stable pigments which mix with each other but of which none are toxic.

Fitness and preparation for work

Any serious work will be the better performed if the performer takes reasonable steps to be in the best condition for the task. Art is so physically and nervously demanding, because of the skill required for accuracy and sensitivity, that it is more important for the artist to be fit for the work than it is in many other walks of life. This accords strangely with the popular idea of the artist as a bohemian character prone to high living and social exces-

ses. This myth has evolved from the biographies of a tiny minority of talented artists, who were victims of one or another form of disability or drug abuse. For the most part, artists of note are sober and respectable persons of the dullest conformity.

No one would wish to be the patient of a brain surgeon whose hand was not absolutely steady due to his drinking a glass of spirits or something of the kind just before the operation. There are few surviving racing drivers, leading jockeys or Test cricketers who have had the habit of eating or drinking too much just before their performance. The high degree of skill that their tasks call upon, leaves no room for self-indulgence. Admittedly, one sees many businessmen, at midday, indulging in large lunches with consumption of wines and spirits; and one can only conclude that the businesses in which they are engaged do not really call for any acutely skilled abilities. The regime requisite for an artist to perform at the peak of ability is much more stringent than that.

One thing that the artist should decide is whether he or she works at the highest skill in the morning or the afternoon since there may be studio lighting problems according to whether the studio faces east or west. If these factors coincide sympathetically, the artist will work well in a particular studio; but if they work in competition to one another, the artist's skill may have shortcomings, the cause of which the artist does not realise.

Indeed, some artists seem to prefer to work at night – as Picasso has been reported as doing. Whenever the peak working time, the less favourable periods of the day should be allocated to the supporting work; such as mounting, framing, casting, printing of etchings or engravings and similar tasks which are secondary to the primary work of creating the original drawing, painting, model, or etching plate.

It may not be realised by an artist who does drawings, that drawing skill can not only be impaired in quality by drinking a single glass of wine or spirits beforehand, but that even a cup of tea or coffee can take away some of the perfect co-ordination needed for precise and accurate drawing. It has been established that even a small amount of alcohol in the blood can noticeably impair the standard of driving a motor car; and that drivers are not aware of the effect until it becomes fairly acute. In other

tasks it is more readily observable. A typist who makes few, if any, typing mistakes in normal circumstances, will make about two errors a page after a glass of spirits; and after two glasses, will type as neatly as usual, but make about four errors per page in the process. A portrait artist who is trying to draw with absolute accuracy the line of an eyelid, or the line between the lips, on the portrait of the sitter, will not do it so well after drinking a glass of spirits.

A rather depressing fact is that a cup of strong tea causes a very light tremor or lack of co-ordination of the muscles. If two cups of strong coffee are taken at breakfast, this tremor will certainly affect the accuracy of drawing; whether in pencil, ink, paint or on an etching or engraving plate.

This means that a certain regime of spartan kind is called for by the fully conscientious artist; who should not eat or drink anything that affects performance; any more than would a pianist or violinist just before a concert. I am not referring to intoxication; or anything close to it. The degree of deterioration of ability needs only to be very slight, in such skilled activities, for the performance to lose its fine cutting edge.

The day before a session of studio work, involving artistic skills such as drawing and the like, the artist should not undertake anything that calls for muscular effort above the normal to which he or she is accustomed. One might even go further, and suggest that, on rising, and also just before starting to draw or paint, the artist should perform some easy, swinging and muscle-loosening exercises, of the kind that competitive swimmers and runners can be seen to do just before a race, to ease their muscles and loosen up.

The final preparation for work, for the artist working on fine papers, is to eliminate all grease from the vicinity and from the artist's hands, that can spoil the paper surface for the reception of washes of water colour or ink. Soap and water may not be sufficient to remove newspaper ink or grease from your hands. Wipe your hands with spirit on a clean rag or cotton wool and follow up with the soap and water.

In studios where engravings, etchings, lithographs and the like are printed, with the use of greasy, coloured printing ink, it is a skilled task in itself to keep the

printing paper in mint condition; but it is not always realised that outside such special conditions, an ordinary newspaper can cause the smearing of any otherwise clean, white surface in the studio. Whilst I do not suggest that the artist go to the lengths of the reader who wrote to *The Times* in August, 1982 to state that he always wore cotton gloves to read the paper, of which he kept two pairs, I do again suggest cleaning the hands with spirit before work. It should not be fierce spirit, such as thinners or petrol, which can be bad for the skin; but paraffin does no harm. Best of all is 'Swarfega' emulsion.

The artist should also pay particular attention to whether it is more comfortable to work sitting or standing. People differ in this respect. The novelist Trollope always used to write his novels before breakfast, standing up at a sort of lectern; because that was what suited him best. The champion golfer Jack Nicklaus always arrives at the golf course three or four days before the competition and carefully walks the course. The Yorkshire and Test cricketer Geoff Boycott always used to arrive early for a Test match, and go out and inspect the pitch, with care, bouncing a cricket ball on it to test its condition. He stated that he always thought carefully before an important match, exactly how he had been bowled out to the particular bowler he was to face, last time they met.

In a similar way, the artist should set out all the working equipment well before a painting session (the evening before a painting session if work is done in the morning) and should inspect the studio to ensure that everything is as it should be; the lighting, the ventilation the availability of materials, the good condition of brushes and other tools. Every interruption to concentration due to material shortcomings during the work will conspire to spoil the result.

For freehand drawing, the old-fashioned 'artist's donkey', familiar in art-school life classes, permitted close work, and also the ability to get back from the work for scrutiny, whilst remaining seated for long drawing sessions. This – consisting of a small bench straddled by the artist, with an upright and crossbar at one end to support the drawing board – is too cumbersome for the small studio; but two chairs can be used in a similar way. However, this is useless for accurate drawing with small-scale detailing, such as in designing or lettering and

Plate 4. George Cattermole (1800–1868),drawn by an unknown artist, when sketching in a studio. His personal arrangement for the backwards and forwards movement necessary for freehand drawing cannot, however, be generally recommended. *Reproduced by kind permission of the National Portrait Gallery.*

illustration. For this, the artist should draw seated, at a sloping drawing board. The work should be attached to the board well up its surface, to allow the artist's elbows to be spread on the board, in a way that would be impolite at the dinner table but gives the needed support for closely accurate drawing. This posture will also reduce fatigue as it supports the entire torso. Any needless fatigue reduces concentration needed for the task.

Artists who are involved with art societies or other

Plate 5. The English painter and portrait draughtsman, Sir William Rothenstein (1872–1945) as a young man, in a rare lithograph drawing by the American portrait painter John Singer Sargent (1856–1925) made in 1897. Rothenstein shows the correct post-ure for accurate, small drawing. The arms and entire torso are fully supported on the drawing board, in an ungraceful but efficient posture. *Reproduced by kind permission of the National Portrait Gallery.*

business concerns, should not hold tiring and, perhaps, controversial meetings the day before a creative work session in the studio. This sort of event drains the artist's nervous energy – even when the occasion is enjoyable, and far more so if it is disagreeable; and it can also cause slight, unconscious muscular tension that impairs skilful executant performance. Henry Moore has stated that he

gave up teaching art at the Chelsea School of Art because it used up creative energy that he needed for his own work.

Finally, however inspired and enthusiastic the artist may feel about the work in progress, it is not a good thing to work too long in the studio without a break or a change. This must not be a 'tea-break' for the reasons explained above; but it should involve relaxing concentration for a while, and, if possible, moving about, perhaps taking a walk round the garden, to ease the muscles. Not only will the physical co-ordination and control be restored, but the mind will also be made once more alert.

These may sound like fussy and needless procedures; but art is difficult enough without adding to the difficulties with others of our own making. The difference between a merely good work of art and a masterpiece is not a wide gulf – it is a hair's breadth difference; a tiny margin that can be lost by not paying attention to the physical and mental preparedness that the exacting nature of art demands.

It should always be remembered that art in the studio is, for most artists, a very solitary activity. The artist is shut away in the studio for long hours, when interruption in unwelcome. It is not a good thing, however, for anyone other than the constitutional hermit, to spend every working day in solitude. In time, it can make the individual less able to tolerate and relate to other people, with side-effects on the personality, such as shyness or a crotchety manner.

For this reason artists, above all the professions, seem to be gregarious outside the solitude of the studio; and the many artists' clubs, and art societies are one outcome of this. Some artists do a day or two of teaching in a working week, and find agreeable artistic company in this way. Even Turner, who was, by many, thought to be of a solitary disposition, enjoyed teaching perspective at the Royal Academy Schools, taking great pains in the preparation of special drawings and diagrams for the students. Many artists do a day's part-time teaching at art school more for this reason than for the money. Other artists take pupils on certain days, and a few take an assistant or two; such as Henry Moore at his Oxfordshire studio.

If an artist takes an assistant, however, this calls not only for proper working conditions for the artist as I have described above, but certain special working conditions for the assistant that might be overlooked.

Can you use an assistant?

As I stated in a previous chapter, an artist's working week includes many duties that are neither artistic nor creative in any real sense. These include mounting, framing, packing, despatching and receiving works for exhibition purposes, canvas stretching, and the care and cleaning of working equipment such as brushes, palettes and painting trolleys. In the past, an artist would rarely do things like this for himself; and the system of apprenticeship provided a supply of pupil-assistants, who would be given these humble tasks to perform; in addition to such things as the grinding of pigments, which does not need to be done today, since the advent of the professional artist's colourmen.

All the same, many artists today have assistants. Henry Moore, as I have said, is helped by a team of assistants at his sculpture studio; and my old friend Sir Charles Wheeler, PRA, the sculptor, best known, perhaps for his dolphin bronzes for the fountains in Trafalgar Square (done with William McMillan), employed a highly talented assistant, Estcourt Clack, a fine sculptor in his own right.

When Sir Winston Churchill went out painting, he had his easel, chair, painting umbrella, paintbox and palette all set out for him by a young assistant, who cleared it all up when the great man went indoors again after he had finished painting for the day.

Many artists today spend hours on unproductive and skilled, but routine, tasks that could be performed by an assistant; leaving the artist free to do his creative painting or sculpture for a greater part of his working time. Yet, strangely, very few artists would feel able to employ an assistant. It would be a very good thing at this time, when the teaching of art at art schools comes under so much criticism[2], for painters to invite young beginners to give practical assistance in return for tuition. I sometimes think that, if I had my time over again, I would not

Plate 6. A self-portrait by the English painter of conversation pieces, romantic history subjects and portraits, John Hamilton Mortimer (1741–79), shown drawing, using a simple and ingenious drawing board with hinged support, which folds flat when not in use. Even a stout folio could be used in this way. Note the comparative darkness of the studio, and the presence of a pupil assistant who is learning how to draw; the only way he could learn before the foundation of the Royal Academy Schools in 1765. Painted in oil on canvas, c. 1765. *Reproduced by kind permission of the National Portrait Gallery.*

(as I did) learn art at an art school, but would ask an artist whom I greatly admired, to let me be his studio assistant, in return for tuition.

This would be nothing more than a return to the system that prevailed for centuries before there were any art schools in the modern sense.

With a great deal of unemployment among young art

school leavers, at the time of writing this book, it would, perhaps, appeal to many young artists, to receive training, not only in the style and methods of an admired painter, but in all the ancillary, businesslike parts of his or her work, of the kind that are discussed in this book.

A young artist may feel that he or she cannot afford to pay an artist for tuition; and a successful artist may feel that his profits do not allow him to pay for the services of assistants. It should not be beyond the scope of such people, to consider a young artist assisting an admired painter in return for tuition. Few, if any, of the topics discussed in this book are taught at art schools; and a young student beginner in the art world has to learn them by trial and accident. I can envisage something similar to the *au pair* system, by which young women learn the language and customs of foreign countries in return for giving some assistance in the house of the host family; by whom, ideally, each is treated as a friend and not as a servant.

In a similar way, many a busy artist could offer hospitality with his family, either during college vacations, or in the period of unemployment that follows college training, and also tuition, in return for practical help with the ancillary aspects of the job, which the young artist will not have been able to learn elsewhere.

In such a situation, however, a certain amount of planning is required for successful co-operation. For one thing, the assistant, in addition to somewhere to stay, will need working space in the studio. As the beginner will have to stay somewhere, whether assisting an established artist or not, there is not really an obligation on the artist to provide free accommodation. The beginner may be receiving unemployment pay, in any case, wherever he or she is living. On the other hand, an artist with a family and spare accommodation could offer it. It has to be remembered that the learner will not be much use for some time; until some proficiency has been attained; and that all his or her time would not be taken up with routine duties, because it would only be desirable and fair that time would be given for original creative work under the encouragement and tuition of the painter – or sculptor, as the case may be.

The reason I broach this idea is not so much to attempt to introduce it as a widespread system, as to provide the

occasion to remind any artist thinking of taking on an assistant in this way, of the obligations that go with it.

One essential thing would be to find out from the Department of Health and Social Security whether it is necessary to pay for National Insurance stamps for the assistant.[3] At the present time, this is required if, in any one week, the assistant is paid £32.50 per week in wages. It should be stressed, in this connection that it is only fair to the assistant to pay for National Insurance stamps if possible; as the longer it is left before a proper National Insurance card begins to be regularly stamped, the less benefits the young person will receive – not only at that time but for the rest of his or her life.

Art students – and their colleges – rarely seem to be aware that, during the three or more years of art training, the student is losing 'benefit years', if National Insurance stamps are not being bought and stuck on the card. For full benefits, throughout life, a maximum of 40 years of card-stamping can usually be expected, and a little more in many cases.

Apart from National Insurance, the artist, being in the position of employer, would have to take out Employer's Liability Insurance in case the student had a mishap during work. There are specialist companies who deal with this kind of insurance[4]. If the assistant uses powered equipment or any specialised tools that are dangerous, it may well be requisite as an obligation to display the appropriate notices regarding safety regulations, as laid down by the authorities concerned. In this connection an artist who has a number of pupils coming to his or her studio for tuition, is advised, in addition to checking the tenancy agreement or title deed covenants, to see whether there is any prohibition against businesses that entail numbers of people coming to the house; to ensure also, by careful perusal of the insurance policy of the house, that the public liability of the policy will properly cover these professional clients. At such a time, it is always worthwhile to contact the insurance company and explain the circumstances accurately, so that they can adjust the policy, if necessary; perhaps with some addition in the premium.

The important thing in such cases is the dual nature of the premises as partly private, domestic accommodation, and partly commercial or professional premises;

and what covers one may not, necessarily, cover the other.

For the student-assistant's own work and training exercises in art, it is quite equitable to expect the student to provide his or her own painting equipment and art materials; although a little generosity will not do any harm. It should be stressed, quite clearly, that patience will be called for; as student beginners however brilliant, and whatever artistic talents they may have, are subject in my experience to two overriding characteristics up to the age of 24 or so; they, without realising it, are very slow; and also, they are usually very inept. It is not fair either to censure, or to blame the pupil for these youthful shortcomings. It is a reflection of the tutor's abilities when the pupil becomes both skilful and speedy in execution.

When the Employer's Liability Insurance is effected, the policy statement will arrive from the company; together with a statutory statement, declaring that the insurance is duly in force. It is a legal obligation to pin this up and display it where the insured employee can see it.

One thing that will have to be considered very carefully is whether – and if so, to what extent – the pupil will be allowed, or expected, to work on the actual products of the artist-tutor. There are very good precedents for this being done; and indeed, in former times, the apprentices in artists' studios always worked on the master's pictures. Everyone knows of how the juvenile Leonardo da Vinci worked on the *Baptism* of his master, Verrocchio, (Uffizi, Florence). Usually, apprentices ground the colours and cleaned the brushes, and so on; the experienced youth became a journeyman, and would copy drawings on to panels, and perhaps lay in the monochrome underpainting – if not on the centre panel of a triptych, at least on the wings. The journeyman might be taken on for so many days for a specific job (hence the name). This meant that work of varying artistic character and quality above a certain highly-skilled minimum level, could appear in a single painting. Sometimes the master painter in a studio might not do any work on a particular picture; leaving it all to his assistants.

Even in a single part of a picture, the underpainting might be by one artist and the colours applied over it by

another. For example, Dürer, in 1507, wrote from Italy that he had turned a panel over to a specialist to have the underpainting laid in, as monochrome, from the sketch, before he, himself put on the colours[5]. This was not at all unusual. On another occasion, he wrote to Jakob Heller that, whilst the wings of a triptych were underpainted for him by someone else, he would do all the centre panel himself.

A master painter in the eighteenth and early nineteenth century might have a 'drapery man' and a 'hands and faces man', and an 'animal man' and an 'architectural background man'. Sir Joshua Reynolds had a drapery and costume painter to finish off portraits on which Reynolds had painted the face. As late as Thomas Creswick's (1811–1869) *Trentside* landscape (Royal Holloway College Collection) the cattle in the foreground were painted by J.K. Bottomley for it to be shown at the Royal Academy of 1861, where it was well received.

Perhaps the last artist of renown to paint pictures with the help of studio assistants was Walter Sickert; though the use of assistants by sculptors has remained more widespread, no doubt due to the laborious physical work involved in the making and handling of heavy sculptures.

From my old friend the late John Wheatley, ARA, RWS, I had an account of Sickert's use of his assistants. For a painter who eschewed many of the traditional painting methods taught him by his master Degas – who was one of the last artists to paint in the monochrome underpainting technique of the old masters – Sickert was very conscientious and systematic in his studio routine.

He not only expected his assistants to set out his materials and then clear them up when he had finished painting. They regularly worked on his paintings; including promising young artists such as Lord Berners, Morland Lewis, his later biographer Robert Emmons, and Mark Oliver who later became an art dealer.

Having selected a drawing from his constant production of drawings from life and nature, Sickert would give it to a good draughtsman among his assistants and have him re-draw it on a canvas that was squared-up for the purpose with pencil lines. Then that assistant or another would place oil pigment on the canvas; using Venetian or Indian Red for the darks, pale Emerald for the half-tones

and pale Ultramarine or Cobalt for the lights. This was a sort of code, so that when Sickert came to touch on the dabs and spots of finishing colour – which he used instead of the old-fashioned glazes – the code would remind him what tone (lightness or darkness) it had to be.

At the end of a day's work, a painting was labelled with the date three weeks' hence; and hung with others on the studio wall. On that date, it was taken down and proceeded with, having dried sufficiently in the interval.[6]

Any artist using an assistant in the studio, therefore, will not only have to teach the proper system of dating the stages of oil paintings so that they do not get worked on too soon, but will have to decide carefully what parts or layers of the painting the assistant may do without prejudicing its claim to be the master's original work. One has to remember that a sculptor does not necessarily cast or carve his own statues, and a printmaker does not always print his or her own prints.

As a student I worked occasionally as studio assistant to Paul Nash; and learned more from that than I ever learned as a student in my ten years in three art colleges; not only about how to paint, but how to carry on the business of being an artist. I wish I had done much more of it.

Removing stains from clothing, furniture, drawings and prints

REMOVING STAINS AND MARKS FROM CLOTHING

A working studio is not a place in which to wear fine clothes; and any artist inviting visitors or clients into the studio has an obligation to see that they do not stain their clothes by brushing against or backing into wet paint, pools of acid, or splashed ink, nor tread on dropped pigment tubes and so on. A studio is full of pitfalls; it can look neat and clean, and the visitor may not be on guard for such booby traps. If the worst does occur, and an expensive suit or dress is stained or marked, the following are some of the recommended ways of repairing the damage.

Paint Do not start by swabbing it with strong spirits such as thinners or acetate, or even turpentine. Try first

with paraffin, which is milder, and progress to turpentine if this is for some reason thought more likely to succeed. Never use nail varnish remover on man-made fabrics to remove paint stains; it may well dissolve the fabric. Never try to swab away paint or oil stains from leather and especially suede; it will remove the leather dye and leave an indelible mark.

Spirits Whether for painting with or for drinking, should be mopped up, rinsed with water and then washed as soon as possible.

Oils Mop up with carbon tetrachloride, with good ventilation. Place the oil stain in a saucer and drip the carbon tetrachloride through the fabric; agitating it on the stain with a soft, clean paintbrush such as a hog-hair oil-paintbrush.

Glue As soon as possible soak in hot water, if the fabric is suitable for this. Soak in white vinegar, slightly warmed for about a minute, then wash the fabric.

Ink Immediately soak and sponge with detergent solution. White cotton and linen can be sprinkled with lemon juice and salt which is left to soak for an hour, then washed. Ball-point ink can be placed in a saucer and methylated spirits dripped through the stain, agitated by a paintbrush; then taken out and blotting paper pressed against the stain to absorb the methylated spirits. Then wash the garment.

Felt-tip or duplicating ink should be soaked in dry-cleaning fluid. Fresh Indian ink can be attacked with cloudy ammonia. When ink has dried it is very much harder to remove and the above remedies will in some cases be too late.

Grease Sponge with turpentine or paraffin, or with dry-cleaning fluid.

Oil Pigment Nothing will remove hard pigment without removing the cloth as well. Fresh pigment that is still soft can be swabbed with paraffin, or turpentine. Fast-drying lacquers respond to amyl acetate, and some to methylated or surgical spirit, or acetone, though *not* on synthetic fibres. Some pigments stain indelibly.

Tempera Remove the raw egg with cold water, with perhaps a little salt dissolved in it. Any heat will cook the egg into scrambled egg, which is more difficult to remove. As with oil paint and lacquers, the pigment in tempera may stain indelibly on its own account. When washing

fabric stained with egg, add a little ammonia to the washing water.

Varnish Swab first with paraffin which removes the stickiness, then with soap and water. If this fails, apply paraffin again and wash off with turpentine followed by soap and water, then launder.

Wax For beeswax, spilt on fabrics when hot and then hardened as it cooled, melt it again with water containing detergent, as hot as the fabric will safely stand then rinse with warm water.

For wax crayon marks, try dry cleaning fluid; the pigment in the crayon may remain as a stubborn stain.

NB: The above remedies are first-aid only, and should be followed by laundering or dry-cleaning.

STAINS ON FURNITURE

On most studio furniture the artist will not be worried about stains. If, like me, he or she has a few surfaces that are kept clean and polished (though not *wax* polished; *cf.* page 97) the most usual marks will be spirit stains on varnished, french-polished or similar surfaces. Try camphorated oil, rubbed on hard until the stain disappears. Re-polishing should not be needed except in severe cases.

STAINS ON PRINTS AND DRAWINGS

Grease stains Remove by gently swabbing with acetone solvent. If the work is valuable consult a restorer.

Brown spots These, on old paper, which are known as 'foxing' are of uncertain cause. It may be a fungus, or it may be specks of iron salts in the paper that literally rust by oxidising. They can easily be spotted out with a solution of Chloromine T, a bleach that is obtainable from large chemists (you may have to order it). Dissolve 2g in 100ml of water (the Tate Gallery use these proportions). It can be spotted on an indelible drawing with a small water-colour brush, or for water colours sprayed on; or the drawing if fairly tough may be submerged in a dish and left, if needful, for several hours. (I should add that for valuable work Chloromine T is not regarded today with the favour it recently enjoyed; as it is impossible to stabilise its bleaching action completely, and the drawing

can undergo long-term damage. The technique that has replaced it is too complex for any but the fully equipped professional restorer. I am indebted to the Tate Gallery Restoration Department for this up-to-date information.)

NOTES
[1] *Cf.* the Bibliography.

[2] In Hornsea College of Art, London, in the 'sixties, there were lengthy and disruptive demonstrations and student sit-ins, protesting against the lack of down-to-earth reality in the training, with echoes in other colleges. In March, 1981, six members of the Council of the Royal College of Art, including heads of some of the leading commercial patrons of art training, resigned, from the view that the teaching was out-of-touch with business realities.

[3] At the time of writing, if the assistant is part-time, there is no need to pay National Insurance contributions below the 'earnings level' currently in force; which, in 1982–83 is £32.50 per week. In every week in which the assistant earns less than that sum, no National Insurance contribution is payable.

[4] One is the National Employers' Mutual, N.E.M. House, Mitre Square, London, EC3A 5AS. A special small notice is supplied stating that cover has been effected; and it is a statutory obligation of the employer to place this where it can be seen by any employee.

[5] Max Doerner, *The Materials of the Artist*, (Granada, 1979), p. 339.

[6] It is an interesting thought that the small *Head of a Woman* by Sickert in the collection of Sheffield City Art Galleries, which was not painted beyond the coded underpainting, may not have any work on it at all by Sickert himself.

Chapter 3

Lighting conditions

Studio lighting

Artists of today, who can obtain the type and quality of studio lighting desired by merely touching a switch, may forget that this state of affairs is of very recent history; and that within living memory it was very difficult for a busy artist to work, between September and the following March, after the winter daylight had waned at about four o'clock in the afternoon. As the year progresses through autumn, the useful working daylight starts later and ends sooner each day; until, for most of the winter months, the working daylight is only of a useful intensity from about ten o'clock in the morning to about three o'clock in the afternoon, at the worst part of the year. This only gave the artist some four or five hours of painting in the day.

For some artists this would be enough. Not only do many artists begin to lose the cutting edge of their abilities after about four or five hours' work – as also do many creative writers – but it must also be recalled that the actual creative work of painting, carving, or whatever it may be, takes up only a part of the artist's working time. There are also, as I stated earlier, such tasks as the preparation of materials, the stretching of canvases or the setting-up of armatures for modelling, and many other similar tasks to be done; in addition to which there are the relatively inartistic tasks of packing and transporting work to and from galleries, and the paper work that even the artist cannot entirely get away from. All these, of course, can be done when the natural light is not good enough for creative art.

The short working daylight is particularly difficult for portrait painters and portrait sculptors, who have to arrange sittings to suit the convenience of their distinguished and often very busy sitters. Up to the mid-

nineteenth century, portrait painting was done by glazing tints over a monochrome underpainting. This was not so restricting as much of the painting could be carried out by the dull early and late light of the winter months, and by candlelight or lamplight. Today, when most painters execute the painting in full colour from the beginning, the correct neutral lighting is yet more important. A visit to an art gallery will reveal the way in which seventeenth and eighteenth-century paintings were mainly left in the more-or-less monochrome condition; with faces and hands, and a cloak here or a drapery there, being tinted with coloured glaze. A look around an art collection with this in mind will bring home to the reader how very little these artists used colour in the sense of colourful tints. In many of Rembrandt's works, for instance, if the small patch of red here or there is covered up, the picture can be seen to be mainly in brown monochrome.

Of course, poor light affects the tones (i.e. the lights and darks) when working on a composition; but not to anything like the extent to which it affects colour. Indeed, the poorer the light, the more colour is lost and only tone (or 'light and dark') remains. In a poor enough light, even the most colourful painting will appear as monochrome.

Ideally, an artist's studio is generally regarded as requiring light from a north aspect. Light from any other direction varies in direction during the day within the room (the sunbeams slowly travel round the studio from dawn to dusk); and also varies in intensity and colour. Early light is moderate and warm; noonday light is intense and very warm in 'colour temperature'; and late afternoon light takes on a rosy character of less intensity.

It is quite impossible to carry out a long spell of painting in colour under such unstable lighting conditions. Any painting tends to compensate unconsciously for the character of the studio light; so that if it is done in a warm light the colours tend to be cold and greyish; and work done in a cool light will end up in warmer colours. A brushload of brilliantly warm and luminous pigment seems fine when applied in warm studio lighting; only to appear dull, drab and cold when seen in a neutral light; most of its glow having been due to the studio light not to the pigment.

Another drawback of a studio of which the window faces east or west is that the light is only fairly strong in

either the morning or the afternoon respectively. A southern-facing window has a longer spell of bright light in the middle of the day but it is very changeable, shining across the window to the right in the morning and the left in the afternoon; and is also sometimes very hot in summer.

It would seem, therefore that an artist should have a studio that is well lit from the north; as the north light does not change as much as other lights, is neutral in colour temperature and does not overheat the studio. The artist might think then that all the troubles are over; but this is far from the case.

Firstly, the north-facing window may be partially obstructed by facing buildings that cut off the light at certain times of the day. The north-facing rooms of the house may not have very big windows; or the ceilings may be too low to accommodate an upright, extending easel (as in my own house). A large attic room may have top lighting but this can lose the advantage of north light and involve all the drawbacks of light from the other directions. Such things cannot be altered without considerable inconvenience and expense; and, if the District Surveyor or town planning authorities do not like the idea, cannot be done at all.

Artists have always had these problems; and a study of their works can indicate how they got round the difficulties. The monochrome tendency of earlier painters is only one effect. Indeed, it is not always appreciated, even by art historians who are not artists, to what extent the successive styles of art have been influenced by methods of studio lighting among other things. One might ask oneself why, for instance, so many seventeenth-century Baroque paintings look as if they were painted in the dark. The reason may well be that they were; if not in complete darkness, then in conditions of candlelit or lamplit obscurity. We must bear in mind that when we have an electricity blackout, and life seems impossible, that before the 1850s people had, in effect, to live in blackout conditions every evening; with a few candles by which to see. One also recalls that, in northern Europe at least, many days of the year are overcast and dull, with our modern lighting being switched on during the day without a thought, and that the earlier artists could not do this. One wonders indeed how all those paintings

would have ever been produced, unless the artists largely avoided reliance on daylight, by the manner of their techniques.

It was only in the French Rococo period of the eighteenth century that paintings took on a paler, silvery tonality, and some of the radiance (albeit muted) that reached greater intensity in the later colouring and tonality of Manet and the French Impressionists. In the lighter ambience of chandeliered Paris 'hotels' the new style of Rococo painting adopted a lighter key and paler colours than the Baroque art of Versailles. The older paintings, of which the dark backgrounds echo the blackout conditions of the winter half of the year, became a thing of the past; and the adoption of lighting in the midnineteenth century, by the use of paraffin (or kerosene) lamps and the later gaslight, removed, to some extent, the daily blackout from late afternoon. The new interior lighting, which may appear dim to us, must have appeared as a brilliant release at the time. It was accompanied also by the new nineteenth-century interest in optics, and the invention of new pigments in the Industrial Revolution; so that French Impressionism and its interest in the character of light arose quite logically.

One can realise how all those eighteenth-century water colours, with their monochrome underpaintings that were lightly tinted with colour (by such artists as Paul Sandby, Thomas Rowlandson, John White Abbott, Francis Towne and many others), may well have been drawn in monochrome by artificial light on dull days and in winter afternoons, and would be tinted on clear days by natural daylight. This would extend the artist's working day, independently of the lighting. It is recorded that, when the young Turner and Girtin copied water colours for Dr Monro, in about 1797–99, they sat face-to-face with a single candle between them. A surviving sketch, perhaps by Dr Monro, depicts Turner drawing by candlelight at a kind of double desk or easel.[1]

Similarly, the *Self-Portrait* by Sir Joshua Reynolds at the National Portrait Gallery, London, shows him peering with his hand shading his eyes in what appears to be candlelight or lamplight. His painting *A Lady*, in the Nettlefold Collection at the Victoria and Albert Museum, London (Plate 7) would seem to have been painted in semi-darkness, with a single lamp or candelabra to pro-

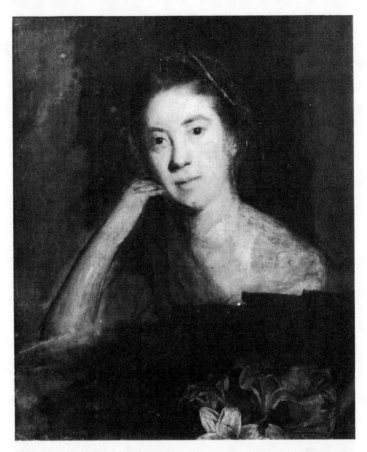

Plate 7. An unfinished portrait in oil of *A Lady* by Sir Joshua Reynolds, which would clearly seem to have been painted by the light of a candle or a lamp in semi-darkness, in the method also used by Thomas Gainsborough. *Reproduced by kind permission of the Victoria and Albert Museum.*

vide illumination. Johann Zoffany's painting *The Academicians of the Royal Academy* in the Collection of H.M. The Queen, done about 1771–72, shows the artists in a studio of the Royal Academy Schools, drawing from the model in the light of a chandelier of about two dozen candles or wicks. Horace Walpole, describing the picture when it was first exhibited, wrote; 'This excellent picture was done by candlelight; he (Zoffany) made no design for it, but clapped in the artists as they came to him, and yet all the attitudes are easy and natural, most of the likenesses strong.'[2] (Plate 8)

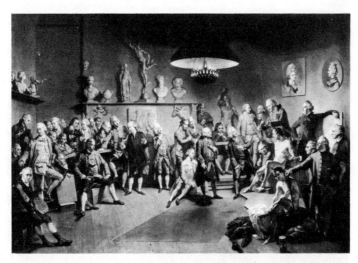

Plate 8. The Academicians of the Royal Academy, an engraving
by Richard Earldom after the oil painting by Johann Zoffany
(1734–1810). The picture, a group portrait of Zoffany's fellow
Academicians, was executed by candlelight, a common way of
painting portraits before the introduction of modern artificial light-
ing. Reproduced by kind permission of the National Portrait
Gallery.

It is recorded that Thomas Gainsborough used the
canvas unstretched and partly rolled, at the side of the
sitter's head, when he was painting a portrait, at least
during the monochrome underpainting, 'practically in the
dark ... in a kind of twilight'; as described by the
contemporary portrait painter Ozias Humphrey
(1743–1810) at Bath in the 1760s.[3] One is tempted to
think that this practice of painting in the half-dark was
from necessity rather than from choice. When the light
failed, or the day was very dull, Gainsborough exper-
imented with candlelit trays of sand with parsley trees
and pebbles for rocks. It is from these candlelit models
that some of his best landscapes were composed and lit.
He also played with painted glass slides in a candlelit
viewing box which is now in the Victoria and Albert
Museum.

In such ways, before the coming of bright, modern
lighting, artists would carry on those parts of their work
that did not need neutral daylight. It is perhaps no
coincidence that the change in painting from tinted
glazes on monochrome underpainting, to painting

throughout in full colour – as seen in the progress from Turner's early semi-monochrome technique to his later fully-coloured style in his middle and late periods – took place in the early-nineteenth century; when bright lighting from the newly discovered paraffin or kerosene lighting and the introduction of gas lighting, gave easy and constant light for people's working conditions, so that they no longer sat every evening in Stygian gloom. Even so, Turner seems not to have worked in full colour in the evening; but to have gone down to the Athenaeum Club for a chat with fellow artists like Sir Francis Chantrey over half a pint of sherry.

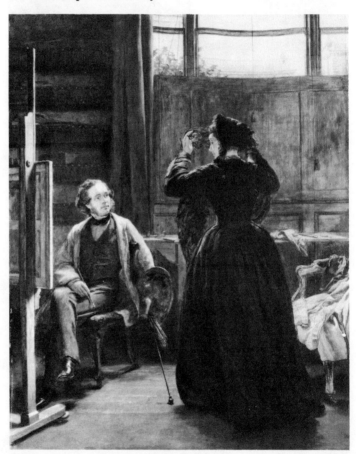

Plate 9. Self-portrait with Model by William Powell Frith (1819–1909) painted in oil in 1867. The window is screened to exclude most of the daylight. Reproduced by kind permission of the National Portrait Gallery.

Turner's later paintings and water colours must surely have been done in full, neutral daylight; though this need not have been of high intensity. It is sometimes said that the ideal studio lighting of today is through bright windows or skylights. If this is true – which is by no means certain – it is a very recent fashionable demand.

At the National Portrait Gallery in 1982 there were several paintings and drawings of artists in their studios, in their exhibition *The Artist at Work*[4], done as either self-portraits or studies of fellow artists; in a number of which it could be seen that the studio window had been largely obscured by shutters or curtains so as to exclude most of the light (*cf:* Plates 9 and 10). These included the *Self-Portrait* by James Sant (1820–1916) which was painted about 1840 with most of the studio window blacked out by a piece of cloth; also *Self-Portrait with Model* by William Powell Frith (1819–1909) and *Sir William Reid Dick in his Studio* by Philippe Ledoux, done about 1934, with the large studio windows fully covered by thin, drawn curtains as the sculptor modelled a small statuette.

It seems from this that many artists, both painters and sculptors, do not want bright daylight to enter their studios during work. The former included Sir Edwin Landseer whose studio, in a photograph in the catalogue of the Landseer Exhibition at the Tate Gallery in 1982, can be seen to have been a dark place with limited daylignt from a window at the end of the room, in the purpose-built studio annexe to his house at No.1, St. John's Wood Road, London.[5]

The dim lighting preferred by such artists, and their cutting-down of the daylight in their studios, may have been due to the difficulties of not having a north light and the consequent instability of the light that entered during the daytime. In the Renaissance, many artists used the twilight hours to make models of their proposed figure compositions, in order to try out in candlelight or lamplight, the different light-and-shadow effects; as described by Vasari.[6] The same writer describes how his master Michelangelo used the dark hours for carving in the studio, aided by a single candle stuck in a home-made cardboard hat.[7] The eighteenth-century painter, Joseph Wright of Derby, used to work in the dark hours to experiment with unusual light effects; as seen in his

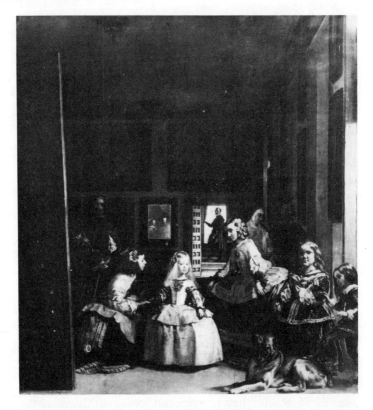

Plate 10. Diego Velasquez (1599–1660), *Las Meninas or The Family of King Philip IV*, oil, (Prado, Madrid). In this painting of 1656, it seems that all but one of the big windows in the studio are blacked out for painting in semi-darkness, with a single light source. Note the studio mirror on the far wall. *Photo reproduced by kind permission of the Mansell Collection.*

Lecture on the Orrery (Derby City Art Gallery). It is recorded that he lit his sitters within a screen in candlelight; and painted these from outside by independent lighting on his canvas.

When bright lighting by paraffin or kerosene, and the later gas lighting, showed up the dingy complexions of respectable Victorian ladies, formerly softened by candlelight, they adopted make-up, which had for long been the unfair asset of actresses and other ladies of liberal outlook. In a Victorian portrait, only a child could have red lips and rosy cheeks. When John Singer Sargent, the American portrait painter, submitted his triple portrait *The Misses Vickers* (Sheffield City Art Galleries)

to the Royal Academy, it was rejected in the 1880s or 1890s, as being morally objectionable, due to their make-up – or appearance of it in the painting – only to be given pride of place at Sargent's RA memorial exhibition in 1928, when opinions had progressed. Meanwhile the pallid Victorian ladies can be seen in Victorian paintings; especially in Pre-Raphaelite works where the artists made an asset out of a liability.

E.L. Drake's discovery of petroleum in 1859, from which paraffin could be distilled as a safe lamp oil, was accompanied by the development of gas lighting. Westminster Bridge was lit by gas in 1813, and later electric lighting came along; the first patent for this in the United Kingdom being in 1845. One wonders how the old masters' works were painted in the semi-darkness which they knew for a large part of the year. Leonardo da Vinci's *Madonna of the Rocks* looks as if the group is in twilight gloom. In 1490 he was dissatisfied with the lamps available to him; and experimented with a chimney in the form of a glass cylinder fitted into a glass globe filled with water. It burned without flickering, and the globe of water would concentrate the light, so that 'the work surface was brightly lighted for night study'.[8]

Modern electric incandescent lighting has a bias towards red which is exaggerated if there is a voltage drop. This rarely happens; and I have tested a photographic studio lighting for two weeks with a sophisticated voltage meter, due to redness in colour photographs, and found no voltage change. Fluorescent tubes have a slight red or warm bias also; but can be 'cooled' by using 'daylight' tubes. It is clear from all this that the artist always has to combat difficulties in studio lighting, which has a profound effect on his style.

My own studio windows face the west; which is, perhaps, the worst possible direction for a studio. Indeed, in discussing the directions in which the windows of a painting studio might face, Ralph Mayer recommends the north, as may be expected, and goes on to discuss the merits of the east, and the south, but makes no mention at all of the west.[9]

Whilst north light is both cool and steady, the east light is warm – and sometimes rosy – and it gains in intensity towards noon; after which it takes on a character not unlike a north light during the afternoon, when, if your

studio window faces east, the sun is on the other side of the house.

The south is relatively bright for most of the daylight hours, but can become very glaring on bright, sunny days. It can also be very hot, even when the studio window is screened by muslin curtains or venetian blinds. The old masters sometimes used to paste paper over their studio windows – or use paper in place of glass – to cut down the glare of sunny daylight. South light also changes its 'colour temperature' during the day. It can be very rosy in the morning, and become warmly bright at noon, turning rosy again in the late afternoon. The effect of this on the colours of an artist's painting has to be experienced to be fully appreciated; and it is only when the picture is taken into a neutral, cool light, that the havoc can be seen to its full effect.

In my west-facing studio, it starts cool and stable in intensity during the first part of the morning, until almost noon; then the sun comes round the corner of the house, and becomes very glaring at midday in sunny weather. During a sunny summer afternoon, it becomes very hot indeed, requiring the adjustment of the venetian blinds to keep out the glare and the heat. Towards the evening, as the sun sinks in the west, directly opposite the studio windows, the light becomes very rosy indeed; ending up with a pinkish quality, when there is a fine sunset. All this variability means that I have to adapt my painting programme to suit the light, unless it is a dull day; in which all directions have the quality of north light.

Indeed, the best days for studio painting, unless you have a north light, are the fairly bright but dullish days; when the clouds form a complete filter to cool down and even out the sunlight as the day progresses.

In my studio, it is quite clearly best, on a sunny day, to paint in the morning. This, I find, is quite sufficient; as there are always plenty of tasks in a studio to take up the rest of the working day.

It is not always possible for a professional portrait painter, of course, to decide at which part of the day it is preferable to paint; as portrait sitters often expect the sittings to be timed for their convenience and not that of the artist. For artists in this situation, it is more than ever needful for some thought to be given to the supporting use of the right type of artificial light.

I paint therefore in the mornings in the summer. My studio has leafy trees at the far end of the garden; and these filter the light a great deal. Indeed, right opposite the wide studio windows which fill the entire width of the outer wall for five metres, and are two metres from top to bottom, the trees, in summer leaf, fill all the sky except a bit to the south. From September through to mid-May, the light is usually cool and fairly stable right through the day.

Artists who do engravings, etchings and the like can do these by the light of anglepoise lamps; as their predecessors used oil lamps and earlier still, focused the light of a candle flame through a large globe filled with water. Painters of small oil paintings have less difficulty, as they can place the painting close to the window. This is not feasible with larger canvases, as one half of the painting is then lit about twice as strongly as the other. Scientific readers will tell me, quite rightly, that this also is the case with a small picture; but the result is not, I find, significant or really discernible. With a largish landscape, however, this can be a real pitfall for the unwary; and an unbalanced tonality in the painting can result, and a similar effect always occurs in trying to light a largish painting by means of electric lamps such as anglepoise and the like. Any variation of lighting over the surface does not show up so much in the finished painting as it does in a photograph of it in uneven lighting; but is there to a degree, just the same.

I have sometimes suspected that the majority of artists paint without north light; and their work suffers from the chilly colour resulting from painting in a warm light (in which the colours look nice and luminous). In the annual art show of a famous society of painters recently, I looked sideways along a line of paintings on exhibition (which is a good way to see which paintings stand out for their warm luminosity) and saw that almost the entire row – albeit interesting and well-composed subjects – were cold and grey in the overall character of their 'colour temperature'. I thought at the time that this was likely to be the result of difficult studio conditions; which few, except the most successful and prosperous artists are able to avoid.

Lighting is not, of course, the only factor by which an artist settles upon the best possible studio conditions for

his or her own particular studio requirements. Once again, portrait painters have a problem; as, seemingly, many distinguished sitters for portraits expect to sit in a studio fitted out more as a drawing room than a kind of workshop. I have observed, over the years, that the studios of portrait painters of my acquaintance, such as Sir Gerald Kelly, PRA, and Henry Carr, ARA, RP, (who painted my portrait some years ago), tended to be furnished and appointed almost like drawing rooms; with armchairs, settees, occasional tables and so on.

This type of ambience was, no doubt, considered appropriate to the reception of sitters of social importance (I recall arriving at Henry Carr's studio one day, to meet the Crown Prince of Iraq coming out). Other artists tend to regard their studios as workshops; with the barest concessions to comfort; and a spare, untidy room will be filled with paint-stained trestle tables and easels, with half-completed paintings stacked all over the place. Such a studio can be seen in the photograph of Picasso's working environment in the Rue Schoelcher[10] and in the Rue des Grands-Augustins, Paris. Braque's studio can be seen to have been tidier and better furnished[11]. In France, Graham Sutherland had an immaculate, big studio with vast, plate-glass windows. I recall very well, before the war, the studio of Paul Nash at Hampstead, which I later described: 'He passed us sherry and gave us cigarettes, and we went across the room to the armchairs before the white fireplace. The other end of the room was workmanlike in a suave sort of way – with a tilting water-colour table on the polished floor and books on shelves, and framed water-colours stacked here and there against the walls.'[12]

Nash's studio had French windows and a large bay window looking on to the garden, being on the ground floor. His easel stood about 2 metres from the windows, turned obliquely towards them. He had a west light; and only painted for a short time each day; and I cannot recall that he used any artificial lighting at all, other than the ordinary room lighting.

Henry Carr, on the other hand, in his South Kensington portrait studio, had a large ground-floor room with a high, flat window which as I recall it, also faced west. As he had to paint his sitters whatever the daylight conditions, he had an installation of fluorescent lights between

the windows, of daylight type, and used the blend of daylight and artificial light (figure 1). There were about ten 1.2-metre tubes placed horizontally on the wall, about 10 cm apart; giving a bank of lights about 1.5 metres by 1 metre, which functioned almost like a window. This made him virtually independent of daylight conditions; and he could, if required, continue to paint after the daylight had gone.

In my own studio, I have two 1.2-metre fluorescent tubes across the middle of the ceiling, and a third at right-angles to them. This is adequate for the size of room – 4.5 × 4 metres (15 by 13 feet). I do not use the studio for portraits, for which it would be too small; but it is alright for water colours and medium-sized oil paintings.

The reason for the T-shaped disposition of the fluorescent tubes is because this is the best way to avoid cast shadows; and is equally useful in workshops and kitchens for it makes it almost impossible to get in your own light. I have the two straight-line tubes on one switch and the third tube on a separate one; so that, if required, I can use the two straight-line tubes for photography of pictures, giving a balanced illumination. The studio also has two ceiling lights, for use when the fluorescents are not required; and these, being rather bright for ordinary purposes are on a dimmer-switch; used when I am writing at the desk, with an anglepoise desk-light, or drawing small illustrations at the drawing table, where there are two draughtsman's anglepoise-type of lamps, for use when needed.

For water colours, I stand at the drawing table, and use the fluorescents; without the anglepoise lamp which can make the lighting of the picture-surface uneven.

An important feature of studio daylighting is the provision of blinds for the windows; to increase the control of the light. Perhaps the most efficient method today is by Venetian blinds. I use these in my studio; and they cover the entire window – with four blinds in all. They are always closed when I do photography; and always partly closed when I am working in the afternoon on sunny days, by being fully lowered and the slats slightly inclined to shut off most of the sunlight.

Because a cool light is important, they have blue-green slats; and the window frame surrounds are in the same

Figure 1a Blend of daylight and fluorescent light.

Figure 1b Blend of daylight and fluorescent light.

Figure 1c Blend of daylight and fluorescent light.

colour. When warm light is admitted through reflection off the inclined slats, they cool the 'colour temperature' of the sunlight.

Studio light is also very much affected by the colour of the studio walls. For some reason it is often widely held that white walls are the best; but this is not necessarily the case. Many artists find that the general, all-over tone values or lightness-and-darkness range (sometimes called the 'key') of a painting can be influenced by that of the studio walls. Painting in a light-walled studio can lift the key of a painting to a tonality that appears too light in average-toned surroundings. Conversely, a picture painted in a room with dark walls can appear very light in this environment; but, when it is toned down, appears too low in key when taken into lighter-walled surroundings.

In art galleries, what tone and tint to paint the walls is a long-standing problem. Should they be light or medium in tone and of a cool or a warmer colour; or perhaps a neutral greyish white, like the newly refurbished rooms at the National Gallery? Perhaps the ideal is where you cannot recall afterwards what the gallery walls are like. Charles Harrison has suggested[13] that Ben Nicholson's first white reliefs may have been white from the influence of the white-walled studios of Arp and Brancusi which he saw in 1932–33. Henry Moore settled all these problems in 1934 by buying a bungalow near Canterbury with enough ground for him to carve out of doors; which perhaps influenced the character of his work as he suggests in his *Notes on Sculpture*.

The painter out of doors is at the mercy of whatever light he gets according to the direction in which he faces when working. This is doubtless why Monet always liked to start a picture out of doors, but always finished it in the studio.[14]

Few artists have ideal conditions. Along the Chelsea river-bank, Rossetti had north light in Cheyne Walk, as did Whistler in Lindsay Row and Turner in his cottage further along, and also the nearby Wilson Steer. But when Whistler lived briefly in his White House in Tite Street, in 1877, he could only have east or west light; even though he had the house built specially; as did John Singer Sargent a bit further up the same street, whose big studio window faced west, like that of the studio occupied by Augustus John just off the nearby King's Road. It is

recorded that 'Whistler took the utmost care in the tones used on the floor and walls of his studios'.[15] When he resigned as President of the Royal Society of British Artists the quarrel was about the colour of the exhibition walls.

STABILITY OF STUDIO LIGHTING

The vagaries of daylight can be smoothed out by a judicious use of artificial lighting; which, today, is sophisticated, scientifically exact, variable over a wide range of colour temperatures and intensities, and is easily installed. The artist, having established the lighting for a particular painting, such as a portrait or still-life, will not wish to alter it from time to time, otherwise the painting will have uneven colour values across the surface as the work proceeds.

Any tint of pigment, in different types of artificial lighting, will vary in appearance. In warm fluorescent lighting it will appear more pinkish; in cool fluorescent it will appear more towards bluish-grey; in ordinary tungsten lighting, using light bulbs with wire filaments of the everyday kind, it will come out more yellowish; and in tungsten halogen lighting it will be more pale yellowish.

It is worthwhile to remember the type of lighting in which the picture will afterwards be hung. A portrait is likely to spend its time in tungsten lighting in a domestic environment, unless it goes to an art gallery, in which event it may well be seen in fluorescent light. A smaller picture may tend more to end up in a domestic situation with tungsten lighting; and a larger picture may end up in a public environment – an office, a hospital or public building of that type, or in an art gallery – in all of which the lighting is likely to be fluorescent.

It is advisable, after blocking in the colour underpainting of a picture, to take it out of doors and check it in natural daylight, like the lady at the haberdasher's who takes her ribbon or material to the shop door. If you do not like the colour, consider changing the mix of lighting in the studio. Take care not to judge the picture in sunlight; and if painting landscape, do not let the sun's rays fall on the canvas during painting, or the general colour temperature of the picture will be yellowed to an extent that is not evident until the painting is seen in neutral lighting.

In the studio, the lighting should be installed so that it is not behind you to cast your shadow on the work; and is not in front of you or it will concentrate the pupils of your eyes and cause you to paint in a resulting high tonality to offset seeming dimness of the canvas. If you cannot, for any reason, fix the lighting directly overhead, have it in front of you with a strip shade to baffle any glare in the eyes.

Colour temperature (the warmth or coolness of the colour) has nothing to do with colour intensity or brightness. Intensity is measured in *foot-candles* (fc); and one foot-candle equals one *lumen* per square foot (1fc = 1 lumen/sq ft). This equates roughly the light from a single candle flame one foot away from a surface. Some examples of fc readings for light strength are: the open air unshaded at noon in summer 7,000 to 10,000fc; art galleries and studios close lighting 10–15fc; general studio lighting 70fc; desk or drawing board lighting 150fc; desk or drawing board close-up work 200fc. This gives a range from 10 to 15fc at the lowest to 200fc at the brightest for studio purposes.

To measure foot-candles you need a foot-candle meter. A photographic exposure meter is not accurate enough and you would have to ask a lighting engineer to lend you an fc meter or take readings for you. As I find the fluctuations of daylight make nonsense of hair-splitting accuracy in general studio lighting, I have the tungsten lighting in my studio controlled by a dimmer-switch and adjust it until I am comfortable for whatever work I am doing. An architect can calculate for you what will establish any given daylight equivalent level from light through a window or skylight; according to the shape, size, height, angle and so on of the window.

It is not at all necessary to have all the studio in bright light; and many of the pictures and photographs of artists in their studios show that windows are screened or shaded. Even in the famous *Las Meninas* by Velasquez, painted in 1656 and now in the Prado, Madrid, it can be seen that the artist's studio has several tall windows, all of which are shuttered except the one nearest to the easel (which is off the picture in the right foreground) which must be open because light comes from it on to the figures of the little princess and her hand maidens. The rest of the painter's studio is in fairly dim light.

Colour temperature is measured on the Kelvin Scale; which measures degrees of whiteness, from zero upwards, of metal when being heated. The colour of the metal passes from black or silver through dark red, pale red, orange, yellow and, finally white, then goes on to bluish-white. If it could be heated further still without melting it would turn blue. There are readings for comparable but different light sources as *co-related colour temperature*, with the exception of the sun and the sky. Some representative Kelvin readings are: tungsten lamps 2,600–3,000K; warm white fluorescent 3,000K; tungsten floods 3,100–3,400K; daylight fluorescent 4,300K; neutral fluorescent 6,500K noon sunlight 4,870K; blue sky 25,000K. It is important to remember that the neutral fluorescent tube gives a higher reading than the sun because these are colour readings not measures of brightness – the bluer the higher.

British artists can obtain advice and information on lighting from the addresses listed on page 273.

Some useful types of fluorescent tube for studio use are: Mazda Kolorite (as used at the National Gallery, London); and the Maxilux de Luxe Daylight tube, which both have ultra-violet light filtration. In my studio I use Osram 'Litegard' 30 watt Daylight tubes.

If an artist is intending to adapt existing space for studio purposes, one of the many questions to be decided is whether or not to have skylights. It was a usual feature of many Victorian and Edwardian studios to have very big glass windows, that were quite often topped by skylights. These can be seen in many houses in the Chelsea, Fulham and Kensington districts of London, where many artists used to live from the 1860s, after they left their old artists' quarter, in the area bounded by Trafalgar Square and the Strand to the south, Charlotte Street and Fitzroy Street on the west, and the Marylebone Road and Bloomsbury to the north. During the late eighteenth and early nineteenth centuries, many famous artists lived in this area; including William Blake, John Flaxman, Sir Joshua Reynolds, William Hogarth, John Constable, J. M. W. Turner and many others; the last survivors of this artists' quarter being Walter Sickert and his friends Vanessa Bell, Duncan Grant, the young Paul Nash and others attached to the Bloomsbury Group.

When the southern part of the area, around Soho, was

taken over by the entertainment world and their sometimes unsavoury supporting establishments, many artists moved west to Chelsea, or to St John's Wood; and lived in houses with big studio windows and skylights. In these areas, they were still within easy reach of their wealthy patrons of Belgravia and Regent's Park. At the house occupied by Sir Edwin Landseer, at No 1, St John's Wood Road, his purpose-built studio alongside the house can be seen from the drawing by H. E. Tidmarsh in 1895[16] to have possessed a great window, almost filling the end wall; and from this drawing and the existing photograph of its interior[17] it does not appear to have had a skylight.

Skylights have certain drawbacks that the artist should bear in mind. They are very liable to leak in severe weather and in heavy rainstorms, even in modern houses; and almost certainly do so if inadvertently left open – however slightly – when the rain splashes in. The paintings left by Turner in his studio in Queen Anne Street, London at his death and the drawings in the studio were stained by leaking rainwater, probably through skylights.[18]

Another fault with skylights is that, whilst top light is admitted, heightening the intensity of the studio light, they can have a greenhouse effect in warm weather, making the studio uncomfortably hot. In cold weather, the cold not only strikes down ferociously, but the heat loss through the glass in winter is very great; causing heavy fuel costs for studio heating. In snowy weather, a skylight is obscured by the snow and the studio is not only cold but also dark. The construction of skylights sometimes means that they provide a lofty roofspace into which, in cold weather, all the warm air in the studio rises, leaving the artist shivering below. As if all that were not enough to dissuade anyone from incurring the pains and penalties of skylights, there is the further consideration that light of high overhead intensity is not only unnecessary for either sculpture or painting, but, as the previous chapter indicated, has often been avoided by artists in their studios, by the use of shutters, heavy curtains or something of the kind. A top light shining down on to the sitter for a portrait, or even on to a still life, does not give a natural lighting effect to the half-tones and shadows.

In a restoration and conservation studio, the requirements are different. A great deal of work is done on paintings that are laid down flat on a table. These days little or no painting is done with the picture flat on its back (although this was quite usual with the old masters, when glazing their underpaintings, which cannot be done with the painting upright as the thin glaze drains down the canvas in streaks). A conservation studio may well have strong top light – and, indeed, should do so; but an artist should not be misled by this into thinking that it is necessarily a good thing in a painting studio.

Landseer had gas lighting installed in his studio in order to work at night. He had two studios and a small room for sketching. G. D. Leslie described it as 'a gloomy looking place, the light just focused on the easel at which he worked, whilst darkness brooded over the rest of the room . . .'[19]

I am aware that Ralph Mayer advises lighting a large area of the room, which should be evenly lighted, with intensity of light;[20] but study of studios of the past up to modern times seems to show that painters by no means follow this in terms either of the spread of light or its intensity; and that they often seem to have made efforts to cut down the strength of the light and the area on which it fell within the studio.

It would seem, therefore, that the artist has several interlinked decisions to make about his studio lighting, involving the tone (lightness or darkness) and the colour of the walls, the size and type of windows and the kind of artificial light. If the right blend of these is attained, with enough flexibility to accommodate different types of daylight, the work of the artist must improve in quality; if only because a proportion of his or her concentration is not so likely to be distracted by wrong lighting conditions of which the artist may be unaware.

If the studio accommodates several of the different work areas in the one room, heating is a problem; especially if the room is a high one; and more so if it has rooflights of any kind. The old iron stove of the bohemian artist's studio is not seen much today; although I remember that there was one in Feliks Topolski's big studio in London in the 1940s. Night storage heaters are a simple installation; and gas central heating is little more complicated.

Whether or not to install double glazing is another decision. If the studio has very large windows, of the nineteenth-century, purpose-built type that one sees around Chelsea, Kensington, Fulham and St John's Wood, remember that these are difficult, if not impossible to double glaze; and skylights are extremely difficult also. If the skylights have wooden frames, they may be too old to stand the extra weight, which is considerable; and if they are metal-framed lights, it is not always easy to attach the extra frames for the double glazing. Otherwise, double glazing is something I can recommend; having had it installed for the picture windows in my own studio, which go across the entire wall of the studio and slide sideways to open, not up-and-down.

In addition to making it easier and cheaper to heat the studio, double glazing cuts down a great deal of the outside noise, of traffic and aeroplanes, and Concorde flying over now breaks my concentration rather less than before.

Whilst many of the alterations and installations in a studio complex can be legitimately claimed as capital equipment, against Income Tax charges, I am not at all sure that double glazing would be regarded by H. M. Inspector of Taxes as absolutely necessary for a painter; who might perhaps claim with success for the cost of alterations to windows, skylights and even doors if necessary; in addition to the cost of shelving, storage racks, drawing and painting tables and the like. Special Venetian blinds for the control of light conditions, together with fluorescent lighting specially installed and similar expenditure should certainly be claimed.

NOTES

[1] Jack Lindsay, *J. M. W. Turner, his Life & Work*, (Cory, Adams & Mackay, 1966), p. 33.

[2] Catalogue of the *Artists at Work* exhibition, (National Portrait Gallery, 1981–82), p. 13.

[3] *Cf.* John Hayes, *Thomas Gainsborough* exhibition catalogue, (Tate Gallery, 1980); Introduction, p. 28.

[4] *Op cit.* in note 2, nos. 13, 14 and 23.

[5] Catalogue of the *Sir Edwin Landseer* exhibition (Tate Gallery, 1982), plates 14 and 15.

[6] Giorgio Vasari, *Techniques*, (Thames & Hudson 1954). p. 214.

[7] Vasari, *Lives of the Artists* (Borroughs, ed.), (Allen & Unwin, 1960), p494.

[8] *Encyclopaedia Britannica* (1951), XIV, p. 105.

[9] Ralph Mayer, *The Painter's Craft*, (Nelson (3rd ed) 1978). p. 174.

[10] Antonina Valentin, *Picasso*, (Cassell, London, 1963). plate 9.

[11] Françoise Gilot and Carlton Lake, *Life with Picasso*, (Nelson, 1964). plate following p. 56.

[12] Richard Seddon, *A Hand Uplifted*, (Frederick Muller, Ltd, 1963). p. 19.

[13] Charles Harrison, *English Art & Modernism*, (Allen Lane & Indiana University Press, 1981). p. 264.

[14] *Cf. Paint & Painting*, (Winsor & Newton and Tate Gallery, 1982), p. 59.

[15] *Encyclopaedia Britannica* (1951), XXIII, p. 572.

[16] Published in *The Magazine of Art*, (London, 1895).

[17] Mackenzie Collection.

[18] Described by Turner's friend Trimmer, as related in Thornbury, *Life of J. M. W. Turner* (2nd. ed. 1877). p. 264: '*prints damp spoiled*'.

[19] G. D. Leslie, *Riverside Letters*, p. 197.

[20] Mayer, *op cit.* p. 174.

Part Two

Equipment and Materials

Chapter 4

Storage and conservation

Space saving in the studio

Like every other factor in studio design and management, the saving of space cannot be considered in isolation. Thus the question of saving space is linked on the one hand with such things as Income Tax and Capital Gains Tax, and on the other is affected by such things as the painter's choice of painting medium for use with oil pigments.

I have stressed that this book is about 'where to paint' and not about 'how to paint'; yet the two are so closely influenced one by the other that, from time to time, notice has to be taken of the side effects of studio layout and arrangement. For example, if you take on a bigger house in order to enjoy the most spacious studio possible within your means, then you are likely to pay higher rates, and the heating, cleaning and maintenance will cost more. It will be important to claim properly for these necessary expenses in the conduct of your work as an artist, when making your Income Tax return. This means that the portion of your house set aside for professional use will be agreed with the Inspector of Taxes, and due tax allowances made against your art income.

This being the case, the freedom of the house, as your home, from Capital Gains Tax, if you decide to sell it, and it has increased in value since it was bought, will not apply to that proportion that is used for professional purposes and when you sell you will have to pay the appropriate proportion of the going rate for Capital Gains Tax. In this way, the more space you use for your studio complex, the more Capital Gains Tax you will have to pay. It is needful, therefore, to give careful thought to the saving of space wherever this can be done.

One way to save space is not to have extensive work-tops and benches so that your appliances and small equipment can be left in position until they are required for use. This means that such things as a flat-bed guillotine for the square trimming of paper, or a photo-print trimmer, a small copying machine, card index drawers for records or exhibited and sold work and similar things, are taking up expensive space for the larger part of the time, as no piece of equipment is in use for more than a part of your working week; and some bits only occasionally. Thus, whilst I use my typewriter every day, and my copying machine about every three days, I only use my photo-print trimmer about once every two weeks or so. In consequence, I keep most of these things out of the way in a cupboard or on wall shelving; and keep the worktops clear for when I am drawing and painting; when they soon become fully occupied with a litter of drawings, sketches, mounts, scissors, and other incidental gear.

For oil painting, I use a three-legged, folding sketching easel, which is folded up and kept in a cupboard when it is not an oil-painting day. My painting trolley (which serves for water colour or oil painting) is 'garaged' under my drawing table. Even the drawing table, which can be adjusted either flat at standing height (91.5 cm) or inclined for water colour (with the fore-edge at 81 cm) folds away; and when I do oil painting, the table, being hinged to the wall fitment behind it, can have its gatelegs folded against the wall and the top drop-leaf folded down against the wall completely out of the way; with the painting trolley in use in the middle of the studio.

Figure 2 Gate-leg drawing table.

In this way, when I do oil paint, I have the entire floor space at my disposal; but when I do drawings or water colours, the large drawing table takes up some of the space. Otherwise I would have to have a bigger studio; and as the one I have fills the entire width of the modern cottage in London in which it is situated, I would have to buy a bigger house. I have always wondered how J. M. W. Turner managed to paint oil paintings for the Royal Academy exhibitions, in his cottage in Chelsea, which is about the same size as ours. Yet, with space-saving, I never feel cramped in my studio; and if I did, I would no doubt console myself by saying, 'Well, if Turner could

manage it, so can I'. Philip Wilson Steer lived a little further along the same row of small houses as Turner; and he managed quite large oil paintings too.

Apart from the drawing and painting spaces, the storage space can also be kept to a minimum by careful planning; though, as I stated above, such factors can affect your method of painting. If, for instance, you store your oil paintings, and the unused canvases on their wooden stretchers, this takes up a lot of space, and calls for canvas racks, for safe and convenient storage. Of course, the storage of oil paintings in progress takes up space unavoidably, unless the pictures are very small ones; and these works are usually stretched on wooden stretchers.

Yet the only oil paintings that really require to be stored on their stretchers are those that are ready for framing and sending to exhibition. All the others can be unattached canvases, stored, if dry, in folios; and if not dry, they can be pinned to the wall, or on drawing boards. There are not likely to be more than half-a-dozen of these in progress at any one time – if that; and they take up little room in a canvas rack on fairly thin board or hardboard, compared with stretched canvases. Another bonus is that a stretched canvas can be damaged very easily, and either dented or have a hole knocked through it; but on a board, it is protected from these mishaps.

Have several pieces of hardboard or plywood cut to the size you prefer, plus a 15 cm margin all round. The best way to fasten the canvas on to the board is not by drawing pins (which will not go into plywood very willingly) but by masking tape, of the sort sold in motor-car accessory shops for use when painting or spraying a car. The tape should not be stuck *along* the edges of the canvas, but in 10 cm strips *across* the edge, about 10 cm apart all round. This will hold the canvas firmly, and quite flat; and is easily removed.

The canvas should be cut with an extra, spare margin all round, above and beyond the intended size of the painting; so that if you wish to extend the composition in any direction, this can be done; something that cannot be done with a stretched canvas on a stretcher.

When an unstretched painting is stored in a folio it is, once again, better protected than if it is on a stretcher. I have wondered by what unthinking habit an artist will

store drawings and water colours, unmounted, in a folio without a qualm, but rarely thinks to do it with oil paintings, which are kept in bulky racks or stacked dangerously against the wall. Once again, there is a bonus in my method; as, when a painting is returned from exhibition, not yet sold, the stretcher can be used for a new piece of canvas for the next picture; thus saving expense in the buying and storage of quantities of stretchers. The spare stretchers can be tied in bundles and kept in the cupboard until required.

There is no need, really, to stretch a canvas before painting on it. Indeed, I dislike passing from drawing or painting on paper on a hard drawing board and then drawing in pencil and painting in oil on a soft canvas on a stretcher, the fabric being flexible and springy. Also, if an artist likes to draw on a canvas in pencil or charcoal, before painting, this can damage the stretched canvas, particularly with a pencil, in a way that cannot happen with unstretched canvas on a board.

Out of the studio, doing a still life or a portrait in another room, or in someone else's house, a canvas on a

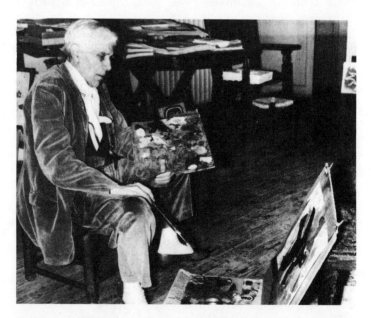

Plate 11. Braque in his studio. Note that Braque is using the simplest equipment and his canvas is unstretched. *Reproduced by kind permission of Keystone Press Agency.*

board can be propped on a chair quite safely, whereas this is not at all safe with a stretched canvas, which can be dented by the chair back. You also avoid the need to lumber the room with a folding easel; and, of course, if you want to paint outside the kitchen door using a chair – as Van Gogh did at Arles when painting his sunflowers – the same thing applies.

In the photograph of the French painter Braque, at work in his studio, he is clearly painting on unstretched canvas that has been fastened to a board; and he is painting with it leaning against a chair in a way that would be risky with stretched canvas. An artist setting off like the painter Henry William Banks Davis, RA (1833–1914) in the photograph by Ralph W. Robinson of c.1891, appears, being evidently posed in the garden, to be demonstrating just how much cumbersome gear an artist can be loaded with out of doors, complete with bulky, stretched canvas. He could have carried a supply of three or four unstretched canvases on thin board in a folio, separated by canvas pins, in the same amount of space.

For space-saving storage of folios containing drawings or unstretched oil paintings (I often keep them in the same folio when the oil paint is completely dry, and save yet more space) an architect's plan chest is most unsuitable. In any case, plan chests, storing the work in flat, large drawers, are intended for blue-prints and dye-line plans, which are smooth, tough and more or less indelible; and which slide into and out of the pile of work in the drawer quite easily. It is very bad for a drawing or water colour to do this to it; and equally bad for an oil painting, however dry it is, because of the surface abrasion. It is far better – and takes up less floor space – to keep them in folios, stored upright in a flat, narrow wall cupboard; of which I describe an example more fully in a later chapter. Of course, they can be stored quite safely and properly in the large, flat boxes used in museums and print rooms, which are called solander boxes. But as a solander box has to be flat on a table to get at the contents, and the lid opens flat also, the box takes up too much space in the studio when in use; and, when not in use, cannot be stored on end, as the contents are loose in the box, rather than held flat as in a folio, and would get creased and crumpled.

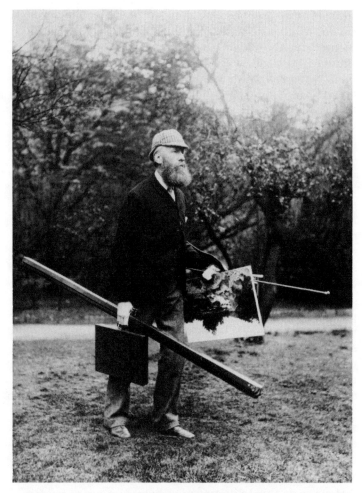

Plate 12. The painter Henry William Banks Davis, RA (1833–1914) setting out paint (c. 1891) with his equipment and fully stretched canvas, both fragile and cumbersome. *Reproduced by kind permission of the National Portrait Gallery.*

Space is saved if the artist follows Van Gogh's example, and paints to one or two preferred sizes of canvas most of the time. In such a case, only a limited range of stretcher and frame mouldings need be kept in readiness, which can be stored in a bundle in the cupboard standing on end.

With unstretched canvas, you have the option of cutting it larger than the intended composition, and, if desired, extending the arrangement in one direction or another to better effect. The painter Chaim Soutine did

this. Some of his paintings were photographed in 1933 giving evidence that the painter tacked his canvases to the wall, with the edge only casually indicated, so that he could either enlarge or reduce the area of the composition if he wished, as the picture developed.[1] Of course, if this option is exercised, then a different stretcher to fit will be required, and frame mouldings also; but one cannot have everything.

I have observed that Turner's very large oil painting *Macon, the Festival of the Vintage* in Sheffield City Art Galleries Collection, has been extended in this way at the top, with 15 cm of canvas added right across the painting; and also the famous landscape by Rubens, *The Watering Place*, in the National Gallery, London, which is painted on a panel made up of several joined planks both horizontally and vertically, has had extra planks added at top and sides on several occasions, by the artist's workshop, during the painting.

Thomas Gainsborough comes to mind as an artist who painted on unstretched canvas; though I do not suggest that he did so, as a modern artist might, in order to save space, at his large Schomberg House, Pall Mall, London; nor was it due to lack of care, as Gainsborough was one of the most technically able artists of his time, as shown by the good condition today of his pictures.[2]

Among modern painters of renown who used unstretched canvas, Morris Louis, the famous American abstract painter, fastened his canvas to the floor of his small studio in New York, to produce such paintings as his very large *Vav 1960*, now in the Tate Gallery, London.[3] An interesting example is the painter Jennifer Durrant, who is described in the introduction to her one-artist show at the Nicola Jacobs Gallery, London of November and December 1982 as painting on unstretched canvas on the floor: 'Here, Durrant can lay out and staple to the floor four areas of canvas and work on them concurrently. When they are almost ready (and only then) she hangs them, still unstretched, on the walls'.[4] I have in my possession a *Head of a Girl*, in oils, by that sensitive and fine portrait painter B. Fleetwood-Walker, RA, RWS, RP, whom I have seen painting on unstretched canvas, as in this instance. When I acquired it, it was still unstretched; and the mark of a drawing pin head is discernible in one corner. I have, of course, stretched and framed it.

Oil paintings, and water colours, then, can all be stored in the folio; with great saving of space and expense. If you obtain a roll of canvas from which to cut the pieces for use, this can be kept rolled up in the same cupboard as the easel and the stretchers and frame mouldings. When painting outside, canvas boards from the art shop can, of course, be used; or you can make your own by sticking canvas down on to strawboard or hardboard; but I see no advantage in this; and also, if the picture be subsequently sold, the board backing could cause difficulty in restoration if it got damaged and had to be removed. In a later chapter I describe how to look for a bargain roll of suitable fabric in the shops or the market.

Some artists store unstretched canvases by rolling them up. This is not, so far as I know, condemned by restorers; so long as a painting is rolled up with the painting *outside* and not inside. If it is inside, the rolling cracks the paint and then crushes the edges of the cracks; whilst when it is outside, cracks may open up, but they close again when the painting is unrolled. However, I recommend flat storage for loose canvases, rather than rolling, especially for an artist who paints with thick impasto.

The storage of framed works and of spare picture frames can take up a good deal of space. This can be avoided by using the sets of frame moulding sold in different forms today, which can be easily assembled, and the corner mitres secured, by the artist in the studio. These are available not only for water colours and other drawings, but for oil paintings; in a variety of styles and sizes.

I describe in a later chapter how to stretch a canvas when this is requisite, and the frame suppliers give clear instructions for the assembly of their various types of frame. Even so, there will also be a certain number of pictures and drawings in the studio, fully framed ready for exhibition, so that some kind of picture rack will be needed. Later in this book, I describe how such a rack can be simply made, in such a way as to serve also as a useful worktop.

How to make inexpensive storage folios

I have already referred (page 77) to the danger in storing

mounted or unmounted drawings in the drawers of plan chests, and pastels, above all, suffer in such circumstances, even when the artist has stabilised the surface with fixative. Even quite tough works such as lithographs and other prints lose their freshness and begin to look creased and dog-eared. Plan chests are excellent for blueprints and the like but I advise using the folio. Folios, however can be quite expensive; especially in the larger sizes, if well manufactured, and can be rather flimsy at lower prices. Folios can be quite easily and cheaply made at home in a few minutes; and are quite adequate for storage or for carrying work about.

Figure 3a Folio making: two sheets of strawboard on a sheet of brown paper.

First you have to decide what size of folio you want, which should be about 2.5 cm larger all round than the size of drawing, unstretched canvas or mounted work that it is to contain. It is not a good idea to keep works of very different sizes in a folio together; as the smaller ones slide about. Two sheets of 3 mm strawboard should be cut to the required size. You can obtain these from either a paper merchant or, sometimes, a printer. Next, you need a couple of sheets of strong brown paper which are twice as big as the required size of strawboard (so that, when two pieces of strawboard are placed in the centre of a sheet of brown paper, there is at least a 15 cm margin to spare all round as in figure 4a).

Figure 3b Fold over the sides.

The brown paper may be made up of smaller sheets stuck together along their edges by gummed-paper strip. The sheets should be the strongest and thickest you can find; but they are best if one side is calendered – i.e. polished – so that the shiny side can go outside the folio and stay cleaner than a dull surface.

Figure 3c Fold over the top and bottom.

The two pieces of strawboard should be laid side by side on one sheet of paper, which should be dull-side-up; as shown in my sketch at 3a. They should be spaced apart just wide enough to equal the thickness of the pile of drawings you intend to store in the folio. It is best to make several folios to carry a few works each rather than a jumbo sized folio which would be very heavy when full and would not last as long in use. I find 2.5 cm to be plenty wide enough for large drawings; though a folio for smaller works can be correspondingly thicker, up to 5 cm thick.

Figure 3d Mitre the corners.

The corners of the brown paper should be folded as a mitre and the flaps folded over the strawboard, behind which the corner tuck is inserted. Then, the whole thing

Figure 3e Tuck the mitres behind the card.

Figure 3f Fold down the top and bottom flaps.

Figure 4a Folio strap made from two trouser belts.

Figure 4b Folio strap of hat ribbon with key-ring buckle.

is turned over. The mitres at each of the four corners are folded and tucked under, leaving useful flaps at the top, bottom and fore-edge, to keep the drawings clean when stored in the folio. Nothing more need be done. It is not really necessary to use gummed strip to hold things together, as the design is quite stable enough.

Such a folio is designed to be stored on edge; but several can be laid in the drawer of a map or plan chest, and the desired drawing extracted by lifting out the folio containing it and opening it flat, or holding it on edge to take out the drawing without abrasion or tearing.

Such a folio is quite strong and adequate for carrying drawings about indoors, but for transport out of doors, (for which this design is not intended) the same process should be followed using waterproof paper of the type employed by packers to line packing cases (which you can seek at a paper merchant's); or you can use the type of thin plastic sheet sold for gardening purposes, cut to size and folded and mitred as a cover for the brown paper folio, and secured by wide, sticky plastic tape of the kind used by packers.

Straps for holding such a folio closed and for carrying it about are best made from two trouser belts. Use cheap plastic belts. The end of one is threaded through the buckle of the other to double its length; then it is placed around the folio and the remaining buckle and end fastened in the usual way. Folio straps can also be made from strong ribbon such as the 4 cm buckram ribbon used for hatbands, which does not readily twist. Do not use cotton tape or the like as it twists in time to a ropey condition. At one end of a suitable length of ribbon sew two key rings of about 2 cm diameter. The free end of the ribbon should be passed through the key rings as shown in my illustration, when the strap can be pulled tight and secure. It is important, to ensure quick and easy release of the strap, to fold back the strap end as indicated, so that a pull on the end will release the key rings. Two such straps are recommended for a heavy folio; though one will suffice otherwise.

How to stack and handle framed paintings in the studio

When I enter an exhibition room on selection day, or

during the staging of a picture exhibition, I can tell at a glance whether the people handling the paintings really understand what they are doing. A great deal of damage is done to expensive picture frames at most – if not all – exhibitions, from ignorant and careless handling. I do not suggest that there is any irresponsible roughness in the way the paintings are carried around. At the same time, just as you can tell a professionally trained waiter from the way he carries a tray, so you can discern whether a person is properly trained from the way he or she handles and stacks framed paintings and drawings.

Figure 4c How to thread the folio ribbon through the key rings.

The usual, untrained way in which framed pictures are disposed around a busy studio or exhibition seems to be, in most cases, to lean them against the wall in groups; one in front of another; sometimes six or eight pictures at a time, or even more.

This does no great harm, in itself, until some artist or member of the hanging committee – or whoever it may be – wishes to see one or other of the pictures concealed by the one at the front. It is then that one observes an action that always causes me acute distress to see; all the pictures are tipped forward, with the front one, perhaps, supported against the person's knees. It is bad enough when the paintings are tipped forward one at a time, when the front of each frame bangs into the back of the one in front of it. What happens then is that, when the last picture in the stack – by now all tipped forwards supported against each other – has been inspected, they are all tipped back together against the wall.

What people fail to realise is that, when this is done, each picture presses on its neighbour with a considerable weight. It often takes a heave with two hands to tip a heavy stack backwards all at once. At such a time, the top of each frame slides several inches against the face or back of the next frame; scoring and scraping the delicate, tinted and varnished surface or other type of fragile surface so as, in time, to leave an ineradicable mark across each moulding, on each edge of the frame, some two or three inches from the corner. Frames with any degree of moulded surface decoration are even more severely damaged; sometimes losing pieces of the frame.

It is easy to forget that, whilst the front of a frame moulding is usually a fragile surface, the back of a frame

Figure 5a Making a frame pad: crumpled paper on brown paper sheets.

Figure 5b Crumpled paper rolled up in the brown paper.

Figure 5c The ends mitred into flaps.

Figure 5d The ends taped and folded over.

has sharp edges, panel pins and sometimes screweyes that can cause severe abrasion and scratching.

One or two such mishandlings are enough to ruin an expensive frame. Not only do many artists damage their own frames in this way, but those of other people at exhibition selection and hanging days. Among offenders who should know better are the staffs of art galleries or art dealers who may take in a selection of impeccably framed work from an artist, stack it as described above, and send them back with spoiled frames; being, often, quite unaware that they have damaged them.

The proper way to stack and move framed works in the studio is to store them in racks. This, of course, is not always feasible; and wall stacking is permissible but avoid stacking more than two or three pictures together because of the weight. When the picture at the back of the stack is wanted, each work should be tipped forward separately, and tipped back again very gently, handling the works one at a time. An added protection is to place a sheet of strawboard between each work and its neighbour, as the strawboard is smoother and softer than picture frame mouldings.

An additional safeguard is to stack the works front-to-front in pairs; which makes them back-to-back alternately. The reason for this is that the front surface of frame mouldings are more or less as fragile as each other; and are mostly smooth. The back of each frame should be against the back of the next one, so that damage from sharp edges, panel pins and the like, is done where it matters least. Frames with gold and silver leaf finishes, and ornate swept frames, should never be stacked together without pads between them. You can make these pads from small packets of crumpled paper taped into little 'parcels' braced to the frame corners with paper tape or string. On large frames, they are made into long 'sausages', placed diagonally across each corner, with the ends tacked to the frame moulding at the back.

Small movable and adjustable pads can be made by tying them together in pairs with string, and draping them over the top of each frame two to a frame. If the stack is on a slippery floor, it can slide out at the bottom and collapse with a crash that not only scrapes the frames in the process, but can smash picture glasses. A strip of carpet, such as an offcut from a carpet shop, should be

placed in front of the wall for the frames to rest on; being held in place by the weight of the frames, giving them a non-slip security.

Figure 5e The pad in position on the frame, held by tacks.

It should be realised that heavy ornamental frame mouldings are usually 'front-heavy' when the picture is stood on its edge. This means that, if it is tipped slightly back to lean against the wall, it will wait for a moment until you are at the other end of the room, then it will fall forwards with a crash, flat on its face; usually smashing the glass (if any) in the process. Such a frame should *always* be stacked facing the wall, so that it tends to fall towards the wall. Pictures stacked face to face in pairs should never have an 'odd-number' frame at the front with the face of the picture frame facing the room. The stack should contain an even number of frames so that the one at the front has its back to the room; which protects it from knocks and kicks as people walk by.

Stacks which are placed side-by-side should have a gap of at least six inches between each stack, to prevent damage from the sides or edges of the frames knocking together. The sides should never be allowed to overlap; otherwise the tipping forward of one stack can bring the adjacent stack crashing forwards to the ground.

Figure 5f A better fixing of the pad by stapling its flaps together and securing to the frame with string.

It is natural to stack pictures of more-or-less the same size together. This would seem obvious common sense; yet, as is so usual in things like this, the obvious way is the wrong way. Within one stack, the frames should be of graded sizes, with the small ones at the back; increasing in height towards the front. The result is, with luck, a stack in which no frame is resting on another; as shown in figure 6a. There is the added safeguard that, stacked in such a way, it is virtually impossible for someone to get hold of the top edge of the frame at the very back and use it to pull the whole stack forwards; they simply cannot get at it. The temptation to let the whole stack fall back together against the wall is still there, of course, and must be sternly resisted.

Figure 5g The way to tie the pads on the frame with one piece of string; with the frame shown padded in its case.

Every working artist maintains a supply of ready-framed works, from which to select those to be sent to art shows, so storage is a common problem. Of course, the best place to store them is where pictures are meant to go – hanging on the wall. In a studio of the type that I describe, however, all the wall space tends to be taken up by shelves, bulletin boards, storage racks and the like.

Figure 6a The way to stack frames of different sizes with small ones at the back, on a non-slip mat.

Figure 6b Left: the right way; Right: the wrong way.

Figure 6c Twin pad for use with a heavy frame when stacked.

Where works are hung on the wall, each one should be on a wall that is suitable for the purpose. Whilst an oil painting does quite well facing the light, which helps to retard yellowing of the varnish, a water colour should never be hung in such a position, where it will tend to fade. It should be hung in a shady corner, or a shadowy corridor, away from strong light. Even drawings in the modern coloured inks – which many artists seem to think are fadeless and lightproof – will fade fairly quickly in any but the gentlest light. The blues fade first, then the yellows, then the reds, leaving only the greys and blacks. The full process of fading in this way takes, in my experience, about ten years; which seems a long time, but is not long in the life of a work of art.

Storage of framed drawings and water colours and mounted works

I have already described how I recommend that unmounted and unframed water colours and unstretched canvases should be stored, in folios; in a suitable, vertical folio cupboard. Packed flat in the folio they are safe from light and dust. Even so, a certain amount of dust can penetrate cupboards and folios, even if they remain closed for long periods. In art museums, where certain exhibits are kept in display cases that are engineered to very close tolerances in metal, with every safeguard against the penetration of dust, yet dust will get in, just the same. Such an enclosed space 'breathes' in and out due to fluctuating barometric pressures; and draws fine dust in at the same time. The more accurately the showcase is made, the finer is the dust; until, in the most expensive show cases, the exhibits, after a time, become covered with a fine film of dust like black face powder.

I once opened some slide drawers, in a museum where they had not been disturbed for about forty years. The drawers were beautiful Victorian workmanship, and fitted closely. Yet, when I came to lift what I thought was a sheet of black felt placed over the closely packed slides for protection, it turned out to be a layer of dust about 5 mm thick. In the same way, I have mounted a work on water-colour paper for exhibition in London; and framed it in a frame sealed at the front, inside the glass, with

scotch tape and sealed at the back, over the join between the backboard and the frame moulding, with adhesive paper strip. After one month in London, it returned and was unframed and unmounted. It looked clean until the mount was lifted off, revealing the clean 5 mm strip all round the edge of the drawing that had been protected by the overlap of the mount. Then, it could be seen that the drawing paper was no longer white but had become definitely pale grey, in so short a time.

Figure 6d The twin pad in use for an ornamental frame.

When dust of this fine consistency penetrates cases and frames, it actually penetrates the surface texture of paper and card, and cannot safely be removed by abrasion with a cleaning rubber; and has to be cleaned by skilful procedures. Like the loss of quality and sparkle with the fading of water colour pigments and inks, the loss of quality of a drawing due to dust is very gradual and its extent difficult to credit, until a protected area is seen sparkling in comparison.

For this reason, when stored, mounted drawings and other works on paper should, ideally, be wrapped individually in cellophane, which can be bought in rolls; and this should then be sealed with scotch tape. The wrapping must completely envelope the drawing, and, of course, the scotch tape must not be permitted to touch the drawing paper or the mount. The wrapping may become unbelievably dirty whilst stored in a cupboard, but the drawing will emerge sparkling clean. If the drawings are stored in this way for very long periods – as indeed, many of them may well be in the hands of a collector for example – the scotch tape should be examined every two or three years, as it yellows and deteriorates so as to lose its adhesive properties; and, in such circumstances, it must be replaced.

Drawings stored in this way can still be seen through the cellophane, which does not impede inspection any more than does picture glass. A collector can still enjoy them, therefore; or an artist show them to potential clients.

Once a drawing, water colour or print acquires a dirty surface by the type of neglect I describe, it cannot be cleaned other than by a skilled restorer. If it is one of your own works, the best thing to do is to paint it again. Of course, the best of all is not to allow it to get dirty in the first place. You can buy supplies of cellophane sheet in

rolls at household supplies shops. For larger works you need bigger sheets. Sheets of thin, clear flexible plastic suitable for this purpose are often advertised in gardening magazines. A useful alternative method of wrapping is to use the self-adhesive 'clingwrap' type of plastic film. This adheres to itself so that it can also be easily separated; adhering by static electricity. It is usually sold in rolls that are about 61 cm wide and about 10 metres long, but it can still be used for larger drawings by joining it along the edges by self-adhesion. A good overlap of at least 4 cm is advised. When this is taken off the drawing it can be re-used, and in the meantime can be rolled on to the original roll from which it came. With this in mind, cardboard rolls should not be discarded, in any event they should be saved for packing of any unmounted drawing that has to be transported.

Works in mounts, wrapped in cellophane, as I have described, should, of course, be stored in a dark cupboard or solander box; and not left out in the studio to fade. Any valuable drawings stored on the walls should be taken down in any case, between April and September and shut away in the dark during the times of strong summer light that (occasionally in Britain) can occur. Framed works of this kind, if not stored in a cupboard at least in summer, should be stacked in pairs facing each other, with the outer one facing the wall; to protect them from fading.

At any time of the year, drawings and other works hung on the wall will acquire, on the glass, a thin film of sticky deposit, from impurities in the domestic atmosphere and pollution in the air. When the studio is in a family house, and especially if framed works are stored on the walls of the other rooms of the house, this condition is especially liable to be severe, from the dispersion of bathroom and kitchen steam and so on. The effects of cigarette smoke in a sitting room are really incredible, depositing a sticky brown film on picture glass.

I mention on page 261 how this pollution must be cleaned off carefully, together with the fine dust that sticks to it. Once a month is not too often for this; preferably with the mounted drawing removed from the frame. Otherwise, great care must be taken to ensure that, in wiping the picture glass with a cloth slightly moistened with water, on no account does any

moisture creep under the rebate of the frame and round the edges of the glass to mark the mount or the drawing.

Glass cleaning should always take place before a work is sent for exhibition. Artists involved in art societies' exhibitions, however, are advised never to clean glazed exhibits in this way, the risk of water damage to the mount or work is too great under such conditions. The hanging committee and their helpers should be clearly asked during the selection and hanging, never to handle the glass or leave finger prints on it, for this reason. There is no harm in wiping over the glazed works with a soft dry cloth, during the show; but this should not be left to a cleaner or a youthful helper to do.

Some readers may consider these strictures to be fussy and over-cautious; but they are routine practice in any well-run art gallery. A spoiled work of art is always a cause for disappointment and regret to someone; especially when the damage was not expected. Once you have acquired the habit of caring properly for works of art in this way, you will develop an eye for those instances, in studios and art galleries, where works have suffered from neglect. In my experience, artists and the smaller art galleries are among the worst offenders.

A storage rack for framed works of moderate size

If the size and shape of the studio permit it, the storage rack for medium and small works in frames is best placed alongside the folio storage cupboard, or some other piece of furniture of the kind that I also describe on later pages, such as the typing/writing desk; so that it can serve also as a 'side' to the other piece of furniture and thus save materials and reduce cost.

The rack should stand on the floor; and consists simply of two flat sides, and a flat top. The sides should be at standing-work height (about 91.5 cm), less the thickness of the top; so as to bring the top surface exactly to the right height. It is very important to get the standing worktop surfaces the right height for your own comfort. The artist who mounts, pastes down and otherwise deals with his productions at such a surface, will spend many

Figure 7a Securing a worktop for use as a picture rack; with upright battens.

Figure 7b Dowelling the end of the worktop into the edge of the wall shelf, if an end panel is not used.

hours at the worktop, and stooping needlessly can be tiring and also reduces concentration and efficiency.

If some other piece of furniture is made to share a side with the frame rack, the other end can also be supported by another DIY piece or can be run into a corner and supported either by a batten screwed to the wall at the right height; or, as in my own studio, can be dowelled into the fore-edge of the wall shelf, which every studio should have. In the latter case, as the storage rack-worktop may sometimes carry heavy objects, the fore-edge of the wall shelf should be supported by a piece of 5 × 5-cm softwood batten, cut to form a tight fit from the floor to the underside of the shelf. If this is done accurately, it can be tapped into place as a support and does not need any additional fixing.

The storage rack can be as wide from front to back as the size of stored frame requires; but it should not be so wide that it is not possible to reach comfortably to the back of the worktop; nor should it stick too far out into the room if floor space is limited. My own, being 91.5 cm high, is 61 cm from front to back. It can occupy as great a length along the wall as the studio will allow and the number of stored frames requires. In practice I find that mine, which from side-to-side is 107 cm plus the 25.5 cm width of the wall shelf into which it is dowelled at the right-hand side, is not quite big enough to store all the frames and framed drawings or paintings that I have around at any one time; and it has to be supplemented by space in a recess that I have made into a cupboard; which gives me further storage on a floor space of 61 × 91.5 cm. In this recess I have fixed an additional shelf at a height of 114 cm made of 5 × 1.2-cm softwood battens evenly spaced 1.2 cm apart; which gives me yet more space for frames.

However long the worktop extends along the wall, it will need supporting by vertical pieces of 5 × 5-cm softwood batten every 60 cm. These are placed at the front of the worktop, from the floor to the underside, in the same way as the one supporting the wall shelf where it is dowelled to the worktop.

These not only serve to support the front of the worktop, but also provide racking to hold the framed works underneath. The back edge of the worktop is supported at the back by a series of short battens of 5 × 1.2-cm batten

plugged and screwed horizontally to the back wall about 60 cm apart; on which the worktop rests.

The worktop is prevented from moving by dowels in the wall batten, made of 6-gauge screws from which the heads have been sawn off. These slot into holes drilled into the worktop, being themselves screwed into the wall battens at the appropriate points. (As the heads have been sawn off, they go into prepared holes drilled with a twist-drill slightly thinner than the screws, driven in with pliers.)

The convenience of this dowelled type of fixing is that the worktop can easily be removed for any reason; either for alteration or enlargement, or to get at wiring underneath it, or if you simply decide that you want to move it somewhere else. In use, the frames, and framed works, stand on edge, leaning against the upright battens so that they cannot fall over; or with several together leaning on each other supported by the batten alongside. They can easily be slid in and out, without damaging each other. As a finishing touch, I have a piece of strong 61-cm-wide stair carpet of the appropriate length covering the floor surface of the entire rack; so that the frames slide on it without damage. This can be bought cheaply as a roll-end or offcut at a carpet suppliers; and should be the strong type used for office buildings.

Another finishing touch, that is not strictly necessary, but is a very good idea, is to fix a thin plastic curtain-rail system of the right length, along the underside of the front of the worktop, and make curtains of the right size to hang down to the floor. These curtains can be slid aside to get at the frames; and in the meantime, they keep dust out to some extent and also look pleasant.

The worktop should be made of 2-cm chipboard, and covered with plywood veneer or Formica, glued on in the usual way by contact adhesive. A suitable 2-cm-trim for the worktop edge can be found in a variety of styles and materials at the Do-it-Yourself shop or the woodyard and you could either glue or screw it to the edge.

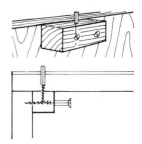

Figure 7c Wood-block securing of the worktop to the rear or end panel.
Figure 7d Wood-block fixing; sectional view.

Figure 7e Picture rack curtain fixture.

Storage of volatile spirits and corrosive fluids

Painters use turpentine in the natural form and the synthetic turpentine substitute form; and designers and

others also use thinners or similar volatile, flammable spirits. Great care and responsible handling is called for in this connection, especially when they are stored in bulk, that is in any amount more than a litre. It is sometimes possible to obtain a bargain consignment of up to several litres but it is better to avoid bulk storage of volatile spirits. These are safest stored in a locked place away from the main building, in case of fire. Even if they do not cause the fire, they will greatly aggravate it.

The heavy gauge of plastic container, or metal containers are more suitable than glass or thin plastic which can be damaged accidentally leading to breakage. When decanting supplies into smaller containers for ready use, this should be done with a large enough funnel, on a stable base, preferably out of doors. It should not be done on a wooden floor, in case of spillage which can saturate the wood; and, of course, there should be no smoking or naked lights.

If you are in any doubt, consult the local Fire Prevention Officer, whose office is listed in the telephone book. For any volatile spirits with a flashpoint of over 73°F, you should consult the Petroleum Officer of your district. (Outside London these functions are usually combined in the one officer; but in London they are separate.) If storing large amounts of volatile or corrosive fluids, you should also consult the Buildings Regulations Department of your local town hall, *before* you obtain the supplies.

Never be tempted to store even small amounts of thinners, amyl acetate, or any other volatile spirit such as turpentine, in a cleaned-up, plastic food container such as a yoghurt pot or a cream carton. All goes well for a time, but if it is left for a day or two in a cupboard or on a shelf, the container will, in all probability, have partially dissolved and leaked all over the place.

Some time ago I met a distinguished etcher and engraver friend of mine, proudly carrying home a large shallow plastic dish of the kind used for photographic developing, which one might be tempted to use for acid baths for etching. I mentioned this a few days later to a friend who is a specialist in materials technology; who told me that he knew of no plastic that had been thoroughly tested as proof against the corrosive acids used in etching copper plates; and that, in his opinion, all the

usual types of plastic are unsuitable and potentially dangerous. All the same, in the studio of another etcher friend, sometime later, I was shown plastic etching baths, and was assured that they have come to no harm used in this way. So it seems that whilst the usual ceramic etching dishes are safe, it is a matter of luck whether any plastic dishes an artist may acquire will be safe or suitable for this usage.

NOTES

[1] Catalogue of the *Chaim Soutine* exhibition, (Westfalsches Landesmuseum, Munster, and Hayward Gallery, London, 1982), essay by Maurice Tuchman, p. 65 (English ed.).

[2] Cf. Catalogue of the *Thomas Gainsborough* exhibition, (Tate Gallery, London, 1980); introduction by John Hayes, p.28.

[3] *Completing the Picture*, (Tate Gallery, London, 1982), p. 100.

[4] Richard Francis, Introduction to the catalogue of the *Jennifer Durrant* exhibition at the Nicola Jacobs Gallery, London in November and December, 1982, page 2.

Chapter 5

The four working areas

The creative area

In the creative area, being the smaller part of your studio, set aside, if possible, for the exploratory and preparatory work – there has to be a drawing table, a wall shelf, a large folio for storing clean drawing paper for ready use, a floor cupboard for storing finished drawings, which has a worktop, and, of course, a chair or stool. In addition, the artist needs a wall cupboard for stocks of media, inks, pens, pencils and so on, a container for clean rags and another for waste paper. For economy of space, this area can be combined, if desired, with the business area; which needs a writing/typing surface, a telephone, a small filing cabinet and some bookshelves.

All these items of furniture can easily be of the wrong sort; causing inefficiency and, perhaps, needless expense. I am assuming that the artist is something of a handy-man or handywoman – and, in my experience, many of us have to be – and will describe how much of the furniture can easily be made on simple lines. Many of the pieces of furniture combine to fulfil two functions, thus saving expense and space; such as the folio cupboard which is also a worktop; and the wall shelf which forms the writing/typing desk, but also supports the hinged top of the drawing table. All the items that I describe, I have made for myself at one time or another, and tested over several years of successful use.

THE WALL SHELF

This should occupy every bit of wall space that is not obstructed by doors, windows or studio furniture. It should go all round the wall at what I will describe as

'standing work height'; that is, the height at which the artist can comfortably draw or write and so on when standing up. This is usually exactly half the person's height, and is about one-third higher than the same person's 'seated working height'. It is higher for a tall person and shorter for a smaller one. The best thing is to experiment and find which is the most convenient height.

The shelf holds all those boxes, tins, bottles, mounted drawings, picture frames and other things for which the open space in the centre of the studio does not provide flat-top space. It should be 25.5 cm wide and 2 cm thick; and preferably is given a front lipping raised 1 cm above the shelf surface.

All those odds-and-ends are kept on this shelf, and drawings can be put on the shelf for inspection, or between spells of work, and can be studied and compared, out of harm's way and without cluttering the room. A most important feature of the wall shelf is that it supports the hinged top of the drawing table.

THE DRAWING TABLE

Whilst splendid drawing tables can be bought from art materials' suppliers, which are rather costly, a perfectly efficient drawing table can be made in the studio. It should be in a strategic place in the room, not too far from the window, with the light from the left (for a right-handed person). It is, perhaps, the most important thing in the creative area. Sometimes the artist needs a sloping surface, as when putting washes on water colours or doing drawing with ruler and T-square, and, at other times, needs a flat surface, as when pasting down drawings and the like.

Figure 8a Design for drawing table gate-legs for level position.

It comprises a flat working top that is hinged at the back to the wall shelf, which should be supported at the point where the table legs would be by two softwood battens 5 × 5 cm, held at the top and bottom by small, steel right-angled brackets drilled for screws (which are obtainable at a hardware shop).

The table top is supported on gate-legs hinged to these battens; and instead of the usual one per side, there are two at each side; one being shorter than the other in each pair. When the taller pair are swung forward, the top is held level with the surface of the wall shelf; and when the

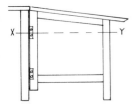

Figure 8b Design for drawing table gate-legs for sloped position.

shorter pair are swung out, the table top is held at a slope. For this purpose, the taller gate-legs are hinged inside – or in-between – the shorter ones, so that they can be folded back flat against the wall when not required.

The degree of slope is a matter of personal preference; but it should not be so steep that pencils and brushes roll down it on to the floor. I always use hexagonal-sided lead pencils and not round ones for this reason. My table has the shorter gate-legs 7 cm lower than the longer ones; with a table top 81 cm from front to back. In width, the table can be as big as you like; but remember that the wider it is the heavier it will be. Mine is 107 cm wide, and seems about right.

The table top is not solid wood; for this would be far too heavy and also expensive. It is easily made from two sheets of plywood 3 mm thick. Mine are surfaced with a mahogany-like wood called sapele, which is used in the furniture trade for the backs of wardrobe doors and places like that; but I think that it is quite a nice wood in its own right, and it is easy to obtain (I have striped mine with water stain to enhance the grain, and you would not know it from teak when it is varnished). Otherwise, if you want your surroundings to look nice, you can get from your wood-yard some plywood surfaced in silver ash, which is very pale, Brazilian rosewood, which is dark and rich, knotty pine, Burmese teak and knotty cedar among others. All these surfaces give a fine finish to the table. If you wish you can have the top surfaced in Formica in a wide range of surfaces, or in Laconite worktop, finished in durable stoved enamel on hardboard.

Whatever the chosen finish, two sheets of plywood are glued on either side of a softwood frame of 2.5 × 5-cm-battens that form the edges of the table top. These do not need to be jointed in any way. They are butted at the corners so as to give the fore-edge an uninterrupted, clean line, and the two sheets of plywood are glued above and below, with the edge battens as the 'meat in the sandwich'. When this gluing has dried, under pressure (piles of books on the floor will do it), the underside of the edges should be bevelled, for appearances' sake at the front and sides – but not at the back where the hinges go. Sharp edges – called 'arrises' – should be sandpapered down a little; and the front corners – but not the back ones – rounded to save painful knocks if anyone walks into one of them.

For a surface of the size I mention, cross battens should be placed within the outer frame, for supporting the centre of the plywood when in use; but a far better method is to obtain a suitably-sized sheet of 2-cm-polystyrene. This should be cut to fit exactly within the frame, before the plywood is glued on. There is no need to glue the polystyrene, if it is a snug fit. This not only supports the top plywood surface all over, but deadens any hollowness in sound that can occur if the table is used without filling. The polystyrene is so light that the whole table top has very little weight at all, and yet is very strong. The plywood top should be finished off with three coats of polyurethane varnish, which is stain and heat resisting. On no account should it – or any other studio furniture – be wax polished, as the wax comes off and gets on to the water-colour paper; which, then, will not take washes properly.

The type of hinge to use at the back is the strap hinge; with flaps about 4 × 5 cm; and two should be used fairly wide apart (about 5 cm from the outer edges of the table top). My diagram shows how the twin gate-legs are fixed to their upright battens so that either or both will fold away quite flat when not in use.

The shelf, and indeed, all the furniture I describe in this book, should be varnished and not wax polished. I do not even wax polish the studio floor, which is hardwood parquet (although I would do so, of course, in another kind of room); so that there is no risk of a drawing falling to the floor and getting wax on it. Instead, I clean and re-varnish it every year, with a *very thin* coat of varnish. This prevents a build-up of thick varnish, and speeds up drying; thus avoiding the studio being out of use for a long time. Also, repeated coats of thin varnish are a very good thing, anyway, compared with one or two thick coats.

When cleaning drawings, or spreading them out for inspection or pasting down and similar tasks, I use the table level; and work standing up. When doing water colour I place it at a slope, and work standing up; and for illustration or drawing with a T-square, I usually work sitting down.

The seat I use is a small kitchen stool of tubular metal with a padded vinyl top. It has a set of ladder steps that fold away underneath and is useful for reaching high shelves. Such stools are widely available at household-equipment shops, and are just the right height.

Figure 8c Plan view of hinge assembly for gate-legs (at X-Y, figure 8b) with batten for outer pair of legs staggered half a width forward to allow the gate-legs to fold flat when not in use.

The only time that I fold away all the gate-legs and let the table hang down against the wall from the edge of the wall shelf is when I am doing oil painting; as my space is limited and I combine the creative area and the production area, in the same room, one at each end. As I exhibit water colours, among other things, I use the creative area drawing table for producing these as well as for initial, trial sketching. When I do illustrations, I use it for these also. I have another pedestal-type water-colour table which I use for larger water colours, and this is brought out (as with my tripod sketching easel for oil painting) and when the large water colour has been completed, using the entire space of the studio to enable me to get back from it during painting, the pedestal table is slid away again into its corner, where, with the top fixed level, it serves as an extra table for still life material (or even for the drinks tray when I have a studio visitor).

In such ways, every area of space, and every piece of furniture is made to serve several purposes. When I state that the pedestal water-colour table is 'slid' away, this refers to my system of placing all moveable pieces of furniture (except the painting trolley which is on large castors) on pads of cord fibre carpet, glued underneath the feet or base by contact adhesive. The carpet surface normally uppermost is placed underneath, and on my smooth, varnished, wooden floor, such equipment easily slides to where I want it; whilst being more stable than would be the case if it were on wheels or castors. Even the bottoms of the gate-legs of my drawing table have such carpet 'sliders' underneath, on which they are moved in and out. Do not use woven, wool carpet as it unravels and also is not sufficiently hard-wearing.

Thus, I use the whole floor surface, when required; and when they are not required, the tripod easel folds up and goes in a cupboard, the painting trolley is 'garaged' under the drawing table with the stool, and the pedestal table goes back into a corner. The jars of paint brushes and other things from the painting trolley go on the wall shelf, the trolley has its lid replaced (as described below), and, if I do any typing at the slightly wider part of the wall shelf, which is set at 55 cm to the underside for writing and typing, the trolley stands at the side to hold books, stationery and the telephone.

Of course, there are draughtsman's drawing stands

that can be used instead of my space-saving drawing table, which can be obtained in various sizes from graphic-supplies shops. For a designer, or an illustrator who does a good deal of precise ruler-and-set-square work, one of these is, perhaps, better. But they take up a lot of room and cannot be folded away when desired. For the artist – as distinct from the professional draughtsman who will want a big one – there are very useful small ones in the range marketed by Blundell Harling, Ltd of Weymouth, Dorset; such as their 'Studland' model which can be used either on a table-top stand or a floor stand, and which incorporates a parallel-motion unit for use instead of a T-square. These will fold up and can be stacked against the wall. They would not be suitably adaptable for use for working level, in cleaning drawings, pasting down under pressure, card trimming, mount cutting and similar work as, unlike my gate-leg table design, they are not intended to withstand downward pressure.

Figure 9a Low worktop fixture used as typing/writing desk with folding lid.

Figure 9b The desk shown with the lid folded open as a copy rest.

THE WRITING AND TYPING DESK

This is simply a shelf of chipboard 2 cm thick, veneered in my case with teak, but available ready-veneered from the wood-yard or DIY shop. It is 42.5 cm deep and 97 cm from side to side. It is supported, in my studio, between a side wall in a corner, and, at the other end, on the side panel of my frame and canvas storage rack, which has a worktop and a curtain in front. I have fitted it with a folding 'harmonium' type lid, hinged across the middle, which lifts and folds back to make a book-rest, which can be closed and thus obviate the need to keep placing a dust cover on the typewriter. I have a typist's three-legged metal tubular-frame chair with swivel seat and adjustable back, for use at the desk. Any writing, proof correcting and other desk work is done with the lid down; this being fitted to have a convenient slope like a school desk. I have glued some cross-banded veneer round the edges, and put a sheet of imitation leather vinyl upholstery fabric in the centre.

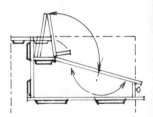

Figure 9c Sectional view of desk showing fixing blocks and hinges.

Figure 9d Front view showing the shelving fixed on blocks.

THE PAINTING TROLLEY

Like my tutor Paul Nash, I find the tea-trolley type of painting table serves quite adequately enough as a

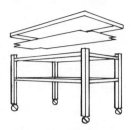

Figure 10a Painting table: tea trolley type with palette surface and lid.

palette and support for brush jars, water-colour box and studio chinaware and the like, without anything further. There is, however, a type of painting trolley which is a small cupboard with a large drawing board screwed on top, and the whole being on castors. Half of it should be cupboard and the other half small drawers. If you prefer to use a traditional hand-held painting palette, this can be hung on the side of the wheeled cupboard when not in use. I do not use one, as it is heavier than the tea-trolley type, and I prefer to keep my materials elsewhere. I have a small kitchen carousel holder, with containers on the top shelf and space for small bottles of ready-use varnish, turpentine and so on below. This stands on the wall shelf, and is turned to obtain the material required. Reserve stock of these materials is kept in the storage area in a wall cupboard.

I discuss this painting trolley at this point and not in the section dealing with the production area, because, as I have described, it is also useful as an adjunct to the writing-typing desk. I also use mine when I am painting in water colour on the drawing table. I have it standing at my side, in front of the table; holding my brush-holder (which is a ceramic jar), my water-colour palettes (which are ceramic dishes), my water bowls (two of these, also in ceramic) and my water-colour paints and paint tubes.

It is nothing more than an old-fashioned tea trolley; and I gave ten shillings for it 40 years ago, equivalent, I suppose, to about £5 today.

I first saw one of these trolleys being used for this purpose when I used to help Paul Nash as occasional studio assistant, whilst I was a student of his at the Royal College of Art in London. As soon as possible, I bought and adapted one just like his. Paul used his trolley purely for oil painting; and had had a piece of 6-mm-plate glass cut to fit the top, which he used as a palette for oil paint, with a piece of white drawing paper underneath it. His jars of paint brushes stood also on the top, and on the shelf underneath he had paint rag, and bottles of turpentine and the like.

I used mine for several years, and then broke the piece of plate glass; but, by that time, plastic was available; and now I cover the top with either clear hard plastic or a piece of Formica. The Formica can be white if you paint on a white canvas or, of course, it can be grained like

mahogany, if you are used to mixing your colours on a mahogany palette. When the Formica top is not in use as a palette, it can be lifted off and cleaned and hung on the wall out of the way, until it is needed again.

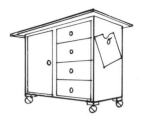

The trolley is, of course, on wheels. I recall Paul Nash standing back from his painting with the trolley at his side, and going towards a painting to add a touch of paint, and then coming back to roll the trolley up to the painting, to work close to the canvas.

Figure 10b Painting table: cupboard type.

American readers will call the wheeled cupboard type of trolley a 'taboret' (in Britain a 'tabouret' is a small stool, from the French). If I had a separate production area, I might consider having a taboret there, but I doubt it, as it is bulky and heavy.

The production area

The needs in this area depend, of course, on the media used by the artist. As stated earlier, a sculptor or a print-maker will have this area on the ground floor, whilst an artist producing drawings and paintings can accommodate it on an upper floor, due to the lightness of the equipment and the better daylight. However, even for drawings and paintings, it should be kept apart from the creative area if possible, as large drawings and even smaller ones drawn from still-life or the model need plenty of room, and larger oil paintings require more still. Where this separate accommodation is not possible, it should at least take up one end, or the main central area with the creative area in a corner or, preferably, screened off.

The production area should be as empty and as spartan as possible, without a clutter of bric-a-brac, mementos, occasional tables, armchairs and other things. Even the portrait painter, with sitters to entertain, should keep the armchairs and coffee tables and so on to one end of the studio and the bare working area at the other. This has the added advantage of protecting the sitter from getting paint on the clothes due to backing into a paint brush carelessly left lying on the paint trolley with the business end sticking out covered in wet pigment.

It also helps the artist to keep the sitter away from the picture in progress; as many portrait painters dislike the sitter seeing the work half-finished.

The sculptor and print-maker will presumably be ex-perienced and well-taught enough to fit out the produc-tion area to the best advantage for those specialised media. My present concern is primarily with the painter; particularly the artist who is fitting out a studio economi-cally for the first time, within whose production area, all that is needed is a folding sketching easel, a tea-trolley palette, a sitter's chair if portraits are done, a table for still-life material if required, and the ubiquitous wall shelf for brush, jars and the like. A small chest of drawers is needed for storage, which can support one end of a short worktop; the other supported on a canvas rack or on a batten fixed to the side wall of a corner.

THE EASEL

As most houses today, unless they were built at the beginning of the century, do not have ceilings high enough to take a traditional easel, something smaller is needed. Painters of full-length portraits, of course, will need the traditional easel and will have to take suitable studio premises with this in mind. Painters of large abstracts can emulate the example of the famous New York abstract painters Jackson Pollock and Morris Lewis, among others, and paint with the canvas laid flat on the floor.

I suggest that the painter of today should seriously consider that the modern, small house demands a change from the space-consuming methods of former centuries, notably the Victorians and Edwardians with their big and spacious studios. One old tradition that I suggest can be dispensed with in such circumstances is that of stretch-ing canvas to paint on. It does not need to be stretched until it comes to be framed, and, indeed, can be stored with much greater safety unstretched and simply pinned to the wall until dry and then stored in a folio. I discussed this in detail in Chapter 2. I mentioned particularly the storage advantages of using unstretched canvas; and here I would like to offer further advantages for the reader's consideration.

Firstly, the artist no longer needs an easel. This will not only save space but also money; it also saves time, as there is no need to get the easel out for work and put it away again afterwards.

If Sundela board is screwed to the wall right along one side of the studio, unstretched canvas can be pinned up with chart pins and painted on. If several sheets of the standard size of 1.2 × 2.4 metres are put up along the wall above the wall shelf, you have room for several medium sized canvases and even more smaller ones. Preparatory drawings and colour notes can be pinned alongside for easy and constant reference, the brush jars and oil bottles can stand on the wall shelf, and the painting trolley serves as a pallette.

When a canvas has been painted as far as possible without a drying period, the artist can move to the next and carry on without loss of impetus and enthusiasm. Small squares of canvas can be pinned up on which to try out passages and treatments during painting; and, at the end of the day's work, the whole lot can stay up there out of harm's way. A sheet of tracing paper or thin textile can be pinned above the canvas to hang down over it, held from contact with the wet paint by the protruding wall shelf, and preserving it from dust whilst wet. The canvas will come to less harm than if being lifted into and out of canvas racks, or left leaning against the wall.

Suitable lighting, as described in Chapter 3, can be fixed so as to make the painter more or less independent of daylight, arranged specifically to give even and shadow-less and unchanging light temperature right across the 'pin-up' area.

Such an arrangement would not do for a portrait painter, of course, who has to face the sitter, nor for the painter of still-life in windows and on mantelpieces, and the painter of interiors and so on, who must go where the subject is. For such artists, two dining chairs placed facing each other are all that is needed. In my photograph of the great French painter Georges Braque, it will be seen that he is painting like that, seated on a dining chair with the canvas leaning against the legs of another and the paintbox on the floor. It will be noted that he is using unstretched canvas fastened to a drawing board. A surviving Brassai photograph of Bonnard at work shows him using an unstretched canvas pinned upon the wall.

It is useful, even when adopting the unstretched canvas method that I describe, to have in reserve a folding, tripod easel which stows away when not required. It is useful for setting up a stretched canvas to show to a studio visitor,

Figure 11a Weighting a tripod easel for a larger canvas.

Figure 11b Securing tripod easel for outside work on windy day.

Figure 12 Victorian *prie-dieu* chair used as a folio and picture stand.

and for outdoor sketching in oils, and is more generally useful than the art-school type of large tripod easel, which takes up too much room. I have never liked the 'art-school easel' in which the upright is fastened to a three-legged base by means of a single large screw and wing-nut. I always thought that they combined the worst features of the big easels with the relative instability of the folding tripod easel.

The tripod easel is useful away from the studio and very stable if it is properly disposed for use – the legs must have a fairly wide stance and the canvas must not be too big. Even so, it is wise to have a spanner to tighten up the adjusting screws. If, however, it is holding a big canvas in a windy field, it can be made more stable by fixing a length of curtain cord (which does not stretch) at the point where the three legs meet at the top, with a strong wire hook hanging about 50 cm from the floor (you can make the hook out of a wire coat hanger; cutting off a length of wire and bending it into an 'S' shape). On the hook you hang an ordinary plastic shopping bag filled with pebbles. If the floor is slippery – as a parquet floor may be – you have to tie the legs in with a piece of cord. It will not matter then how fiercely you attack the canvas, the easel will not collapse. If you also use this easel out of doors, screw a 'screw-eye' into each leg at the bottom; and through the eye pass an ordinary strong metal kitchen skewer as far as it will go into the earth below. With each leg pegged down in this way, it will take a strong wind to blow it over. The skewers should be driven down sloping inwards at 45 degrees, so that, taken together, they exercise a 'biting' grip on the earth; and if a leg tries to lift in the wind and withdraw the skewer, it is not pulling it out endways, but is trying to pull it sideways at right angles, which is almost impossible.

A studio picture support that I have found extremely useful is a Victorian prie-dieu chair, that I bought for a few pounds many years ago, and which is in my studio now. Like almost all my equipment, it fulfils more than one function; and in this case whilst it provides a comfortable seat for a visitor to the studio, or for myself during breaks, its most useful function is for holding mounted drawings, unframed canvases on stretchers or framed works, when I wish to scrutinise them myself or show some to a visitor. I first saw this type of stand in the

backrooms of Bond Street art-dealers such as Messrs Colnaghi and Messrs Agnew, where they had very big ones that were evidently purpose built; and on which I examined numerous paintings when I bought from those galleries occasionally. I found mine in a second-hand shop without much trouble. It is on its original free-running castors, and can easily be moved around the studio as desired.

As the production area is more active than the creative area, it should be large enough to be able to move around without bumping into things. Even though most art students are used to working in crowded studios at art school, they will not want this to continue for the rest of their careers. Yet, space is expensive to buy, furnish, heat and maintain; and modern houses do not have big rooms.

For a sculptor or a print-maker with printing press, perhaps a large hut in the garden is better than an indoor production area; with space for the sculptor to work out of doors in suitable weather. When the sculptor Gaudier Brzeska worked in Putney, he used one of the brick arches under the overhead railway as a studio. It is still occupied by a Royal Academy sculptor. Feliks Topolski the illustrator and painter has used a similar railway arch in London.

The presentation area

As I described previously, by 'presentation' I refer to all those aspects of the production of drawings and paintings, that take the unframed work and mount, frame and otherwise present it for ultimate exhibition. Once again, the demands on this area vary with the medium used; but for all the pictorial media (drawings, oil paintings and prints) the needs are much the same. This work does not need a large area; but, at the same time, there should be room to move around without crowding.

The central feature is a large, strong, kitchen or dining table with reasonable space around it; the size depends on the size of picture the artist produces. For a miniaturist, at one end of the scale, a table with a top of about one square metre would be adequate. For oil paintings of some metre or two in length, a quite large table surface is

needed. There should also be a strong worktop along at least one wall; and if possible, in every part of the wall that is not otherwise occupied. The worktop can be supported by a range of accommodation that includes frame racks, drawer units, cupboards and so on. Over the worktop there should be a tool rack and shelving.

If there is enough space in the house, a separate small room should be used for clean work like paper trimming and mount cutting; which also needs a strong kitchen table and worktop and the rest. Where this cannot be done, the artist should consider having two tables, if space permits, one at the 'clean' end and one at the 'dirty' end; for mounting and for frame painting respectively. If the same table is used for both, a sheet of plywood or hardboard should be cut, the same size as the table top, to be used when dirty work is afoot, to keep the table surface clean for white paper and card. There should also be a fairly large rectangular sink, which need not be deep. The old-fashioned shallow sink is ideal. This is used for soaking water colour paper, and immersing water colours as described in Chapter 7.

With limited premises it may be best to ally the mounting and fitting-up area with the creative area, and the framing and packing can be attached to the storage area. The advisability of dividing the types of work into compatible areas is of great importance for efficiency and the final appearance of the work.

The framing and packing area should have ample worktop space; and at least some of this should be sturdy enough for the heavier tasks of woodwork that require the use of a vice. If possible the worktops should go right round the room, leaving space in the centre for a good, strong table, with a strong top. A heavy old dining table from a second-hand shop is better for this purpose than a proper carpenter's workbench. Firstly, a proper bench is quite expensive, as it takes skilful assembly of very heavy, sound timber; and secondly, for the handling and assembly of picture frames, a carpenter's bench is not big enough, and has a 'trough' down the middle that is an impediment rather than a help, when dealing with smaller frames.

In assembling picture frames, it is essential to ensure that the assembled mouldings are flat and in one plane; otherwise the frame is what they call 'skellered' (i.e.

twisted); and a piece of picture glass, on being fastened into it, will promptly break. An absolutely firm and flat surface is necessary, on which the frame can be assembled under weights, if need be; to keep it flat. I say more about this, later, when discussing frame-making; but, for the present, it is important to see that the centre table has a perfectly flat and rigid top. An old-fashioned wooden kitchen table is ideal; but I have found that such a table sometimes costs as much, second-hand, as a new dining table; so that it behoves the artist to shop around for the right one. If there are any slight undulations in the table top, they can be planed out without much difficulty, and checked with a steel straightedge.

The legs of the second-hand centre table may not be strong enough for the most heavy work; and I have seen a table with reinforced legs in a framing workshop, as shown in figure 13. Each leg is enclosed in 1.5 cm boards; four to each leg, which fit closely round it and are packed at the bottom with small wood blocks; the whole leg-case being glued and nailed into position. The four table legs thus strengthened are further reinforced by 'stretchers' (wood battens of 7 × 2.5 cm) nailed from leg to leg, 15 cm from the ground, at each side. From the centre of the table frame, on each side, a wooden brace of 5 × 2.5 cm dimensions is taken across the angle to each leg, as a strut, to reinforce further the strength of the table. Nothing is worse than working on a table of which one or more of the leg joints has 'sprung', so that it is not perfectly steady.

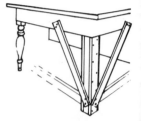

Figure 13 Reinforcing the legs of the production area work table.

Added to the advantages of this strengthening, the leg-cases can be made of such a length that the height of the table top is raised, if preferred, to a comfortable level for a standing worker, i.e. about 91.5 cm. The science of assessing the best working dimensions for furniture and similar things is called 'ergonomics'; and if you want to get it absolutely right, you should consult one of the books on ergonomics, giving sketches and dimensions for most things.

The area of the table top will depend on two things; the size of the room and the size of picture that the artist wishes to deal with. I have already stressed that the size of the artist's work is an important factor in choosing the size of furniture, and of the rooms and, indeed, in consequence, the size of the whole house! In an old Victorian

house, it is possible to deal with paintings up to some 180 ×
250 cm (6 × 8 feet); but above this, some other accommoda-
tion should be sought. In my own studio, with creative and
writing area at one end and production area at the other in
a space of 3.96 × 4.50 metres (13 × 15 feet), I can manage
oil paintings up to 76 cm largest dimension (2 feet 6
inches), on my tripod easel; but over that size I place the
canvas on the wall shelf; either on a stretcher or un-
stretched, fastened to a sheet of hardboard, and I can
accommodate paintings up to 107 cm (3 feet 6 inches)
maximum height and 1.52 metres (5 feet) wide; (above this
size I get lighting problems).

The size of painting decides the size of the framing and
packing accommodation and equipment; which, in my
case, is separate. One thing that it certainly influences is
the size of the centre table; as it is difficult when the table
is not big enough, and a waste of space and money if it is too
big. You should always leave sufficient space around the
table to be able to work and move freely.

In cases where it is simply not possible to have separate
areas for all the work, and, for example, the production
area has also to serve as the framing and packing area,
then it may be better to have a knock-down table of a sheet
of blockboard on two strong trestles. This can be set up for
framing and mounting purposes, and taken down and
stored out of the way when the centre of the floor is needed
for (say) oil painting.

Blockboard is supplied in sheets 2.5 cm (1 inch) thick
and 122 × 244 cm (4 × 8 feet) in size, giving a table about
as big as a table-tennis table. The blockboard can, of
course, be cut smaller if desired. One drawback of this
system is that, for a lady artist at least, a sheet of
blockboard is very heavy to lift up and down; and another
is that it is not, of course, as rigid.

However, I have done quite heavy framing quite suc-
cessfully on such a table. If it is to be used for both frame
assembly and tinting, and mount cutting, then the artist
should take care to use one side of the blockboard for the
'dirty work' and the other side for the clean work. My
former trestle table, having had many frames tinted on it
in delicate pale colours, developed, after a time a superim-
posed texture of tinted rectangles all over the top, which
was so effective as an 'abstract' that we were seriously
tempted to send it in for a modern art exhibition!

The storage area

In this area or room, one necessity is an old wardrobe; for storing all those rather long things that seem to accumulate in a studio; folded tripod easel, camera tripod, rolls of canvas, corrugated cardboard, brown paper and lengths of frame mouldings. It should not have a central door, but two doors that go right across the front. Shelves can be fixed in the upper part of it, to store working supplies such as stationery stock, carbon paper, and similar things. Old wardrobes are easily found in second-hand shops and auction rooms. If it has a mirror on the door, do not dispose of it, but fix it to a 1-cm-plywood backing and hinge it to the wall or the side of the window frame in the studio production area; where it is useful for enabling the painter to see the work in progress the 'wrong' way round. This is a great help in composition; for, after a certain time, the eye becomes blind to certain faults, which stand out when seen in reverse through the mirror. If the wardrobe – or any other second-hand furniture – is rather shabby, a nice smooth coat of paint works wonders.

Shelving, as always, is valuable, and, in this area, absolutely necessary. This, in the storage area, should take two forms; simple softwood shelves on 'Spur' type adjustable metal brackets on metal wall battens with rows of 'keyholes' for attachment; and also pigeonhole shelving, made of 5×1 cm battens. The battens are made up into shelves with slats, and also into side frames with horizontal battens on which the ends of the shelves rest. The open shelving is for packets and parcels of clean products, that stay where you place them; and the pigeonholes are useful for dirty materials, such as half-used tins of paint, or things which tend to fall over or wander about, such as boxes full of old take-away foil containers (which are useful in a studio).

Clean materials should be stored at one end of the area – such as stacks of framed pictures and drawings under dust sheets, stocks of drawing paper, new canvas, spare frames and so on – and at the other end should be 'dirty' stores, such as stocks of oils and spirits like turpentine, tins of paint, a box of waste paper for making pads for packing and stacking (as described in Chapter 4) and the like.

STORING PAPER AND DRAWINGS

I have described in Chapter 4 how finished drawings and unstretched canvases can be stored in folios in a special cupboard and framed works can be stored in a special rack. These can be in the storage area; but are far better where each can support a useful worktop, and have the writing/typing desk slung between them if appropriate. Conversely, loose stacks of framed paintings, stacked as described in Chapter 4, are far better at the clean end of the storage area, which has less frequent use, and therefore places them at least risk of damage. They should never be stacked beneath a wall cupboard containing liquid art materials which might spill; and should be covered with dust sheets against both dust and unwanted light.

The stock of unused drawing paper and card should be purchased in bulk for economy; but then, there is the question as to how and where to store it safely and cleanly. At one time you could buy paper by the quire (25 sheets) but many paper merchants now will not sell in bulk less than a ream (500 sheets). Artists and art societies can always club together to buy paper in bulk; but any quantity of paper over 50 sheets is bulky and heavy. In a small studio, where there is no room for a plan chest, one way that I store unused paper is in a big, specially-made folio.

BULK STORAGE FOLIO

The sides of this are made of hardboard, gloss painted over hardboard primer. They are hinged together 6 cm apart with bookbinder's cloth, which is fastened by adhesive cloth carpet-binding. This holds a stock of my water-colour paper which is in sheets 72 × 100 cm or so, of which, being handmade paper, the edges are deckled. The folio therefore has been made slightly larger, at 75 × 103 cm to protect the edges. It has a flap to keep dust out and I stand it against the wall of the creative area under the wall shelf behind the drawing table, where it is out of the way. It is quite easy to slide out a clean sheet of paper when I want one; and, of course, it takes up no usable floor space at all.

Figure 14 Bulk drawing paper storage folio behind the drawing table.

A FOLIO-STORAGE CUPBOARD

The popular bohemian concept of the artist and of the way he handles his equipment and folios is illustrated in nineteenth-century paintings showing artists in their studios. In the seventeenth-century paintings, from which it appears that artists kept almost everything lying around on the floor, and the later Rococo studio paintings of the eighteenth century of connoisseurs and fashionable collectors, it would seem that they were even more careless with all these symbols of their taste and discrimination.

The statue of Sir John Millais, PRA, outside the Tate Gallery by Sir Thomas Brock, RA (1847–1923) shows the artist leaning against a four-legged draughtsman's stool, with a folio of drawings stuffed between the legs, resting on the stretchers, with several paint brushes pushed in alongside for effect. I am quite sure that Millais was more careful than that with his drawings; as are most artists from my experience. However, this is not a subject on which much, if any, tuition is given in art schools; and a few pointers on the subject may well be useful to younger artists and other beginners who have not yet fitted out their studios.

Space can be saved by avoiding the use of plan chests for the storage of drawings and prints, and it is better to keep these in folios, stored upright in a suitable floor cupboard, as I have described on page 77, and which also provides a convenient worktop. Pastels in particular, and completed water colours, should not be stored flat on top of each other as this causes rubbing and deterioration and lays them open to dust. A further disadvantage of plan chests is that they take up a fairly large area of floor space, and unless stacked to comprise a number of drawer units, they do not provide a worktop at the right level. Yet another drawback is that, for the smaller studio they arc fairly expensive, even when bought second-hand. It is quite cheap and easy for the home handyman to make a folio cupboard at the right height, with the minimum of tools, which, if desired can provide one part of a larger lateral unit of picture rack, drawer units for tools and materials, typing/writing desk and so on.

I recall that the famous architect Le Corbusier described and showed a photograph in one of his early books, of an upright cupboard for the storage of duplicat-

Figure 15a The shape of folio storage cupboard commended by Le Corbusier.

Figure 15b The same shaped square to hold a worktop.

Figure 15c The construction of 15b with two end panels and supporting battens; shown without the worktop.

Figure 15d As in 15c with the door and chains added.

ing stencils; which he suggested was an example of superior design and an example for the future; so that my adaptation of this type of cupboard for folios has a distinguished precedent. In Le Corbusier's example, the foot of the cupboard protruded giving a sloping front; but in my version, the front is vertical, with a recessed foot space at the bottom, to allow work at the worktop when standing.

In the simplest terms the unit is made with two solid upright sides of 6-cm plywood, strengthened at the vertical edges by 2 × 2-cm softwood, glued and pinned along the edges from top to bottom. The rear of these two battens should be set in 1 cm from the back edge to form a rebate to take a back panel if desired. This will not be needed if, as in my own studio, the unit stands against the wall. This should not be an outside wall; and if, for any reason it is, the wall at the back of the unit should be insulated by covering it with a sheet of insulated wall lining such as Rosslite 'Rio' lining, made 2 mm thick as an expanded polystyrene wall veneer, for this purpose, by Metal Closures Rosslite, Ltd., of Liverpool, and obtainable from your neighbourhood painting and decorating supplies shop. It can be covered if desired by wallpaper or emulsion paint.

If, like mine, the unit does not have a back panel, the bottom of the back edge of each side panel should be scribed to the surface contour of any skirting board, and cut to a close fit. (I explain how to scribe to a surface in Chapter 5.) The two sides are joined to each other at the requisite width to suit the size of your folios, by four battens; depending also on the available studio space. The two rear battens should be of 3 × 2 cm softwood, and the front ones of 3 × 3 cm for the top one and 3 × 9 cm at the bottom (to be high enough for the foot recess). The front battens are stronger as they do not have the added reinforcement of the back panel. If you dispense with the back panel, then the rear battens should both be 3 × 3 cm also. The back panel if used, should be the requisite height (according to the artist's height and thus of the standing-work height of the worktop) and a width to take your largest folio; and should be cut as a simple rectangle from 3 mm plywood. Hardboard is not strong or durable enough, as the back panel (or back wall) takes the weight of the folios as they lean back against it.

At the front, the top edge of the lower batten takes a piano hinge to secure the hinged front door, which is in one piece and opens forward vertically. The door is a simple rectangle cut from 6-mm plywood, slightly bevelled at the edges all round, and cut to overlap at the sides and top by 1 cm. To secure the piano hinge to the bottom edge of the door, a thin batten of 1 × 1-cm softwood is pinned-and-glued to the inside bottom edge of the door. A 'piano-hinge' is a continuous length of brass hinge with sides of 1 cm wide, and screw holes every 6 cm or so. The right length is sawn off with a hacksaw, between screw holes; and is far easier to fix accurately than two small hinges. It is sold in 1-metre lengths, and you simply cut off whatever length you wish to use. The hinge should stop a few centimetres from each end of the bottom edge of the door.

Figure 15e Cross section showing folios in position for easy reference to drawings.

The door is closed by a grip-catch at the centre of the top edge, obtainable at the ironmonger's; and should be fitted with a knob in a suitable place. Because a single knob looks rather odd up near the top, I have two knobs lower down on mine, which is lightly scored down the centre of the door to look like two doors.

Figure 15f Front view.

The lateral battens that hold the side panels together are secured by drilling pilot holes into their ends, and screwing 2-inch screws through the side panels from the outside. They can also be glued at these screw points; unless, as I do, you wish to retain the 'knock-down' construction which can be easily dismantled. If you live in a cottage with a twisting staircase as I do, this is an advantage, for when you move the cupboard can go with you.

Figure 15g Section of door hinge assembly with reinforcing batten at A.

All that remains to do is to fix the top. This should be of 1 cm chipboard, cut to size. Now, you can have it an exact fit all round; or projecting only at the front; or at the front and sides; according to your purposes. If you intend to screw a small vice to the front edge, and give the worktop energetic use, it will need to be screwed into place by small blocks, as in my sketch figure 7d. My own simply has dowels fixed into the top of the cupboard and holes drilled into the underside of the chipboard top; and when it drops into place, it holds the whole cupboard together very nicely. The top should be edged with hardwood lipping 6 cm by 1 cm; placed so that the front lipping overlaps that on the sides as in figure 15 to give a neat appearance.

Figure 15h Attachment of side panel to the transverse battens.

Figure 15i Worktop lipping showing front corner overlap.

Small chandelier chain of suitable length should be attached at each side of the door, as in figures 15d and 15e, to hold the door firm when it is open so that an opened folio can rest against it, as in figure 15e.

If additional cabinets are fitted at either side of the folio cupboard, there is no need to fix plywood sides; simply the battens. I give several suggestions as to the ways in which other units can be attached alongside, in figure 16; including frame or canvas rack, small writing or drawing desk at 'sitting' height, tiers of tool drawers, and a metal file-drawer cabinet.

The additional drawer units can be obtained very cheaply from 'whitewood' cabinet suppliers and the larger DIY shops. To fix them to your folio cabinet, drill through the sides of both and fix with a ¼ inch bolt, washer and hexagonal nut; at the top and bottom back and front. The whole thing can be painted, in one or two colours, and the worktop can be surfaced with Formica or similar plastic top in plain or wood-grain finish (I veneered mine in rosewood and teak, and fitted a mahogany fore-edge 6 mm × 6 cm to the top, projecting down to hold the front of the side-by-side cabinets firmly.

The only tools required are: screwdriver, small spanner, ¼ inch drill bit and drill; a small saw, sandpaper, etc. The plywood can be cut to size for you at your wood-yard. The folios stand in the cupboard as in figure 15e. The door, by opening forwards, allows folios to be opened and the contents sorted without taking the folios out.

If a folio has to be taken out, it should not be dealt with on the floor; but on a dining chair placed facing a table as in figure 16. The chair will not tip backwards; the heavier the folio, the more it holds down the chair.

A single folio should never contain a large weight of drawings. It is more convenient to divide them between two or more folios, which are then lighter and easier to handle. With my inexpensive method of making folios, you should be able to have as many folios as you like. (see page 80). Above all, at the end of the day, never leave drawings and water colours loose, outside the folio, unless still on the drawing board. The bohemian life is all very well; but remember that, although Picasso's studio was not a model of neatness, his drawings are always immaculate.

Figure 16 A chair used correctly as a folio stand.

There are certain minor items of equipment that should appear in each of the four work areas. A large studio, as in an art school, may have a clean dustbin for debris; but in a small studio this is neither aesthetic nor convenient; and I find a kitchen pedal bin with foot-pedal for lifting the lid is very useful. As some of the refuse is soiled by paint, bin liners should be used, to contain the wandering pigment from getting where it should not. Also a container for clean rag is very necessary. The dirty rag can go into the pedal bin. The supply of clean rag is in constant use; and no scrap of waste cloth should be discarded from the household, to avoid the continued use of a paint rag when it is thoroughly soiled and should be replaced.

A large box or bin full of rags can catch fire through spontaneous combustion, especially if some are soiled with turpentine, varnish, pigment and similar substances. For this reason, and also for appearance's sake, I use a large Ali Baba type of linen basket; which allows any fumes to escape, and also looks more agreeable than a rough and ready box, at least in the creative and production area of my practice (which is largely water colours and illustration with some oil painting). In the production, presentation and storage areas, rough boxes may well do. A small container with only a few rags is worse than useless; as nothing is more inconvenient than running out of clean rag in a messy palette cleaning process.

Figure 17 Various arrangements of units supporting worktop surfaces; with picture rack, typing/writing desk, folio cupboard and store-bought drawer units.

Chapter 6

Tools and materials

Some points about timber for use in the studio

Timbers are given trade names that are often very confusing; and they also have traditional names still in popular usage that are equally imprecise. Indeed, perhaps the only way to be exact, in the description or specification of a desired timber, is to use the Latin name of the species. Even then it is wise to add the country of origin, if this be known, as a timber of a given species can differ according to the country in which it has grown.

For instance, the layman might be forgiven for thinking, purely on a basis of common sense, that 'hardwoods' are hard and 'softwoods' are soft. As the reader may well be beginning to suspect, nothing could be further from the truth; the English language, with its charming and baffling inconsistency, does not allow it to be as simple as that. Some softwoods are quite hard to work with – and *vice versa*. The confusion arises because the terms are botanical, and do not refer to the timber's density or working qualities. For example, the frail and light balsa wood is a hardwood; whilst the very hard yew is a softwood – botanically speaking.

Hardwoods come from broad-leaved, deciduous trees which lose their leaves in winter; whilst softwoods are coniferous and are mainly evergreen. Hardwoods include many tropical woods; whilst softwoods tend to grow mainly in the cooler, temperate and sub-arctic zones.

Drawing boards are made almost entirely of the softer density of the botanical 'hardwoods' such as pearwood, whilst artists' palettes are made from dense hardwoods such as mahogany, as are oil-painters' paint boxes. Modelling tools and pottery tools are made of hardwood of

various types which is of hard density. Artists' quality paint brushes have hardwood handles; usually mahogany.

The softwoods, apart from their use for worktops and studio shelves, are too soft in density and too flexible for picture-frame mouldings of slender construction (as used for drawings and water colours) and the pale hardwoods are more suitable. However, for heavier picture-frame mouldings, softwoods such as the varieties of pinewood are often used.

For making up your own picture-frame mouldings from material from the timber merchant, pinewood and similar softwoods are suitable. For a box-type frame for a big painting you might consider timber-yard window-sill moulding, which is made in both softwood and hardwood, (but you have to rebate the back to take the canvas). For heavier picture frames which are to be finished by being painted, softwood is better than hardwood as the paint adheres better, especially on the arris or sharp edges where, in time, the paint may crack. The sharp arris of hardwood literally 'cuts' the paint. The risk can be reduced by blunting the arris with sandpaper before painting; though cracking might still take place.

Figure 18a Woodyard timber mouldings suitable for assembly as frame moulding.

The different skirtings and architraves obtainable can be combined in a variety of frame mouldings; and these are usually of softwood. For polished frames showing the wood grain, Douglas fir or red cedar are often obtainable in the timber merchants' ranges of mouldings; but longer notice of delivery may be required.

For more exotic or rarer woods, the timber yard which serves builders is not usually able to help; and you would have to find a timber merchant who serves the cabinet-making and furniture factories. It is worth enquiring at the building-timber merchant's yard, however, for agreeable wood like parana pine, which has a showy grain.

Figure 18b A typical assembly glued up as frame moulding.

For handsome studio worktops the ordinary Finnish birch 5-ply blockboard is quite good; or even more handsome is the blockboard veneered with sapele or teak; which costs more, of course, but is worth it when it has been finished well with about six coats of polyurethane varnish.

If you know how to stick veneer on, and live near to a furniture factory where they make large items such as wardrobes, you could ask them, as I have done, for some

Figure 18c Large and small frame moulding assemblies.

veneer short-ends and offcuts which are often quite large. Veneer pieces that are under about 1 metre long are not much use in a mechanised factory making large tables or wardrobes; and they are usually willing to give you some. I have veneered all the worktops in my own studio with teak and rosewood in this way.

Of course, wood panels have been used for centuries as painting supports by artists. Care should be taken in applying good grounds of well-made primer to wooden painting panels, as softwoods contain resins, and hardwoods sometimes contain oil, both of which can affect the durability of the painting.

Hardwoods are, on the whole, dearer than softwoods; though the costs overlap and cheap hardwood costs about the same as the dearer softwoods. Narrow timber is cheaper for the same cubic quantity of timber than wider stock; and this favours the picture framer. Short lengths are cheaper per metre than long stock; so that smallish frames – apart from using less wood anyway – get it at a cheaper rate. It does not always pay, therefore, to buy wood for picture-frame mouldings in long lengths, if you can get it shorter.

Apart from the confusion in describing 'softwoods' and 'hardwoods', the naming of individual timbers is also confusing. For example, 'British Columbian pine' is also called 'Douglas fir', although it is neither a pine nor a fir. Similarly, 'Scots fir' is not a fir and 'Western red cedar' is not a cedar. The term 'redwood' is applied equally to two different timbers, one being a pine and the other a sequoia.

I have occasionally heard do-it-yourself craftsmen and women say that something could be made in 'deal'; and from the context it was clear that they had the impression that 'deal' is a kind of wood. It is, in fact, the term used for apopular size in all kinds of softwood. It dates back to about 1400 AD or even earlier; and is from the Middle Low German word 'dele' meaning 'a plank'. It is restricted in practice to the size of about 23 cm × 7.5 cm; and is usually about two metres long. More often than not, it will be made of pine, of which one type tends to be called 'white deal' and another is 'red deal' or 'yellow deal'.

For framing, 'ramin', 'pine', and 'obece' are good, having fairly straight grains. Honduras mahogany can vary from straight grain to very wavy, and so can oak; so

that, when buying any of these it is necessary to 'read the grain'. Teak can be very oily; and most hardwoods resist paint and other finishes. The old Cuban mahogany is not much available now, being replaced by Honduras mahogany which is not so good for our purposes; though the alternative Brazilian variety is good.

For inexpensive and simple studio furniture, worktops and furniture sides and doors can be made on a frame out of plywood, or of blockboard or particle board such as chipboard; of which the most usual sheet size is 244 × 122 cm and the best thickness for our purposes is 12.5 mm. It must be remembered that cabinet-makers measure in millimetres whilst timber yard salesmen will give you a blank look if you ask for a sheet of chipboard '2440 × 1220 × 12.5 mm'; as they usually think in metres of length, and centimetres of thickness (except the older ones who still like to think in feet and inches, and will not mind a bit if your order is so expressed).

For worktops, blockwood or chipboard are very good, and should have the edge protected by a hardwood 'lipping' glued and pinned along it. This does not need to be mitred at the corners; but the front ends should lap over the side ends, for neatness. Blockboard is very strong, for a worktop where a vice and a bit of hammering may be part of the set-up. Chipboard is quite tough enough, however, for most studio tasks. There is also a board called 'flaxboard' but this is becoming obsolete, and, anyway, has a strange smell.

If hinges and other fittings are to be fixed to chipboard, it must either take the fixing screws into the lipping, or be bored to take a glued dowel, into which the screws can be fixed. Never screw anything into pure chipboard; though you can screw through chipboard into something else. As it has a resin base, chipboard takes the edge off working tools very quickly, so that they should be sharpened every time they are used for it (except saws, which are difficult to sharpen and should be used gently with chipboard). If you pay your timber yard they will cut it to stated dimensions for you. If you saw pieces yourself, the saw cut should be planed before attaching the lipping, to give a true bonding surface.

Lipping in various materials – wood, metal and plastic – is available. Some of these are for tongued-and-grooved or rebated fitting; but for this you need special

equipment to route the groove in your worktop. For studio use, a plane-surface, pinned and glued fixing is adequate. A strong batten held to press on the lipping during the setting of the adhesive is useful, tightened by two or three rope tourniquets if you do not have sash-cramps.

These materials are sometimes available veneered attractively. For instance, blockboard can be obtained veneered with West African mahogany, for furniture and worktops. Plywood is also available veneered with a range of hardwoods which are very decorative when polished; and can be bought in thicknesses up to 25 mm (1 inch) (length and breadth of plywood is usually given in feet and inches and the thickness in millimetres). It is graded according to the quality of the veneer; A and B which are high quality and C grade will have knots replaced with inlayed patches.

If you cannot obtain veneered chipboard or blockboard, and do not feel skilled enough to veneer it yourself, the best solution to the problem is to obtain the thinnest possible veneered plywood and glue it on to the surface with contact adhesive, using a wider lipping to cover the edges.

In finishing the surface of timber, especially flat surfaces, it should always be sanded with the grain, lightly. Never press hard with veneered surfaces otherwise you will rub through the veneer, which is only about 1 mm thick. If you do have this mishap, cut a diamond-shape piece of matching veneer, clean out the damaged portion to fit, and glue in the patch with thinly applied PVA adhesive, applying pressure until it has hardened.

To avoid the expense of fine-looking, veneered surface, whilst having the benefit of handsome furniture, an artist worth the name should be able to apply water stain to imitate almost any grain desired. It should be treated just like water colour, with the wood surface slightly sloping, as in putting on water-colour washes. The wood stain should be diluted very much from the dense solution that you will begin with; and the desired effect achieved by the use of several thin washes. After staining, the wood fibres will have opened up and will need sanding.

The final surface finish can be linseed oil (like oiling a cricket bat), teak oil, petroleum jelly (Vaseline) or wax polish made from beeswax and turpentine, nowadays with carnauba wax, and silicones. I always avoid silicones

as they make the surfaces too slippery, which is a handicap on a working surface. Otherwise for a really hard-wearing surface, polyurethane lacquer varnish in the single-pack form is applied with a brush. A sealing coat should be followed by at least three further coats for a fine surface (the old coach painters and tramway builders used to apply as many as sixteen coats of varnish).

Always use water stain, which is compatible with any type of varnish or lacquer. Otherwise test your stain on a spare bit of wood, and, when dry, try the desired varnish on it. If it is not compatible, it will refuse to dry and will remain sticky indefinitely, like old-fashioned fly-paper. Never leave the timber standing about in strong light during the making of the piece of furniture and the finishing, as most timbers fade quickly. This does not matter except that one piece will not match another; and, if you left anything standing on the timber in the interval, it will leave a dark 'shadow' that has to be sanded out.

Never store or stack lengths of timber or sheet material up against a wall. The wood will bend and refuse to come straight again without time-consuming effort with it flat on the floor under weights. Picture frame moulding, for this reason, must always be stored flat along a shelf or the floor. Planks of timber should be placed flat and weighted down as soon as you get them home; preferably in the place where it is to be installed so as to acclimatise to the different temperature and humidity. A plank left for a few days in a change of atmosphere will warp, bend or twist. It does not need much weight to keep it flat; a few books will do. Reject any wood that is of a coarse texture or is resinous, if you wish to give it a fine finish. If it has a strong smell, it is probably fairly new and you will have to store it for a few weeks to make sure that it is dried out; otherwise it may warp, or 'skeller' (twist) after a time. It should be laid flat on a firm base with something to hold it down flat; and left to accustom itself to the indoor temperature and humidity. Do not bring it indoors and leave it propped against a wall or lying loosely about, or it will surely warp. If it does, place it flat under weight, and give it time to straighten out again.

Most woods will glue well if you use the correct procedure; mixing good glue and clamping under light but firm (not too firm) pressure overnight. If using heat to hurry the setting of the new glues such as P.V.A., do not forget

Figure 19a Faults in timber: end shakes

Figure 19b Felling or compression shakes (A) and cup shakes (B).

Figure 19c An acceptable live knot in softwood.

Figure 19d A dead knot which will fall out.

that if you heat it too much or too long, it starts to go soft again. Some woods, such as teak, glue best when freshly worked or sanded. Some alkaline adhesives stain some types of wood which can spoil a picture frame or paintbox. Some tropical woods available with the increasing forestry and timber production in the rich forests of the developing countries, bring us less familiar timbers that have not yet been fully tested in working practice.

Other ways in which timbers have varying suitability for particular purposes are: the blunting of cutting tools (which only matters if it is severe); dimensional movement (important with flat or panel forms as it moves across the width); whether the grain is too wavy or interlocked (for all but the very skilled, the straighter the better); nailing qualities (satisfy yourself that the timber will take pins or nails without pre-boring of pilot holes; and, if it will not, drill these beforehand with the right size of drill to avoid either splitting or the twisting-in-two of brass or aluminium screws if these are being used). There is also *durability*, the only really perishable wood being any that includes sapwood; *dry-splitting* and other distortion which can be disastrous with, for example, a frame moulding or a canvas stretcher; 'staining' of adjacent material (which is of concern in framing drawings); *resin exudation*; and *wrong or poor texture*, which impedes the achieving of a fine finish if desired.

Also examine the wood before paying for it, to ensure that it has not been damaged in the timber yard or in transit; that it has no loose knots (especially with softwoods) and is not scarred, splintered or split, however slightly; as this can get in the way when cutting the wood for use. Refuse all damaged pieces; and also any that are already warped through bad storage.

Lengths usually start at about 1.8 metres. The smallest length that a timber merchant will sell you at this time is 0.9 metres; which he will cut off for you, as a rule. Prices vary, so that it is always worthwhile, if you have the time, to shop around. You will save money with straight wood if you are able to plane it yourself. Remember that if you are asked whether or not you want the wood planed by the timber merchant, he will *start* with the dimensions that you have ordered and what you ultimately get will be smoother, and also smaller in varying degrees. If, in his catalogue he offers timber 5 × 10 cm and you have it

planed, you will get it about 4.5 × 9 cm which may well be too small for what you want to do. You should add the proportion for planing when you order it, to avoid mistakes. If the wood as offered is not too rough, see that it is *lightly planed*, otherwise the yard is planing away wood you have paid for.

Metric equivalents – wood thickness

Metric	Imperial	
3 mm	⅛ inch	(3.2 mm in case of hard-
6 mm	¼ inch	board)
9 mm	⅜ inch	
16 mm	⅝ inch	
19 mm	¾ inch	(18 mm in sheet material)
22 mm	⅞ inch	
25 mm	1 inch	

Wood length

Metric	Imperial
7.6 cm	3 inches
15.2 cm	6 inches
30.5 cm	1 foot
61 cm	2 feet
91.5 cm	3 feet
1 metre	3 ft 3⅜ inches

Adhesives in the studio

There is a wide variety of trade names for adhesives; but they fall into a few principal types. For our purposes I regard these as falling into two different categories; adhesives for general and structural use; and adhesives for mounting and framing.

For uses varying from sticking documents together in files to gluing-up furniture, the following are the main types. *Casein glues* (made from cheese) are in powder form to be mixed with water, useful in resisting heat, and not needed in the studio. *Cellulose adhesives*, which dry quickly but are not very strong, are not particularly useful to the artist; nor are the *contact cements* such as Bostik and Evostik, except for fixing sheets of plywood on to worktops, or gluing plastic laminates on to timber backings.

Latex adhesives such as Copydex are useful with stationery and filing, and have the added value of being easily removed from paper, as the adhesive forms a thin, rubber film that is easily rubbed away. This sort of glue is also a useful stopping-out medium in making water colour drawings with textures and lined and spotted effects by protecting the paper with latex where required and removing it after the wash has been applied.

Polystyrene cement is useful for mending plastic ware; but has no particular function in a studio. The two most useful general adhesives in furniture making and woodwork are the *urea-formaldehyde* type, such as Cascamite; which come in powder form to be mixed with an equal volume of water; and PVA adhesives (poly-vinyl-acetate) which are sold as a white cream, used for adhesion undiluted. PVA is the more generally useful; as, unlike Cascamite, it does not set hard if left after use (never leave your brush in urea-formaldehyde or you will never get it out). The drying times of both are very similar; and both can be accelerated by heat. PVA has the added advantage that, if diluted with water, it can be used as a thin adhesive for paper and card; and also provides a very good and adaptable painting medium; either diluted like water colour or in thicker consistency like oil paint.

The *epoxies*, such as Araldite, are generally useful, as they will virtually stick anything very strongly, and come in useful for general small repairs. This type is too expensive to use on large areas gluing furniture and equipment; and is not suitable for use with paper.

There are other adhesives with special features, none of which are of particular use in the studio. The selection that I would recommend, therefore to the artist in the studio are: latex adhesive (e.g. Copydex) for use with papers and for stopping-out water colours; a large container full of PVA (Rowney and Winsor & Newton both sell it in a variety of sizes) which you can use for anything from doing your water colours to gluing-up your furniture and equipment; and, finally a tin of contact cement (e.g. Evostik Impact) and a twin-pack of epoxy (e.g. Araldite). For general purposes, these should cover all the studio requirements.

The correct adhesives for mounting fine drawings are quite different and call for other types of glue.

ADHESIVES FOR MOUNTING DRAWINGS

Some artists have difficulty in mounting their drawings, especially if they are water colours painted on good quality paper up to Imperial size; and are not sure which adhesive should be used for attaching the drawing to card backing before putting it into a mount (or mat). The question arises, also, as to whether the work should be pasted to a card backing before being mounted; or whether it should rely on its own stiffness to stay flat under the mount.

The short answer is that it should not be pasted down. It is assumed that some artists have difficulty because the work cockles after being detached from the drawing board; especially after being painted with water colour, even when it had been stretched first. There could be several reasons for the cockling.

Firstly, thin paper cockles more easily than thick, perhaps the heavier grade of an artist's chosen paper would be a better choice than the thin grade, and with the heavier grade of paper, the artist might not suffer this problem. Then again, the artist may have allowed the drawing to lie about in the studio after it has been detached from the drawing board, when bulges and bends can gradually appear due to the paper's tension relaxing after the stretching process. To avoid this, the work should always be placed in a folio, or in a mount and perhaps a frame, as soon as possible, to keep it flat. If it has cockled badly, it can be flattened by the gentle use of a moderately warm iron passed over the back of the work. This should flatten it in most cases; after which the work should be put under light pressure to cool, and then constrained in a folio.

If ironing is, for any reason, not desirable, then the work should be placed face downwards on a flat surface protected by blotting paper; and a wash of clean water wiped over the back with a clean sponge. A further piece of blotting paper should be laid on top, and then the drawing board should be laid on top of that, held down by some weight such as a few heavy books.

When a bevelled mount – or what professionals call a mat – is placed over the drawing with a similarly robust backing sheet behind it, the drawing should lie quite flat without trouble, when suitably hinged to the backing support. It is alright, perhaps, for an artist to paste down

his own work for framing; but in framing a master work, museums and restorers prefer it to be hinged, rather than stuck down, to facilitate cleaning and restoration.

If pasting down is unavoidable, it is better to use natural adhesives rather than the synthetic types; as the latter are marketed, as a rule, without lengthy testing and research to ascertain the nature of their long-term effects.

Office adhesives derived from latex are not suitable as you cannot get the work unstuck again without a risk of damaging the paper surface at the back or even tearing it. Synthetic wallpaper adhesives are good for their intended purpose; but surface streaks can later discolour. Clear household adhesives may show through the paper.

I have been informed by a materials technologist who specialises in plastic and allied new material that PVA (poly-vinyl-acetate) diluted with water to a thin creamy state and used thinly is a suitable adhesive for drawings. It is not attacked by mould and can be soaked off again if desired. I have not used it in this way myself, but readers might experiment with it. So far as I know its long-term effects in this use have not been tested; and there is no readily available information on any tendency to discolour or harden after a long time.

I have for years used flour paste, made to a smooth cream, with ten or fifteen drops of Formalin per cupful. I have never detected any ill effects. It will come apart again after damping, if desired. Even flour, today, contains many additives; but none likely, I would think, to harm a drawing. It should be cold pressed. Any heat would cook it. In use with timber, PVA can be heat cured; but it becomes rock hard, so that great care should be taken.

Formalin can be obtained from large chemists. It is a trade name for 40% solution of formaldehyde which, in the pure state, is actually a colourless gas; which is sold commercially as a water solution. It is a disinfectant and preservative, and is also used in paper making, textiles, plastics and some synthetic-fibre production. It tends to evaporate over a period of time and you lose it; but if a picture frame is properly sealed, the gas inside will still give some protection against mould spots.

Otherwise, old-fashioned plain starch is ideal. An adhesive that is approved by conservators is sodium carboxymethyl cellulose (CMC). The dilution depends on the size of the paper to be fixed. The drawing should be

fastened to its card backing by paper hinges made from acid-free paper. Thin Japanese paper is perfect for this; either in a T-shaped hinge, under the window mat, or a long hinge concealed by the edge of the drawing itself. No acid materials should be used either for the drawings, the mounting or the adhesives.

SCREWS AND NAILS IN THE STUDIO

Whilst the usual rusty, old biscuit tin filled with discarded screws and nails will not be good enough in a well-run studio, there is no need at all to embark on a purchase of many different types and sizes.

The supply of screws will range from those used in making studio furniture and shelving to the small ones sometimes used with picture frames for fixing detachable backboards, and the attaching of mirror plates (if these are used). Avoid screws for structural work such as furniture and shelf assembly that are made of brass, copper or aluminium, as they are easily damaged and are not robust enough. Mild steel screws should be used; with either the ordinary slotted heads or posidrive heads. They should be the flat-head countersunk type; and not raised-head or domed-head, for which there is very little use in the studio. A supply of the conical washers called 'screw-cups' should be obtained and used whenever they will improve the efficiency or the appearance of the job.

Whatever thicknesses of screws are kept in stock, the same size of twist-drill, screw-cup, screwdriver and so on will be requisite; so that it is best to limit yourself to very few sizes, to obviate the need for a comprehensive tool kit. For furniture, equipment and shelving, try steel, counter-sunk, flat-headed screws, in the 4, 6, 8 and 10 gauges (7/64ths, 5/32, 3/16 and 7/32 inches thick). Gauge 4 in ½ inch, gauge 6 in 1 inch and 1½ inch, gauge 8 in 1½ inch and gauge 10 in 2 inch (a few only) will be useful.

For tasks where the screw heads show prominently, such as the frame of a bulletin board, brass screws can be used, but a steel screw of the same size should be first driven in, with a pilot hole if necessary, to make it easier for the brass screw to go in without breaking. It should never be necessary to force it home. I keep my screws in screw-top jars, with a few drops of fine oil in each jar which soon leaves a thin film on every screw, keeping

them bright, making it easier to drive them in and get them out and preventing any rusting in use.

For furniture and equipment making, and the heavy framing of large oil paintings, 1-inch oval wire nails are useful. The oval head should always be along the grain to avoid wood splitting. For pinning backboards into smaller oil painting frames and the frames of drawings, a stock of panel pins is needed. Get the thinnest you can find in ½-inch and 1-inch lengths. Otherwise, round nails, cut nails, lost-head nails, clout nails and the rest are not really needed.

A studio tool kit

The first thing to do if you have some tools already is to inspect them and throw away all the damaged, rusty and blunt ones, as they will spoil the work and perhaps cause injury. At the same time be very careful not to throw away any old and well-kept tool, perhaps of a kind that is now obsolete or difficult to find. The best gimlet I ever had was one that belonged to my great-great grandfather; and it would go through wood faster and easier than any other I ever used. Those tools that remain should be cleaned and overhauled, and, if appropriate, well sharpened. If you have some old chisels with handles that have been chipped and knocked about, buy a new set of handles at the ironmonger's, which you can fit yourself. Clean up the chisels – on the grindstone if necessary (but do not overheat them or it will spoil them). Oil the moving parts of pincers, the swing brace (of the brace-and-bit) and the wheelbrace and the like. Remove light rust with emery paper from steel tools. After that, it remains to complete the tool kit, according to what you wish to do. The artist who intends to make studio furniture on the simple lines described in this book will need more tools than the artist who restricts their use to picture framing and the fitting-up of sculptures on wood bases and the like.

A good kit of tools for making the furniture, fixing shelves and so on, is a permanent asset and the cost can be offset in your Income Tax return, so that, if you pay tax at the current rate of about 30%, you get your tools at what is virtually cost price of around 70%.

A special carpenter's bench is not necessary for the type of work I describe. If the first thing you make is a fitment (with picture rack, drawers and folio cupboard incorporated), it can be strong enough to have a firm worktop which can take a small vice, and be used in making all the other things. When they have all been made, the worktop can be finished and surfaced nicely to cover up any scars and marks. The vice should be a medium-sized woodworking vice of the sort supplied by tool dealers to be screwed to the bench top. They are made to take two flat pieces of hardwood screwed between the jaws of the vice to protect wood being held. It should be fastened to the worktop by nuts and bolts, not by screws; and the worktop similarly bolted down to the carcase of the bench by nuts and bolts through wood blocks glued and screwed to the frame. The worktop is fastened down before the back of the cabinet is attached and the structure placed in position against a wall to which it should be screwed using Rawlplugs, to hold it firm when you are planing or chiselling. If you are not going to use the furniture for work quite so heavy as this, the frame can be lighter; but otherwise should be of stout construction and assembly.

The only saws you will need are a 22-inch taper-backed panel saw and a 12-inch tenon saw. A thin-bladed pad saw is useful for cutting hardboard and is less inclined to 'wander' than a panel saw (and if it does, it is easier to bring it back in line). A pin hammer is really the only one you need; for 'pinning and gluing' purposes. Do not use it for knocking pins into picture frames in fixing back-boards; for which you should use the side of a firmer chisel, as described on page 250. For getting panel pins out, you require a sharp pair of pincers. For driving in the heads of nails, a steel pin punch is very necessary, and will do for the sizes of nails I describe above. There are round section and square section punches; the square ones do not roll away. Never let your punch get rusty (by leaving it outside or letting water get on it in the studio) as the point (a flattened head) is hollow ground, to stay on the pin or nail head, and the tiny rim is easily spoiled, causing the punch to slip.

A small metal plane called a 'smooth plane', about 8 to 10 inches long is all that is really needed. It is quite equal to the tasks which I describe, and for 'shooting' the mitres

of frame moulding. The artist will rarely, if ever, need to plane long wood; for which a jack plane is better, being about 14 or 15 inches long. The plane blade should be taken out and sharpened every time the plane is used. If this is done regularly, it only needs two brief rubs on each side to keep it biting keenly; which is a matter of a few seconds. The same applies to chisels; which when not in use should have plastic caps on the cutting edges to protect them.

You will need *firmer chisels* and the heavy 1-inch size is invaluable. It is not only the best tool for driving panel pins into a frame, against the backboard, and for cleaning the corners of picture glass in a frame, with a piece of clean cloth wrapped round the cutting edge, but is actually very useful also for chiselling! I advise three sizes of firmer chisel; 1 inch, ½ inch and ¼ inch. If you intend to make your own canvas stretchers, you will also need a ⅛-inch firmer chisel for clearing the waste wood from the slot in the corner mitre at each end of each piece. Because the 1-inch firmer chisel is so useful, I have two; one is for driving in panel pins and cleaning picture glass, and the other is kept sharp for chiselling. For chisel and plane sharpening, use an oilstone. This is an oblong tablet of abrasive compound, about one inch thick, on which the blade is rubbed, with a little machine oil. The fine grade gives the sharpest cutting edge; and the coarser grades are not needed. You will buy it, no doubt in a cardboard box, and you should make a wooden box for it. In doing so, leave room at each end of the stone for a small block of hardwood to act as 'buffers' at the ends of the stone. Boxed in this way, the oilstone is easy to use, and it will not move about or scratch your worktop.

Two cabinet screwdrivers are advised; one about 12-inches long and a smaller one about 6-inches long for smaller screws. It is not necessary to buy pump-action screwdrivers, or a range of very small ones, as the need for them rarely, if ever, arises. For boring holes, in making furniture, a brace-and-bit and a wheelbrace should both be part of the tool kit. The brace-and-bit are useful for boring holes up to ¼ inch in the frame timbers of furniture, and for holding the countersink bit that makes the recess to take the screw-head. The wheelbrace is best for drilling the wall for Rawlplugs when fixing shelving and securing fitted furniture. Neither of these is

very expensive, considering the usefulness of them both. It is advisable to obtain the type of swing brace that has a ratchet to enable it to be used in tight corners. The wheelbrace should not be too small; as all drilling is hard and exact work, and it is easier to drill with a larger wheelbrace than with a small one, and thus makes for more accurate work. Conversely, do not get one that is too large, as this can be difficult in cramped corners.

A wide variety of very marvellous and fancy bits is available for use with the swing brace; but few are needed in the studio. They should all have a square-section shank to fit into the chuck of the brace. You can use round-sectioned twist drills in a swing brace, but they are inclined to slip round. The most usual type of bit is the 'Jennings pattern'; it is useful to have a ¼-inch one in your kit. For smaller holes, use the wheelbrace with twist drills of smaller calibre; I suggest buying a set at the tool merchant's; they are not expensive. As even the best cabinet makers have been known to break the thinner grades of drill, it is sensible to buy several of each grade below 3/32 inch.

As for gauges and levels, squares and scribers, there is also a variety of these, both traditional and modern. The selection I would advise for the artist's studio is: a *wooden-stock square* with a 12 inch blade; a *combination square* which is very useful as it has a sliding head with 90° and 45° faces, usually incorporating one – and sometimes two – little spirit levels. Also a *sliding bevel*, which is like a square, but has an adjustable metal blade that can be set at any angle. For anyone, such as an artist, who deals with mitres, this can be set at 45° and used for marking frame mouldings and timber for canvas stretchers. A *marking gauge*, of the time-honoured and traditional type is very necessary; if only for marking the timber for making canvas stretchers, to place the tenons and slots. A three- foot folding boxwood rule is often more handy than a flexible metal measuring tape; and more accurate; if only because it is more clearly marked and does not wobble about when you use it. Always use your own three-foot rule, because it will have some inaccuracies, as they all do, but you avoid the errors caused by the difference between one rule and another.

The last category of equipment for the tool kit is a selection of useful cramps and gripping tools. These are usually missing from the tool kit of most woodworking amateurs; and yet they are among the most useful aids to accurate and strong work. As with other tools, there is a variety of types available; few of which are needed by the artist. In making furniture by traditional methods and not by the labour-saving and knock-down methods which I describe, a sash-cramp or two come in very useful, when gluing up a piece of furniture. But, as most of the things I describe for furnishing and equipping the studio are dowelled together for easy assembly and removal, sash-cramps are not really needed.

I have made several references to cramps of various kinds, notably *G-cramps*. These are sometimes called 'G-clamps'; and both terms are in current use. A couple of medium-sized, or small G-cramps are a very useful adjunct to the studio tool kit; and serve to hold things steady and firm in many ways. A pair of little ones, made from strip steel, is also well worth having at hand. For instance, if you have stretched water-colour paper on to a drawing board which has, in consequence, bent, it is not so easy to paint the water colour. Four G-cramps will hold it flat on your drawing table without difficulty. Again, in cutting mats for mounting drawings, a small G-cramp can hold the far end of the straight edge. Anything that is being glued up in assembly can be held by G-cramps, either on their own, or to grip battens that hold the component pieces in firm pressure.

There are useful small ones, such as the Stanley H155, and the cramp set made by Futters (the Futters 747) in three sizes, and costing only a few pounds. The very small ones are *fretwork cramps*, such as the Draper 2138. Examine them for smoothness when purchasing, as otherwise they can damage surfaces; file them smooth if required.

One or two files are useful; and I advise an 8-inch flat file, of ½-inch width; a ¼-inch round file of the same length; and an 8-inch half-round rasp with fairly fine teeth. These will do most tasks called for in the type of work I describe.

Also valuable is a pair of fairly large, sharp scissors, and a smaller pair with symmetrical points in each case (not one sharp and one rounded).

You will need so-called glass-paper or sand-paper, and should keep a reasonably large quantity in stock. The standard sheet of about 28 × 21.5 cm (11 × 8½ inches) should be torn into six; by tearing it in half, and then dividing each half into three pieces. Each piece will wrap comfortably around a standard cork rubbing block, for sanding wood and paint. If a softly curved frame moulding has to be sanded, a cork rubber should be cut to fit the shape, using a small *bowsaw* or *fretsaw*, and made to fit exactly by placing abrasive paper on the frame moulding and using it to rub the cork block into accurate profile. Then lengths of that moulding, or a made-up frame, can be sanded using the special block. When frames are painted (as described on page 219) the undercoats should be sanded.

I describe on page 217 how to contrive an efficient, home-made system for cramping a frame during the setting of the glued-and-pinned mitres. However, I should perhaps mention that other systems can be bought at the tool dealer's. There is a *cramp-frame* available, with four right-angle jaws in polypropylene plastic, and 3.5 metres (12 feet) of terylene cord to go round them, secured by a cleat. The four angle pieces are placed – one at each corner of the assembled frame – and the cord placed round the whole and tightened. There is also a *clamp-web*, as described by the makers, with 3.5 metres of nylon webbing tape tensioned around the assembled frame and secured by a ratchet-action lock. They are no more efficient than the hand-made type that I describe, and the webbing tends to get clotted with surplus adhesive. With my version, the piece of string is simply thrown away and replaced by another. There will always be those occasions however, in making furniture and equipment, when the craftsman seems to need about five separate arms to hold things together; and this is where a few cramps come in useful. In addition, some tasks call for the contriving and assembly of some sort of 'jig' – or 'holding arrangement' – in order that the particular task may be assembled; and cramps are useful in this also.

The designs for studio furniture which I describe are specially contrived to dispense with the need for jigs and large cramps. However, any artist who is interested in the making of picture frames in the studio, to save the cost of professional framing, is involved in joints and

mitres; which call for some sort of cramp to hold the joint together during the setting of the adhesive. A variety of *mitre cramps* is available; and these are very useful in making picture frames for ensuring accurate corner mitres. However, with the minimum of skill, these are not really requisite; and a picture frame can have its mitres pinned-and-glued in the bench vice, with little difficulty. I explain how this can be done on page 213.

The home-made, disposable form of cramping device which I describe on page 217 is not only as efficient as the heavy, metal cramps that are available, but costs nothing to provide, is simpler to use and takes up almost no storage space.

The question of whether to invest in a range of power tools and accessories has to be decided by the artist. I can only point out that power tools are not needed unless a great quantity of work of a repetitive kind is being produced. A power tool is time-wasting. It has to be set up in its jig, or housing, and fitted with the right accessories, which have to be carefully adjusted for accuracy. So long as simple, traditional and home-made equivalents are available, the small quantities likely to be needed by an artist in his studio are better done by the hand methods I describe elsewhere in this book.

There is, however, a more serious reason why I do not advise the use of power tools in the studio and its ancillary tasks. This is that the use of power tools is something that demands both skill and experience; in the absence of which, the work suffers and very disagreeable accidents can happen. I have had a long experience of woodworking machines and their workshops; run by very skilled and experienced operators. Every one of these experts regarded his machines as highly dangerous and to be treated with the greatest caution and respect; like a lion tamer with his lions. The thought of an amateur messing about in his workshop would make them shudder at the possibilities. They should never be used unless someone is within call in the event of an accident. I advise the artist to dispense altogether with power tools: the power drills and their accessories, the circular saws and the rest. I have had personal experience of very bad accidents, even to skilled users; and I never use them in my own studio or workshop for this reason.

The tools described above are also, in some cases, useful in mounting and frame-making. A few additional tools are also required for those purposes, however; and these are described in the sections on these processes elsewhere in this book.

Unorthodox but useful studio equipment

In addition to the furnishings and equipment I have mentioned for the various areas of the studio, there are, of course, items of equipment that specialists – such as print-makers or sculptors – will have in the production and workshop areas; but their creative areas will be much the same as that which I describe.

Additionally, there are expensive items of equipment that can be purchased by artists who can afford them – such as a mitreing machine in the framing area or a mount-cutting machine, and the like. However, I am writing primarily for the younger artist or the older beginner who may not want to go in for that degree of elaboration at first. Such things can always be bought later; one hopes out of the profits from the work already produced.

At the same time, there are several items of very useful equipment, in addition to the orthodox things that are likely to be found in any painting studio – such as the easel, the painting trolley, the brushes, palette and so on. These include things that I have noted in the studios of artist friends, and which, at first may appear rather unexpected, but which, on reflection are really rather a good idea.

I remember Sir Gerald Kelly, PRA showing me the hand-held hair drier with which he used to speed up the drying of his work, to avoid long waits between painting sessions. It is not only useful, in a self-evident way, for speeding up the drying of ink drawings and water colours on those exasperating days when a lot of humidity blows in from mid-Atlantic after a storm at sea, making work dry very slowly; but Kelly at least, used his to hurry up the drying of the oil tempera that he used for his well-known portraits.

In his studio, after dinner one evening, he gleefully

demonstrated how he waved it about over the surface of a painting to dry it quickly; and did so with a painting on his easel which he told me was in egg tempera. 'Some people might say that I make an omelette of it!' he quipped. Paul Oppé, at that time the Keeper of Prints and Drawings at the British Museum, was with us; and I did not quite know what he thought of this ingenious idea by the current President of the Royal Academy. I thought hard about it; and whilst I not only have no objection to it with ink or wash drawings and water colours – indeed I use one myself – I wondered about the soundness of it for tempera painting. Yet, I can think of no valid objection to it on technical grounds. Of course, it will not do much to hurry up the drying of an oil painting; it will merely drive off the volatile spirits from the medium but will not affect the oxidisation of the drying oil to any significant extent. Oil paint will dry quicker with the judicious use of siccatives, as sold by Roberson and Winsor and Newton.

A waste-paper basket is always a good idea where paper work of any description is done; but in a studio, because of the need for perfect cleanliness, I always use a kitchen pedal bin, with a lid that opens by a foot pedal. Because old paint tubes and similarly messy debris goes into them, I always use bin sacks, which are easily disposed of and prevent the paint and other sticky things getting where they are not wanted.

I briefly mentioned a rag box, earlier; and should amplify this in passing to suggest that there should be two rag boxes; one for clean, unused rags, and the other for soiled paint rags. It depends how much rag you use; and if it is not a great quantity, the used rags can be thrown into the pedal bin. However, a word of warning is perhaps worthwhile here; to the effect that used paint rags are flammable, and can cause spontaneous combustion. If the pedal bin is emptied frequently, and does not contain much used paint rag anyway, there is little risk; but an artist who uses a great deal for any reason, and discards them in a large and rarely emptied dustbin may face a greater fire risk by spontaneous combustion, or a certain aggravation of a fire started by any other cause (see also page 91).

A piece of equipment that is not found in every studio, and which no one ever taught me to use at art school, is an adjustable mirror. It was in Paul Nash's studio that I

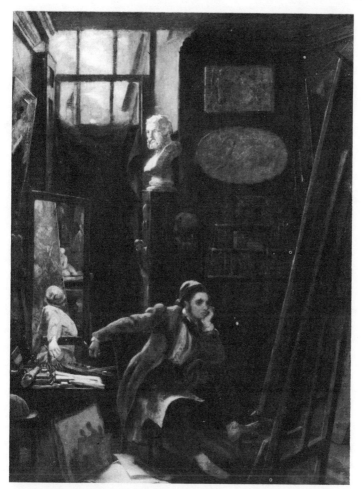

Plate 13. James Sant (1820–1916) *Self-portrait in the Studio,* oil, c. 1840. The single large window has been substantially blacked out by pinning up a dark sheet. The studio mirror for seeing the work in reverse during painting is behind the artist. The untidy scatter of folios, sketches and studio props is perhaps exaggerated to enhance the current myth of the artist as a careless romantic. *Reproduced by kind permission of the National Portrait Gallery.*

first saw a plain mirror, about 30½ × 20 cm (12 inches high and 8 inches wide) hinged at the side to the window frame; so that, when Nash wanted to see a painting the other way round, during the painting of it, he could swing the small mirror to the correct angle and inspect his painting in this way. It gave him a fresh view of the work

and often made evident things that had escaped notice as they were gradually built up into the composition; but which leapt to the eye through the mirror.

I have always used one since that time; and find that a composition that appears quite alright seems to look wrong in certain cases, when viewed through the mirror. A composition that appears quite well balanced the right way round can be seen through the mirror to be lop-sided; and a passage that seems to fit well into the picture can be seen through the mirror, perhaps, to be jumpy and obtrusive. A figure which, during the drawing or painting of it, has seemed well defined, can be seen to be, in fact, out of drawing; if viewed through the mirror.

It is not always necessary to have a special mirror hinged to the wall; a flat hand mirror will do just as well; but it is more difficult to contemplate the painting at length and hold the mirror still at the same time. Nash only had his mirror attached to the edge of the window frame as this was a convenient wooden feature to which it could be screwed. The best thing is to experiment and find the most useful placing in the creative area or the production area. The one at present in my studio is fixed flat on the wall and gives a good view of the work in progress.

In most studios used by architects and designers, there is almost certainly to be found a bulletin board; but this useful piece of equipment is, for some reason often overlooked by painters. Yet if you plan a picture with the care that is exercised by a great many artists, who make a series of preparatory sketches and studies before transferring the composition to water colour paper or canvas for the final version, a bulletin board provides a convenient place to pin up these studies for constant references during the progress of the painting.

I have my bulletin board placed on the wall behind my hinged drawing table. It is in front of me when I paint a water colour and can be seen beyond the easel, when I paint in oils. In my case, the only time that it is not readily visible is when I decide to paint on a larger canvas; I place the canvas on the wall shelf against the bulletin board. This is possible because I have left this wall space among the surrounding shelves; which occupy the wall above and on either side, with the table imme-

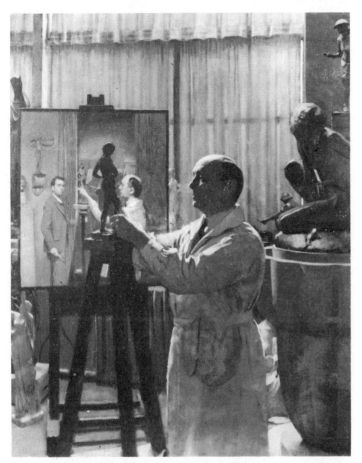

Plate 14. Sir William Reid Dick, Sculptor, in the Studio, an oil painting by Philippe Ledoux, exhibited in 1934. Note the exclusion of all side light, and the completely veiled window; with some light coming from above. The studio mirror is in the background with the reflection of both the painter Ledoux and the sculptor. *Reproduced by kind permission of the National Portrait Gallery.*

diately below. In this way, every bit of wall space is put to useful purpose.

In order to pin sketches and other things to the bulletin board, it needs to be made of a material that takes pins easily. Thin plywood or hardboard won't do and the best material for this is a type of fibre sheeting called 'sundela board'. It is tough but rather soft, with a velvety surface; and is sold by some timber merchants. You may have to telephone around to find one who stocks it; but it

is worth seeking. Like most other sheet materials sold by timber merchants, it comes in sheets 244 × 122 cm (8 × 4 feet).

In order to fix it to the wall, it can either be screwed to the surface, using Rawlplugs or plastic plugs, or you can use some picture-frame moulding, suitably thin; about 2 cm (¾ inch) will do. This should be mitred at the corners in the usual way, and screwed to the wall using very thin screws, of either brass or steel (you can even risk aluminium screws if you do not try to force too thick a screw into too thin a plug-hole). The screws should be 2.5 cm (1 inch), in a gauge of 6 or 8 calibre. The frame moulding should be drilled carefully and the holes countersunk; and the moulding should then be used as a template to mark the wall for drilling the plug-holes. Whatever size of sundela board you cut for the bulletin board can be used also as a template to ensure that the top and sides of the frame are square. Use a wheelbrace to drill through the plaster and into the brick (you can tell you are into the brick when the white dust begins to turn into red dust); and drill about ½ cm deeper than the length of the plug that you intend to use. As the sundela board is ½ cm thick, your 2.5 cm screw will only go 1.5 cm into the plug; so that your plug-hole should be drilled 2.5 cm deep.

The screw heads can be either 'countersunk' (which are flat-topped) or 'raised-head' (which have a shallow, dome-shaped top with a shallow countersink underneath the head). If you prefer to use 'round-head' screws (perhaps because you have an ample supply of them), then, as these are flat under the head, the frame holes should not be countersunk.

The small conical washers called 'screw cups', which fit into the countersink bevel of the frame holes, are advisable; though not strictly necessary. They make a neater job with a better appearance. If, of course, you screw the sundela board to the wall without a frame, then I advise 'round-head' screws, and flat washers wide enough to prevent the screw head going through the board. The screw holes around the frame or the board should be about 30.5 cm (12 inches) apart; with one at each corner and the others spaced equidistantly between.

Chart pins are better than drawing pins as they don't hurt your fingernails. They can be bought at any drawing-office supplies shop. They are also better for use on a

drawing board, than drawing pins, as you can paint a wash right round them without leaving a disc of white paper.

Among other unorthodox equipment, I would include a feather duster. No one should ever be allowed to dust a studio using a cloth duster crumpled in the hand. It catches around things and pulls ornament from decorated frames, and holds greasy dust, only to spread it where it is not wanted, as for example on the surface of a drawing board. A flick-over with a feather duster lifts the dust; and, if it is done every day, the dust is so light that it 'disappears'; mainly on to the floor, where it will do no harm until the vacuum cleaner or floor mop removes it.

A felt table cover is a useful asset. When the drawing table is not being used at a slope for drawing or water colour, it is used flat. At such times, drawings and photographs are spread out on it, and are difficult to pick up again from a polished or varnished table surface. Also, unless you keep several drawings or watercolours in progress at the same time – as I sometimes do – on which occasions these are stretched on hardboard sheets that can be placed upright on the wall shelf when not be worked on, then there is no reason to stretch or tape the paper to a drawing board for placing on the sloping table; it can be fixed to the table surface. For this to work well, the table top must be free from dents, scratches and other marks; and should be treated with the same care as a drawing board. Whenever the table is used with the top flat, therefore, the cover should be in place. The material need not be felt; an old blanket will do quite well.

A supply of bottle corks is useful, for slicing into canvas separators, or putting on to the sharp points of instruments and tools, not only to protect the points but also the artist's fingers. This means that another useful thing in the studio is a small hacksaw, for slicing the corks; also useful for cutting thick card.

Among the less obvious aids in the studio, a box of matches or a cigarette lighter is useful. This is not for lighting cigarettes, but for opening water-colour tubes that may have been left unused for a long time so that the caps have stuck. Instead of using pliers to open the screw caps (which can damage the cap) light a match and hold the tube in the flame so that only the cap becomes hot. The cap will then unscrew, on most occasions, without

difficulty. There is nothing more frustrating, in the middle of a water-colour session, to find that a tube of colour will not open. This also, of course, works well, as a rule, for oil paint tubes, by expanding the cap; but you have to take care not to warm the tube itself; as this is not good for the paint. If a plastic cap refuses to come off, then use pliers, taking care not to pull the tube itself in half. For this purpose, therefore, always have a small pair of bull-nosed pliers in the studio.

I mention elsewhere (page 229) how to make a useful weight for mounting drawings, from an old soup can and some nuts and bolts. In handling mounts, the marking out has to be erased, and it is a mistake to sweep the crumbs of the eraser away from the white card with the palm of the hand, as this can cause greasing and soiling. A clean, little hand brush or a small, feather duster should be kept near the mounting and mount cutting table for this purpose. Don't use it for any 'dirty' purposes, and wash it in soap and water from time to time. It should never be used, either, for dusting the studio shelves; and when not in use should be kept in a drawer out of the way of temptation.

Several clean sheets of strawboard as backing for cutting bevels in mounting drawings, should be kept. These can double as separators in stacks of framed works. Without a backing sheet, mount-cutting will ruin your worktop and your cutting knife. Also a few sheets of clean, thin plywood should be kept at hand, on which to stretch a supply of water-colour paper. These do not need to be thick plywood; and the bending caused by the stretched paper can easily be balanced by stretching another piece on the other side.

Some minor but valuable items of equipment in the studio are the various types of sticky tape. A roll of 1.75 cm (¾ inch) adhesive tape such as Sellotape is useful in sealing parcels in which rolled canvases or drawings are packed on the cardboard tube; and for tasks of this kind. This type of adhesive tape should not, however be regarded as suitable in connection with mounting and framing. For instance, it should not be used for hinging a drawing to card, in the mounting process, nor for hinging the mat to the backboard. It deteriorates after a few years, turns yellow, becomes brittle and loses its adhesion. It should never be used for 'taping' a drawing to card. The tape to

use for this purpose is the gummed, paper tape readily available. Even this, in dry conditions, will lose its adhesion after a time. The best method is to cut strips of thin, strong paper, and stick it with flour paste, which retains its qualities.

A large plastic set-square is often useful in doing drawings – especially illustrations that have to be accurately squared. A jar of assorted pencils is, of course, a self-evident provision; with a piece of sponge in the bottom of the jar and the pencils placed in the jar point downwards, to obviate injuries.

Scribing to an edge or a surface

Many busy artists who set aside space for their work make fitments, shelving and the like to suit their purposes, in which rectangular timber or other material is to be fitted as well as possible into spaces which are not square, and with edges and surfaces that are not truly flat. A studio worktop, for example, which has gaps round the edges from this cause is both unsightly and inefficient.

Then again, an artist making sculptural abstract constructions has the need, from time to time, to trim the edge of one piece of material to fit exactly into the irregular shape of an adjoining piece of material which is already fixed in place so that it cannot be used as a template for the new piece.

In such situations, scribing is used to ensure a perfect fit, however 'cater-cornered' or out-of-true the edges and however winding and irregular the apparently flat surfaces involved.

In old houses one expects to find few right angles; but in new, modern houses, also, there are few true right angles or truly flat surfaces.

All that is needed is a sharp pencil and a pair of compasses with a screw which can be tightened to maintain the required adjustment. The pencil point and the compass are set about 6 to 12 mm (one quarter to one half an inch) apart and the screw tightened to hold them firmly. The material to be cut is placed against the surface or edge to which it is to conform, and the point of the compasses is placed against the latter.

Figure 20 Scribing an edge to a wavy wall surface in a corner which is not a true square.

The compasses are slid along the surface or winding edge so that the pencil traces a corresponding track on the material to be trimmed.

It is a simple matter then to cut the new material to this winding line. The scribing can also be used in this way when a piece of material is to be fitted to go round an existing moulding which must be accommodated, or any other similar feature.

If the conditions are very much out-of-true, the compasses will need to be used with a wider setting. For perfect accuracy it is necessary to hold them so that the distance from pencil to compass point is at right angles to the scribed surface at all times.

Otherwise, this simple skill solves many awkward fitting problems.

Chapter 7

Drawing and painting equipment

Tools for drawing and painting

In addition to the T-square, set-square and other drafting aids mentioned elsewhere in this book, the tools actually used in the process of painting require care in their selection and use and conscientious maintenance for them to serve their purposes efficiently and for a long working life. This has no relevance to the painter's style, except that the paintings will be impeded and the artist distracted if the working tools are not in good condition.

The making of artists' brushes, for oil painting and water-colour drawing, is a very old and skilled occupation. Brushes have been made since the dawn of history; and there is little reason to assume that their manufacture is very different today from what it was in classical times or the Middle Ages. The main difference between the types of paint brush is in the type of hair that is employed. This varies from hog hair, for the heavier brushes, to soft animal hairs for the finer types. All brushes, including the finer types, require hair that is springy; and has a natural and persistent resilience that will endure through a long life. The best hair for fine quality brushes is red sable, which is obtained from the tails of the kolinsky or weasel. Some soft brushes are made from ox hair (from the animal's ears) and the hairs from the tails of squirrels. I find ox hair less springy than sable, and squirrel hair less springy than either.

The brush needs to be springy, as there is little control over the accuracy of drawing with the point of the brush if it is flopping about from side to side. Also, when a brush is lightly pressed on to the paint surface – as in laying a water-colour wash, or in almost any touch in oil painting – it is disconcerting, to say the least, if the brush

Figure 21 Types of brush in the studio. Top row (l. to r.) round, water-colour, sable-type brush; lettering brush; hog-bristle, filbert-shaped, oil-painting brush; flat, hog-bristle, oil-painting brush of short-haired 'brights'. Bottom row (l. to r.) long, flat, hog-bristle; round, hog-bristle; stencil brush; varnish brush. (All one-third actual size).

comes away from the paint surface with the hairs bent almost at a right angle, so that it has to be manipulated straight again before another touch can be made. It should spring straight again, of its own accord.

Not many artists buy kolinsky brushes today as they are very expensive. The animal is a member of the mink family; and increasingly, modern technology is producing substitutes for sable and other animal hair for brush making. Hog hair is not likely to become obsolete for a long time as there is no scarcity in pig's bristle; of which the silky and very white type comes from France and some comes from China. Brushes with synthetic hair are now produced, by firms such as Pro Arte, the 'Dalon' range by Daler, and Winsor and Newton's 'Sceptre' range, which mixes sable and synthetic. Some synthetic hair is made from 'prolene', a filament that reproduces the appearance and some of the special characteristics for which sable has become renowned. Nylon is also used for brushes, with a resemblance to white hog hair. In my own painting experience I have found these to come up to expectations with considerate use; and even under the usual modicum of rough usage.

In buying a brush, when the shape and size has been decided upon, to suit the artist's personal preference (there is no 'right' or 'best' shape for a paint brush) it should be brushed briskly to-and-fro across the hand (known in the decorating trade as 'flirting') to test for any hair loss, of the kind that is not unknown with a new brush. Before buying a quantity of the particular make of brush, buy a single example and take it into the studio for testing. This may appear fussy; but as a single brush can cost £10 or £20 today, it is worth while.

The brush should be brushed across wet paper and the wet hand, and again after washing in warm water, to test the firmness of the hairs in the ferrule. It should be closely inspected to see if it is well made in the three parts of the brush: the handle, the metal ferrule and the hairs or filaments.

The handle should be clean and well shaped, and of good hardwood such as walnut or mahogany, and well varnished to a high gloss. After immersion in water or spirit such as turpentine for a week, the varnish should be unaffected. The ferrules should be of bright metal and seamless, with heavy, smooth plating, and after suspen-

sion in water for two or three days should show no signs of rust. After prolonged soaking, the filaments should not indicate any loss of working characteristics or change of appearance. The varnish on the handle should not go cloudy or soft.

Test the brush in water colour and in oil paint; with attention to the brush's handling for fine work, straight edges, broad effects, control in cross-hatched and scumbled brushwork and so on. It should be tried out on thin and fat handling in oil. If satisfactory, then a stock should be bought in the preferred sizes and shapes. With synthetic brushes, the smaller sizes are about half the price of sable, and in the larger sizes reduce this ratio to about one-twentieth. At the present date of publication, for example, the price of a round, water-colour brush in 'prolene' of size 2 is 57p, and £1.55p in sable; the size 5 is 84p compared with £4.20p; the size 8 is only £1.49p compared with £12.65p; and the jumbo-sized 12 is only £2.12p as against £25.30p respectively.

Drawing pencils range from the hardest grade 9H to the softest 6B. The hardest that the artist needs is 2H for the faint limning-in of the first impression of a drawing. With this hardness, it is important not to press hard on the paper or grooves will appear, which will darken if water colour is applied. The grade H is better as it erases easier. Whichever is used at first, it is drawn over for emphasis here and there and for corrections; with HB or B which, being softer, give a bolder line; and can be sparingly touched up with 2B.

In pencil drawing, whether freehand or with T-square and ruler, it is better to draw in a light touch with a sharp, soft pencil such as a B than in a heavy touch with a harder pencil such as the HB, for the same density of line. If any drawing is done with a grade of 2B or softer, the drawing should be fixed with spray fixative, otherwise it will rub and lose its quality unless it be framed under glass immediately. It is not needful, in ruler-and-set-square drawing to use a grade harder than a lightly handled, sharp HB. It is important that the paper should be absolutely dry; as pencil behaves 'harder' if the paper is humid. Also, the softer the paper, the softer the pencil should be; and if it gives too emphatic a line, the touch should be gentler (or use harder paper). The rougher the paper, the harder the pencil can be for a given density, as

the roughness takes off more lead-graphite than a smooth surface.

The artist should aim to get the desired line density with an effortless, light touch, without pressure; so that the pencil point slips easily over the paper surface. Even the smallest amount of pressure, to a slight extent only, will affect the fluency and precision of your drawing. If the resultant drawing is too faint, use a rough paper, a softer pencil or both.

The rotary pencil-sharpener should only be used for the rough sharpening of the pencil, and the point should finally be fashioned by scribbling on a piece of scrap paper, preferably of the type on which the pencil drawing is to be done. It should not be necessary to stop drawing in order to sharpen and re-fashion the pencil point as this is disturbing. Have a jar of pencils all sharpened in readiness, and when one is blunted, lay it aside and take another. Although I, personally, do not like the painting of Chaim Soutine, I am impressed favourably by the report that, when painting in oil, a brush that had been used for a particular colour was not wiped clean and re-used for the next colour, but was thrown aside and a clean brush taken from a large jar containing sufficient supply to see him through the painting session, about forty of them, all immaculately clean.

In architectural and ruler-and-set-square drawing, the point should be gently rotated as the pencil passes along the straight-edge, to give a liveliness to the line and to the whole drawing; it also keeps the point sharp without incessant sharpening. A propelling pencil has a lead of 0.5 mm, and there is no need to sharpen it; but it is inclined to break frequently in drawing. The wooden-cased pencil appeared in the sixteenth century[2], and before that time the term related to a small brush. Conté pencils and crayons were first made by N. J. Conté in 1795, and formed the basis for modern pencils.

For marking timber in woodworking, the pencil is sharpened to a flat, chisel point; and a 'carpenter's pencil' is a flat, wooden shape. It is best sharpened on a bench with a firmer chisel. Other less well known drawing tools include the pin feathers from the woodcock. There is one on each wing joint; about 1 cm long. When fastened to a thin wood spill, or fixed into a fine quill, they are very

good for water colour and ink line work, and were formerly, highly prized by coach painters for painting lines on coaches. The wood spill itself is an efficient drawing tool, with water colour or ink, and can be sharpened to the desired thickness or thinness. With both the woodcock feather and the wood spill, the drawn line is of even width, whereas a paint brush varies its line in thickness unless used with great skill. To make a fine brush draw a line of even thickness in water colour or ink, it has to be held differently from the way it is used in painting. The correct way can be seen in Chinese and Japanese art depicting artists and calligraphers. The brush is held vertically with the fist clenched, and the brush held against the knuckles by the second finger. If the fist is placed on the paper, and the position of the brush adjusted so that the tip just touches the paper surface, a line can be drawn of perfectly consistent thickness without any wobbles. A quill will still make as good a pen as it did for several centuries before the invention of the steel nib in the early 1830s. It remained in common use until the 1890s; and at that time Conan Doyle in the Sherlock Holmes story *The Red-Headed League*, describes Jabez Wilson buying 'a penny bottle of ink and a quill pen'. In the portrait of Charles Dickens by W. P. Frith, RA, (Victoria and Albert Museum: Sheepshanks Collection) which was done when Dickens was 47 in 1859, the writer is seen sitting at his writing desk, with the synopsis of his current book on a small stand at his left side, and by his right hand – a quill pen.

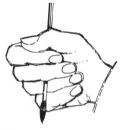

Figure 22 The right way to hold a brush for line drawing in ink or water colour.

To sharpen the quill, a curving cut is made, to leave a flat point, as seen in a steel nib; and the point is trimmed at the sides to the desired width. The end of the 'nib' is cut cleanly across about two degrees off the right-angle (or slightly more according to taste) to allow for the fact that the feather points over the writer's shoulder slightly off-centre. The underside of the tip is bevelled gently to a chisel edge; and lastly, is split in the centre for about ⅛ to ¼ of an inch. It wears out fairly soon and can be re-cut until there is not enough quill left. The two vanes of barbs (the feathery part) on either side of the shaft of the quill should be stripped off, starting at the tip of the feather, not at the quill end. The pen-knife should be sharpened on a whetstone before commencing. The varied and lively

Figure 23 The right way to cut a quill pen: (l. to r.) the raw quill: the point sliced off obliquely; the sides of the cut (side view); the sides hollowed (top); the point squared off obliquely at 20°, left-handed or right-handed (bottom).

quality of drawing possible with quill pens is seen in the drawings of Van Gogh.

Both pencils and brushes should be stocked in a very limited range of sizes and shapes but in plentiful quantity; rather than having one or two of each of a great number of varieties. Three sizes should be sufficient; small, medium and large; and an artist should in oil painting, use either square, round or filbert but never a mixture of these all over the picture. Square brushes, indeed, are mainly useful for getting straight-edges in painting houses, and fences and so on; and it is crude and mechanical to complete a picture entirely in square brushes (it is rather like playing a mechanical piano). In water colour, there is, of course, no need to put aside a brush after use on one colour; it can easily be rinsed in water; but this should always involve two bowls of water, for a first and a second rinse, to ensure that the brush is really clean. It also prevents the second bowl of water – the 'painting water' – from becoming cloudy and discoloured and taking clarity from the picture. The water-colour brush should be wiped on a sheet of blotting paper and stroked to a point, after rinsing, before painting proceeds. If any colour appears on the white blotting paper, repeat the rinsing. Naturally, for successive applications of the same tint, no rinsing is needed; but avoid, if possible, the error of thinking that it does not matter if closely related tints are successively being applied; such as Venetian red and Vermilion. It is all the more important not to allow them to pollute each other, or the painting will lack clarity.

There are many other tools for drawing and painting; but I have described those most likely to be used in monochrome drawing, water colour and oil painting. Among others, there is of course pastel – which is a subject in itself. Quite often, famous old masters have had their favourite idiosyncracy in method. Titian painted sometimes with his fingers,[3] and Goya painted the cupola of St. Antonio de la Florida in Madrid by dabbing and wiping it with a sponge.[4] Palma Giovane (1544–1628) also painted with his fingers,[5] and it is related that Titian used some brushes as large as brooms; and told the Spanish Ambassador that it was to avoid any possibility of appearing to imitate Michelangelo or Raphael.[6]

HOW PAINT TROLLEY AND PALETTE MANAGEMENT CAN WIDEN YOUR TECHNIQUE

Whistler used to mix quantities of his tinted and diluted mixture of pigment-and-medium, called his 'sauce', in varying tints ready for use. A modern artist who, as most of them seem to do, uses what I call the 'toothpaste method' of painting, in which pigment is squeezed from the tube, mixed with white or black straight from the tube to settle the tone, and then, perhaps, diluted haphazardly with medium, can widen this admittedly narrow and pedestrian technique by painting wet-in-wet on a thin underpainting, and adding 'fat' impasto as final touches in the lights, with fairly fat scumbles in the light half-tones. This gives a very much richer and brilliant effect to the painting; as seen in the pictures of Degas, Sargent, Whistler, and others, and earlier still in the work of Rubens, Rembrandt, Van Dyck, Frans Hals and many other old masters.

The first thing is to buy a number of small ceramic or glass pots; those in which sandwich spread and meat paste are sold make ideal paint pots. When the contents have been enjoyed in your sandwiches, clean the pots and mix your 'sauce' in these, in your chosen colour scheme for the work in hand. A description of the painting method is to be found in my book *The Academic Technique of Painting* (1963)[7]; the term *academic* meaning that it was taught in the art academies, though it is not taught anywhere today, and refers to the handling of the paint layers, not to the style of painting.

Do not squeeze any pigment from the tubes on to your palette for the underpainting stage or the wet-in-wet painting that follows it. The tints should be used in your small pots, almost like water colour. During painting, these containers can be left on the paint trolley overnight, with the trolley lid in place. The original tin lid of each pot should be retained and placed on overnight also. With the ceramic or glass pots I have recommended, screw lids are not used; which is useful as the push-on lids employed are easy to remove when screw lids would tend to stick. Left with their lids on under the trolley cover, the 'sauce' will remain fluid, like paint in a paint tin, for several days if necessary, between painting sessions, during which the picture will be drying sufficiently for work to

proceed. It is advisable to complete a passage of wet-in-wet painting in one session.

Pigment should not be set out on the palette and mixed with white or black and medium, until the stage of painting scumbles or impasto to the dry underpainting, by which time the pots of 'sauce' will no longer be required and can be cleaned and put away. Any 'sauce' left over should be put into a jar or tin and saved up for tinting the primer in the preparation of canvases.

If leaving the painting trolley overnight when doing scumbles and impasto, intending to continue work next day, there is no need to scrape all the unused paint from the palette surface, unless, for some reason, it has become very mixed up and sullied. There is no necessity to waste all that pigment. Make a close-fitting, flat lid or cover of 6-mm plywood, with sides of 2 cm depth to fit over the trolley top. This not only keeps off dust but delays the drying of the residual pigment. If a rag soaked in turpentine is placed under the lid, the vapour will fill the space and slow down drying still further; so that the paint is usable next day. Before doing this, wipe clean the mixing areas of the palette, just leaving the dabs of pigment ranged along the edge. Place lids on your pots of Whistlerian 'sauce' or any remaining glaze mixture (if you use ceramic sandwich spread or fish-paste containers, the original press-on lids will suffice for this). Any clear tints spread out on the palette surface can be scraped into heaps to keep moist. Clean and refill the dipper and retain it under the lid to add to the saturation of vapour.

If a jar of varnish or glaze medium is left overnight, cover it with a piece of brown paper held by an elastic band, to prevent evaporation (if you do not have an elastic band, simply place the paper on top, it will serve almost as well). A screw lid or a tight-fitting cover is not necessary and may well stick and be difficult to remove. A varnish brush need not be cleaned. Drill a small hole through the handle, and insert a piece of wire; then suspend it in the jar of varnish with the wire resting on the lip of the jar. Make a hole for the handle in the piece of brown paper and slip it over the top of the jar.

Any half-finished drawing or water colour left on the drawing board overnight taped to the surface, should be covered by a clean piece of cloth kept for the purpose. A sheet of tracing paper will do, if need be, or the piece of

man-made textile used as a table-cloth when the table is fixed level for sorting drawings and so on. During work it should be folded and placed in a drawer to keep clean; and should be washed about once a month or so; at other times being given a daily shake. A modern draughtsman's desk has a roller-blind dust-sheet; but it is not necessary to go to that expense.

If, in your production area, you use a cupboard-type of taboret, use it to store ready-use supplies of varnish and similar substances; and also have a drawer in it for rubber gloves and, if you use noxious volatile substances for any reason, a small nose mask.

Drawing board technique

Do not tilt your drawing board too steeply so that pens and pencils roll down it on to the floor. Some tilt is desirable, however, therefore, always use hexagonal pencils rather than round ones to minimise rolling. Stick a piece of corrugated cardboard at the side of the board, somewhere near the top, on which to place pencils and pens. To prevent plastic set-squares and similar things from sliding down the drawing board, put one or two dabs of latex adhesive such as Copydex, on the underside and allow to dry. These form small rubber 'brakes'.

Never work on the raw wood of the drawing board; but always cut a piece of white card to fit and pin it to the surface. If there is too much glare, use a piece of pale grey-green card. Never cut mounts or card with a knife on the surface of the drawing board. If there is nowhere else to do it, protect the drawing board with a piece of strawboard or hardboard. On the protecting card on the board, draw in with ink some horizontal and vertical lines for placing smaller pieces of drawing card – this is specially useful for illustrators. Do not fix the drawing card with pins; use masking tape, of which three small pieces – two at the top and one at the centre-bottom – are adequate.

In ruling lines with a ruler, place chart pins against which to hold the ruler steady; one at each end. When ruling with a T-square, stick a strip of card underneath the T-square, 0.5 cm from the drawing edge, to raise it 1 mm and prevent drawing ink leaking underneath from

the pen. Never mix different inks; they are not always compatible; particularly do not mix waterproof ink with non-waterproof, or different waterproof inks with each other. For diluting ink for monochrome wash drawing, use distilled water obtainable from the car supplies shop or the chemist. Tap water has chalky and other pollutants that can clog your drawing pen and affect the stability of the ink.

If the drawing is being done on thick card, stick a strip of the card along the edge of the drawing board to compensate for the thickness under the stock of your T-square. Stick it with Copydex, so that it will easily come off again.

During work on a sketch it is useful to mask it in order to visualise the finished effect. Cut two L-shaped pieces of card with arms about 20–40 cm long; which, superimposed, will mask off any rectangular shape within those dimensions. When photo-copying with a camera stand, cut similar pieces out of black card, to mask the edges of your picture and prevent any white margin from making your exposure meter give an inaccurate reading.

In black-and-white drawing, waterproof ink is rather thick for very thin lines. Use red ink, which is thinner; it will come out black in block-making. Border lines to assist in getting your drawing the right size, and any ancillary instructions or indications, should be drawn in blue ink, which will not register at all in block-making, as they do not use pan-chromatic camera plates.

Handling fluid materials has difficulties sometimes. Some rubber cement can stain white mount card or drawing paper. If acetone thinners and rag, will not remove it, spread rubber cement all over the surface and when it is dry, remove it with a pick-up (gum) rubber. Clean acrylic paint brushes with clean water, alcohol and soap and water: by first taking off the excess paint with rag, dipping the brush in alcohol, then rinsing it in white vinegar and finally rinsing with soap and water. In mixing any powder with water – such as Cascamite adhesive, or cornflour – stir it with a stiff brush such as a bristle paint brush, and use the brush to squash out any lumps. This works far better than stirring it with a spoon.

When using a compass on fine card or paper on which a wash is later to be applied, place a small piece of card beneath the compass point to avoid a pin-hole which will later show up.

If you are right-handed it will usually be best to draw horizontals from left to right and verticals from top to bottom; drawing right to left if left-handed. Always drag or 'draw' the pencil never push it. This keeps it sharp. When trailing the pencil point, twirl it, which not only sharpens it to a fine point but gives a more lively pencil line. When two ruled lines end at the same point – as in the corner of a rectangle – always very slightly cross them; and never, on any account, leave a tiny gap.

If, for any reason, two pieces of paper have been stuck together – such as a drawing pasted down on to a piece of card – and you wish to separate them, this is possible if the adhesive used was water soluble, such as flour paste. The work should be dampened, if this does not injure the drawing, by placing it between sheets of damp blotting paper. After the adhesive has softened, take hold of a corner of the part that is dispensable – in this instance the backing card – and bend it without creasing it, and pull gently. Where it does not come away completely the card will disintegrate, leaving a layer still adhering. If you had taken hold of the drawing and bent it before pulling, leaving the card flat, it would have been the drawing that disintegrated. The rule is that the piece pulled whilst being bent will give way. To make sure, bend it as far as it will go without creasing. The remaining pieces of card can then be damped afresh and rubbed off with the finger.

When water colour has hardened in the tube, warm the cap with a match or lighter and gently twist it off. If this is not possible, slit open the tube and prise out the pigment; placing it in an empty water colour pan (of the sort used for cake pigment) and putting it underwater to soften. When it has softened, place it in a cool place to dry out a little, and work it with a spatula into a smooth paste, before returning it to the pan. It can then be used in the paint box as if it had been a cake of water colour. If an old tube of oil paint hardens or in any other way deteriorates, throw it away as the oil in the pigment will have oxidised.

If a piece of drawing paper has been rolled and you wish to straighten it out again, do not roll it in the counter direction. I have often seen art students wrestling with large sheets of rolled paper to no effect. The way to do it is to place the curled paper on a flat, clean surface which has a fairly sharp edge but which is slightly rounded at

the arris where the two faces meet. Draw your paper downwards with a smooth action over the edge, whilst keeping the rest of it flat on the surface. After this has been done once or twice, it will be completely flat. Do not pause in the action, or you will get a crease mark across the paper; and do not use too sharp an edge over which to draw it, as this also can cause crease marks.

Beginners sometimes think that a water colour that has been pasted down with water-soluble adhesive (and no other should have been used) will run or smear if submerged to soak the adhesive. This is not so, so long as the wet surface is not touched, and it will emerge from the sink or bath none the worse. It should be dried flat and slowly under blotting paper and light pressure, to prevent cockling and distortion.

Drawing pins and chart pins

From time to time, I warn against equipment or procedures in the studio that are to be avoided on the grounds of safety. A seemingly trivial thing can cause a painful – if not dangerous – accident. One of the most common instances is the use of the common drawing pin; than which, one might think, there could be nothing more harmless. Yet, if an artist, working in the studio in rubber-soled shoes treads on a drawing pin that is resting point-upwards on the floor, the resultant painful lameness and possible inflammation can put a stop to high-quality work for several days.

Many years ago, I became tired of painful accidents in the studio, and adopted safer measures in several ways. One of these was to banish the old-fashioned drawing pin from the premises, thus preventing broken finger nails in normal use of the infernal device, and painful punctures of various parts of the anatomy. Similar mishaps can occur from the sharp points of compasses or dividers sticking up in a jar, or lying in wait at the back of a drawer. A sharply pointed pencil can be just as lethal, but, unlike the drawing pin cannot be dispensed with.

The large-headed chart pins, with their long and very sharp points and flat heads are particularly dangerous and painful. If one of these drops on to the floor, it can settle on to its large, flat head, point upwards, and can

pierce a thin-soled shoe, when trodden on. Long ago, I banished these also; and adopted the round-headed chart pins instead. These, when dropped, fall on to their sides, and cannot lie with the point upwards. If they are stored in a box or drawer, they lie down and do not stab the hasty finger. For good measure, and for speed and ease of access, when I am in the middle of a drawing session and do not want any hold-ups, I keep a ready-use supply stuck into an ordinary wine-bottle cork, in the shallow drawer of the metal file cabinet in which I keep small drawing equipment. Nothing could be safer.

I have never understood why artists continue to use drawing pins. If pressed fully home into the corner of a sheet of drawing paper, they restrict the working area. A chart pin, pushed partly home allows a water-colour wash to be taken right up to the shank of the pin. They can be bought at the shop of any dealer in drawing-office supplies.

Figure 24a Dangerous points in the studio: (top row, l. to r.): drawing pin; flat chart pin; round chart pin; (bottom row, l. to r.): tin tack; canvas pin; bone-handled drawing pin. The safest is top right.

Figure 24b Chart pins stored safely in a cork.

For fixing drawing paper on the working surface, masking tape is even better than round-headed chart pins. It holds the paper flatter during work, as small strips can be taken across the edge of the paper at regular intervals all round, if necessary; and if you did this with chart pins, they would get in the way of the T-square and catch in your sleeve. For papers which have a delicate surface that would be marked by masking tape, a margin must be left all round the working area of the paper. I find, in practice, however, that none of the usual drawing papers that I use are marked in any way. The secret is to peel off the masking tape when finished with, by bending it sharply back so that the point of detachment is bent and it is the masking tape that disintegrates. Similarly if you bent the drawing paper and peeled it from straight masking tape, the paper would disintegrate. The surface that remains level is not affected. Masking tape used in this way is a good substitute for pins in stretching water-colour paper, if, for any reason, you are in a hurry.

Figure 24c Pens and pointed instruments in a jar: the wrong way.

Pens and sharp pencils are often kept in jars, for ready access, and can stab the unwary hand reaching for one of them without really concentrating. I have stabbed my hand more often than I care to recall whilst drawing, and, now, I keep these things point downwards in their ready-use jars, with a piece of flat rubber sponge, plastic foam or polystyrene at the bottom to prevent breaking or

Figure 24d The right way.

dulling the points. An advantage of this method is that the grade-mark of each pencil – HB, B, BB and so on – is easily visible in the selection of the right pencil.

Whilst I am on the subject of sharp points, I am reminded that, sometimes, one needs to extract a stubborn chart pin – or more often a panel pin or thin nail driven half home – which has 'wandered' in framing a work or something of the kind. If the chart pin has been forced into material that is really too hard for it, or the panel pin or nail has gone out of true, withdrawal can of course be easily done with pliers – unless you have mislaid them. In the latter event, bend the pin or nail to 45 degrees, and turn it in the hole by pushing it round with the finger or a screwdriver. It should then lift out easily with the fingers. This works even with large nails.

NOTES

[1] Monro Wheeler, *Soutine*, (Museum of Modern Art, New York, 1950), pp. 79 and 81.
[2] Mentioned by Conrad Gesner of Zurich in 1565 as made of 'English antimony'; perhaps being graphite from the famous Borrowdale mine discovered at that time.
[3] P. & L. Murray, *A Dictionary of Artists*, (Penguin, 1959), p. 414.
[4] *Ibid.*, p. 177.
[5] Max Doerner, *The Materials of the Artist*, (Granada, 1969), p. 346.
[6] *Ibid.*, p. 345.
[7] Richard Seddon, *The Academic Technique of Painting*, (Artist Publishing Co., 1963).

Chapter 8

Canvases and supports

Textiles for canvases

The excellent canvases supplied by the established artists' materials firms are, alas, rather expensive for the beginner and the student; and it is well to be able to use some cheaper and easily available textiles. Some cloth that is quite good for painting purposes can be snapped up at bargain prices and used unstretched, or stretched on old stretchers that are ready to hand.

It is best to know something about the basic qualities of fabrics that are most useful for this end. The subject of textiles and their properties is, of course, a very big one; and all I can do is to outline some of the main characteristics of the different types of textile, as a framework of information within which the painter can exercise personal choice according to opportunity and circumstance; together with a word or two about the other materials that provide suitable painting supports.

Traditionally, the mediaeval artists painted on various kinds of animal skin, such as sheepskin, smoothed and prepared as parchment; and calfskin, prepared as vellum for very thin folios of the smaller mediaeval books, such as the 'book of hours' carried by every well-bred young lady. Timber planks were also dowelled together at the edges; and this method provided panels for painters in mediaeval and renaissance studios and up to the eighteenth century. About 1700, the sawing of thin panels became mechanically good enough to provide hardwood in thin panels for smaller paintings, all in one piece; often made of mahogany, or pearwood and similar materials that had less oil in them than mahogany. Today, industry provides plywood and hardboard, which are both excellent for painting upon; especially if the

plywood is marine plywood which is very damp-resistant.

Metal sheet was also used from the seventeenth and eighteenth centuries; notably sheet copper of the kind also used by etchers and engravers; but this use died out in the nineteenth century. Cardboard and strawboard have been used for painting supports; though they are rather fragile on their own. However, they are rotproof and mothproof (which cannot be said of most textiles); and, perhaps the best use of them is with textile glued to the surface. In the latter form they are sold by artist's colourmen as 'sketching board', suitably primed and prepared.

Among the textiles most commonly used for painting, perhaps the one most fully approved is linen flax, in the 1 – 1 weave; in which the plain weave takes the weft over-one-and-under-one of the warp, giving a smooth, grained surface of a fine or coarse texture depending on the thickness of the thread. There are other textiles which do quite well, however. The raw stem fibre of the flax plant is called a 'bast'. The word 'canvas', often referring to the cloth woven from linen thread, is from the hemp plant *'Cannabis satva'* (from which the drug called 'cannabis' is also extracted) and from it a useful bast is obtainable for making painting supports. Hemp was used in China and Japan 5000 years ago. It is grown to a height of six metres with the plants close together to force the growth of long stems, which are a centimetre thick with a pale-yellow fibre that is as strong as flax. Whilst the spun yarn can often resemble flax, hemp tends to be used for rope and string. Today, the word 'canvas' is used to refer to any heavy linen or cotton weave; of which linen is the stronger. For artists' painting canvas it is usually treated with a dressing or 'primer', in the same way that for maritime use it was dressed with paint, oil or red lead for ships' sails, or with tar for tarpaulin.

Other textiles used for artists' canvases include cotton; but this textile is only suitable for smaller canvases, and is not strong enough for large pictures. Old masters such as Tintoretto and Veronese used hemp weave for their big canvases; for which its great strength made it suitable. All these yarns have been used either in their natural colours or bleached.

There are many varieties of textile of which the artist may be able to obtain quantities quite cheaply; but they are not all suitable for painting supports; and some are not

recommended. These include: linen weave with irregular threads; and Gobelin linen which has a weft of heavy thread which gives the texture a lined effect; and also Irish linen which has a cotton weft. Cotton thread in a twill weave looks attractive, but is not really strong enough for any but the smaller canvas sizes, as with cotton in general. Similarly, 'calico' which is a light-weight cotton, and 'muslin' which is a thin cotton with a linen warp can only be used in the heaviest qualities, and then only for the smallest canvases. In the same way, 'cambric' which is available in old shirts and handker-chiefs, can be used in the heaviest grades; but only for very small paintings.

As an art student, I found the coarse linen weave with a slightly slubby yarn, which is called 'crash', served me very well and cheaply. It is obtainable in several different weights, and is quite strong enough for a canvas of up to ten or fifteen square feet in area. It tends to be dark coloured; but this does not matter; it can be given a good, white primer for oil painting to give a surface as light as could be wished. The slubby threaded texture does not interfere with any painting technique other than the most highly precise style. Another good substitute for the more expensive linen is sailcloth, if you have any obtain-able. Any artist who lives near a boatyard and boat-builder who rigs sails, should go along and make an offer for the off-cuts from the sailmaking. For a reasonable sum it should be possible to be set up in painting canvas for years, for at least the more modest sizes of picture.

Other textiles which are quite useful for painting supports are the ticking weaves of linen, in addition to the twill weaves of this thread; but the artist should take care to ensure that they are not merely half-linen; in which case they should be discarded. Twill is a 2 − 1 weave, which gives a variety of textures characterised by a diagonal, linear appearance, which some artists may find agreeable in oil painting. Such surface-weave tex-tures can be used to good advantage in the oil painting technique which lays on a thin underpainting or *impri-matura*, over which the artist floods pale or strongly coloured clear glazes of pigmented linseed oil, with the canvas laid flat, of course, on a table. The glaze will enhance the canvas texture, with a crystalline and spark-ling effect that is largely lost in modern painting, in

which many painters often apply the paint as a kind of paste, in a manner that is more like plastering than painting. The finely textured treasures of ancient linen from the Byzantine and other earlier civilisations, in such museums as the Victoria and Albert Museum, London, and the Metropolitan Museum, New York, are usually of twill weave.

The artists' canvases which can be obtained from the art-materials suppliers, are made for the purpose, and comprise special weaves; such as 'Roman linen' in different grades with multiple warp and weft. They are also supplied in heavy linen with double threads in one direction and single in the other. Cheap canvas from the art suppliers is often filled with dressing such as starch paste, clay or other mineral filler, so as to appear heavier. Another pitfall of cheap textiles is that inexpensive linen bought from the draper, may have knots. These can be smoothed out with fish oil or other means by the suppliers, and tend to go dark when wet, as they may become in tempera painting.

One source for a variety of suitable fabrics for use, suitably primed, as painting supports, is the upholstery-materials supplier. A good example is A & C Fabrics of High Wycombe, in which town is centred the traditional furniture-making industry of the Cotswolds, where, among other famous furniture, the so-called 'Windsor' chair was first designed and made.[1] In the catalogue of such a firm will be such textiles as buckram (hessian), calico, cambric, hessian, brown drill and the like, by the piece or in the roll at various widths.

There remain the new man-made fibres; which usually have the initial advantage of costing less than their natural equivalents. The variety is confusing, also they have not been subjected to proving trials for their suitability as artists' painting supports; which does not seem, as yet, to have occurred to the manufacturers as a worthwhile market. Also, there is little published material as to their natures and identities. Even their descriptions and the trade terminology are not standardised; and thus, 'denim', for example, which is a cotton textile originating in France (toile de Nîmes), is now applied to textiles which are not cotton and are not French. To many modern man-made textiles, synthetic resins have been added and applied for various purposes – such as ease of

washing and cleaning, or to make them shrinkproof or creaseproof. These textiles may, one day, prove to be very useful to the artist; and, indeed, the synthetic resins may replace the sizing and under-primer normally applied to traditional canvases. However, there is no substitute for trial under working conditions, augmented by sufficient years of observation of the result; and in this connection, only time will tell. I cannot, therefore, make firm recommendations about such textiles.

What I do suggest is that, as the artists' market may never be regarded as important enough for the makers of synthetic textiles to undertake the requisite tests, artists will have to do this for themselves. For this reason, an artist who is able to obtain a supply of likely textile fabric, and who wishes to try it as a painting support, will be well advised to experiment with it at least for preparatory painted studies and personal paintings that are not sold to clients for high prices. Yet, this will serve little purpose if the artist is not sure of the identity of the textile in the first place.

In this connection, therefore, it will perhaps be of value if I say something about how the different man-made textiles can be identified.

Types of textiles

In the modern world, the greatest division between types of textiles is that between the natural fibres and those that are man-made. The natural textile fibres are either vegetable fibres made from cellulose, or animal fibres made from protein. The vegetable fibres such as those of cotton or linen are the skeleton of the plant, compounded from carbon, oxygen and hydrogen, and the animal fibres make the protein from carbon, oxygen, hydrogen, nitrogen and sometimes sulphur. Most of them are only a tiny fraction of a millimetre thick; and their lengths vary from about one cm in cotton, two to five cm in linen to seven to 15 cm in wool. Perhaps the longest natural fibre is that of the silkworm which can be several metres long.

The fibre, whichever it may be, should cling to others of its kind; and they do this sometimes because they are crinkly, and sometimes because they have a scaley sur-

face like that of wool. When they are twisted together they form a strong thread which can be woven.

Man-made fibres, which are mostly made by forcing liquid through the small holes of spinnerets, rather as a spider does, can be almost any length; and in the last 75 years of research, many types have been discovered. All fibres have to be uniform, flexible, strong and hard-wearing, not only in the final use, but to withstand the rigours of weaving and processing in manufacture. The warp of cloth takes quite a lot of wear and tear when being woven even in a hand-loom. Many kinds of cloth are suitable for clothes and furnishing fabrics, but not all are equally good as painting supports. Thus, whilst linen and strong cotton, hemp and silk have been used by painters for centuries, wool is not really suitable.

One requirement of painting support fabrics is that they should not unduly absorb water or humidity; as this expands them and causes stretched and framed canvases to sag and bulge in humid weather. Another is that the textile should be strong enough to withstand being stretched on a canvas stretcher without splitting, particularly at the edges where the canvas folds over the sharp angle (the 'arris') of the stretcher (which should, in any case be rounded to guard against this). Some textiles are less strong when they are very dry, but others, such as cotton are stronger when wet. It is not so important to keep stretched canvases in a dry atmosphere, therefore, as to keep them in stable conditions, without fluctuations of humidity, so that, once the tension of the stretched canvas has been established, it remains in that state without expanding or shrinking.

It is also useful if the fibre is immune to attack by moth and the bacteria and fungi that cause it to rot.

Whilst the characteristics of the well-known natural fibres are familiar to most people, those of man-made fibres are not so widely understood. They by no means possess all the advantages whilst avoiding all the faults. For example, the early types of rayon fabrics are liable to attack by moths and bacteria, though they stand up well to heat of the kind a painted canvas might experience in being re-lined by the hot-iron method. Conversely, whilst the newer synthetic fibres resist moth and bacteria, they are more susceptible to heat. Again, whilst rayon fibres absorb water, the newer synthetic fibres are water-resis-

tant, which does not matter when they are used as painting supports, but makes the dyeing of them more complex in other uses. Rayon loses a lot of its strength when it is damp, and if it is wet enough to take in its own weight of water (which should not happen in painting, but can occur during the initial sizing of it before applying the primer) it becomes only two-thirds as strong, and should therefore only be stretched slackly if at all at this stage in its preparation.

Perhaps the most likely fibre to be of value for painting supports in the future is some type of nylon. As the earliest of the modern synthetic fibres, it is about twice as strong as cotton, and remains very strong when it is wet. Also it will not absorb very much water. Artists thinking of trying a man-made fibre textile for making canvases for painting should take care to ensure several things before acquiring a 'bargain' roll of it. A piece of it should be pulled to assess how elastic it is; and should be discarded if it stretches. This can occur especially in those man-made fibres which have been manufactured by 'false twisting' to produce an elastic yarn. It should also be checked that, however thin, strong and smooth it is, the textile is not knitted; as the stretching of a canvas on to a picture stretcher depends on there being a straight warp and weft.

A third precaution is to assess whether or not it has been impregnated or otherwise treated with a resin to increase its stiffness, crease-resistance or waterproof properties; as this could cause difficulties. For one thing, it will tear more easily in stretching. Whichever textile is tried, whether natural or man-made, the artist may be attracted to it, among other qualities, if it has a high degree of whiteness. This really does not matter for painting, as, in any case, the canvas will be given a coat or two of primer, which can be as white as you like. Also, the textile may look very white because it has been heavily bleached; but this can impair its strength. Some very white fabrics one sees have been treated by fluorescent washing. This is not likely if they are new, but a batch of nice white linen at an auction room might not be new; and should be well washed before use, however nice and clean it appears; unless, of course, the artist wants to experiment with fluorescent foundation for the painting.

Some modern textiles are made from mixing wool and nylon together; to give the wool the higher strength of the nylon. The artist who has the chance to pick up some of this cheaply can only try it in the studio and see how it fares. One last difficulty is that, by the sophisticated modern technology, the manufacturer of textiles can treat cloth with chemicals that change its properties; and in a fairly recent development, can impregnate the textile with monomers that are then bombarded with high-powered nuclear radiation which changes the molecular structure of the material and gives it different properties than before; so that for example nylon will lose its water-repellent character and soak it up.

It is not likely that anyone will undertake this experimentation unless the artist does it in the studio; and, indeed, it is not likely that any other type of research would really do it so well or with the same understanding of the requirements of textiles for painters.

Man-made fibres first appeared in the late nineteenth century, being developed from cellulose in the form of wood pulp and cotton linters; and they included viscose, rayon and cellulose varieties. The polyamides, polyesters, acrylics, polypropylene and elastanes were produced from liquids and gases in petroleum and coal; first appearing in 1939. There are others developed from mineral sources for special purposes, such as asbestos fibre, glass fibre and aluminium fibres and fabrics; which are of doubtful interest as painting supports.

Acrylics, though used as paint medium in the liquid state, are not often suitable in character as textiles for studio use. Under the names of Orlon, Acrilan, Courtelle and Dralon and others, they serve in textile form as a substitute for wool, being soft and warm to the touch in the form in which they are marketed; and are used for sweaters, woven flannel, blankets, carpets and the like. They were first on the market in 1950, made from at least 85 per cent of acrylonitrile, a liquid produced in oil refining and coal carbonisation.

The polyesters first appeared in the USA in 1953; and can be treated to produce textiles ranging from fleecy, woolly wadding to fabrics resembling fine wool or cotton, with the same characteristics; and are often sold blended with cotton for bed linen; having the fineness of cotton with the strength of man-made textiles.

These synthetic textiles, if used for painting supports and requiring a join in the making of a large painting canvas, should always be sewn with synthetic sewing or machining thread; and natural fibre textiles should be sewn with natural thread of the same kind.

Nylon fabric, in the polyamides group, was developed in America and Britain (as Antron, Bri-Nylon, Cantrece, Cellon, Enkalon etc), and is used for products ranging from hosiery and underwear to upholstery and carpet materials. The polyamides are, as a group, long-filament textiles, and their properties depend on the weave and the weight. Generally, the fabric does not shrink and does not absorb moisture. It tends to yellow. The fabrics are, I would think, of rather too silky a character for use as painting support, which may lower the adhesion of primers and grounds. But this remains to be tested.

The polyurethane textile fabrics also tend to have a silky character; and are strong, light and very elastic, which may cause difficulty in canvas stretching. They are marketed as Lycra, Spanselle etc., and are found in support and foundation garments and swimwear. The polypropylene fabrics, available as Courlene, Typor, Ulstron, Meraklon and so on, are a recently developed group of which the potential has not yet fully been explored. They are produced by a process in which petroleum gas is chemically converted into small pellets which are then melted and spun into light, strong fibres which are fairly inexpensive. This group comprises fabrics which are totally water resistant; being made into socks and sweaters, blankets, carpets and artificial lawns, among other things.

On the whole, it is well worth the effort, if a quantity of man-made fabric becomes cheaply available to an artist, to obtain a sample and test it by priming and executing a painting on it. Whilst only time will reveal whether in the long term, it maintains its suitability, it can, meanwhile, be used for preliminary studies. I would think that these synthetic fabrics have considerable potential in picture restoration, for the re-lining of damaged paintings; and, doubtless, trials are now in progress in the conservation and restoration studios of the large art museums.

For the artist who may wish to put questions related to the possible studio use of man-made fibres to the research

departments of the manufacturers, the table on page 276 lists some of the main categories, with the names of the producers and the trade names of the fabrics.

How to identify natural and man-made textile fibres for possible use as painting supports

Because of the highly flammable nature of some of the available textiles, any tests for identification should be carried out in controlled conditions. The main types of man-made fibres are; polyester, acrylic, triacetate, polyamides and diacetate. The test method is as follows. A small bunch of the textile fibres should be teased out of the fabric, or a small piece of fabric can be used. A flame should be carefully applied to ignite it, and the flame carefully inspected, especially at the tip. Secondly, the flame should be carefully extinguished and the surrounding area where it was should be smelled. Lastly, the burnt residue of the fibres should be inspected.

According to the findings, the fibres can be recognised under four headings. If the textile burns readily, with a strong smell of burning paper, and leaves a black, crushable residue, it is Group one; one of the cellulose fibres, such as cotton, flax or jute; or it can be regenerated cellulose rayon (e.g. Evlan or Sarille). Group two burns with a spluttering flame, with a strong smell of burning hair or feathers, and leaves a soft, black residue; which indicates one of the animal fibres, such as wool or silk. Group three does not burn easily, and does so with a strong smell of burning celery (if you do not know what burning celery smells like, you will have to obtain some celery and set fire to it); and this fibre leaves a hard, fawn-coloured bead of residue; which places the specimen among the polyamides; such as Nylon or Perlon. Finally, Group four burns easily, with a flame that shows a pronounced, smoky cap like a candle flame or a badly trimmed oil wick, with a strong but indescribable smell that is difficult to compare with anything that it might recall, and leaving a black, hard residue. The conclusion in this test is that the sample is acrylic (e.g. Orlon, Courtelle, Acrilon, etc).

For a further test, a small piece of the fibre or the

woven fabric should be placed in a glass container and covered with acetone (nail varnish remover). If the sample dissolves completely in one minute or less, it is a diacetate fibre (e.g. Dicel). If it only partly dissolves, leaving a gelatinous mass in one minute or less, it is triacetate (e.g. Tricel).

The above two tests are devised to give the observer clues from his or her own responses and reactions. A further group can be recognised by achieving negative reactions in the tests; so that a fibre that fails to be identified by burning or dissolving in acetone is probably a member of the group called polyesters (e.g. Terylene, Dacron, Trevirs, etc).

Panels

Panels are not used today – at least in the form in which they appeared in mediaeval, renaissance and later art up to the mid-nineteenth century, when panels went out of favour. An artist who, today, used a piece of primed hardboard, as a perfectly good support for a painting, would not, perhaps, think of it as a panel painting, although that is what it is. The old masters made up their panels from planks dowelled edge to edge; and some, such as Rubens for instance, would add a plank or two during a painting's progress, to accommodate changes in the composition. His *Watering Place* (National Gallery, London) had evidently been enlarged in this way at least twice and perhaps three times.

Italian renaissance panel paintings are usually on poplar, such as *The Vision of St Jerome* by Parmigianino (1503–40) and *Portrait of the Doge Leonardo Loredan* by Giovanni Bellini (c.1489–1516) which are in the National Gallery, London. Also in that Gallery, *St Jerome in his Study* by Antonello da Messina (fl.1456–1479) is on lime wood. In northern Europe, the artists used the plentiful oak tree; and in the same Gallery, oak was used for the panels of *The Donne Triptych* by Hans Memlinc (fl.1465–1494), by the master of the St Bartholomew Altarpiece, *St Peter and St Dorothy* (late 15th century); also in *The Ambassadors* by Hans Holbein (1497/8–1543), *The Adoration of the Kings* by Pieter Bruegel the Elder (fl.1551–1569)

and *Woman Bathing in a Stream* by Rembrandt (1606–1669).

Indeed Rembrandt and Rubens among others appear to have used either panel or canvas on different occasions in their work. An interesting example, there, of a painting on a copper sheet is *Angels Weeping Over the Dead Christ* by Guercino (1591–1666). Teak and mahogany were always too oily to be much used as panels for painting, although mahogany was I believe sometimes used after about 1740. Before that date it was neither used nor heard of. Vasari stated: 'In Venice, they do not paint on panels, or if they do occasionally, they use only fir wood imported from Germany or Slavonia. Canvas is the preferred material'.[2] They rarely used maple or poplar wood. There was not much timber available around Venice, and also they found that canvas did not warp and split in the damp, like wood. All the same, for his paintings in the Hall of the Grand Council, Gentile Bellini had to obtain special permission to paint on canvas, instead of doing the work in fresco.[3]

The priming of canvas

Strictly speaking, the *primer* (often wrongly called the priming) is the first coat of the basic preparation of an unprepared material intended for use as support for a painting in oil, tempera or a blend of the two. The material, as described previously, can be textile, wooden panel, hardboard, or a variety of other materials. It provides a durable filler of any absorbency in the support, and protects the support and the paint medium from each other. Some supports, such as certain types of wood, contain elements that can stain or discolour the paint; and some paint media can produce acids which attack textile supports.

The primer should be brushed well into the surface of the support, rather than being laid on the top with a roller or a spray. With a textile support, you should be able to see it seeping through the weave very slightly at the back. In priming their commercially prepared canvases, Messrs Winsor and Newton apply two coats of glue size and two of primer; and there is no reason that this practice is not widespread with good quality canvases.

A second purpose for the primer is to provide a tinted or textured base for the subsequent painting, if the artists should wish for this. Some old masters, and some contemporary artists, have painted on a thickly applied ground with pronounced brush marks, over which thin glazes of paint could be laid with attractive and expressive effect. On the other hand, a thin mix for the primer, leaves the texture of the painting support rougher through the preservation of its own grain, and cannot be rendered very smooth as can a thicker mix after two or three applications which have been lightly rubbed down after each coat if desired. With either type of mix, the surplus of each application should be scraped off with a piece of wood or plastic.

There are hundreds of recipes for primers; with some weird ingredients; and there is some drawback or objection to every one of them for one reason or another. There is, in short, no perfect primer. Normally it comprises size, filler and pigment; and the simpler recipes are the best. After sizing the support with whichever type of size is preferred, mix equal measures of the chosen filler and pigment and add some of the same size solution to achieve a thin or thicker cream, according to preference and mix well.

The stretched canvas, if that is the support to be used, should not be too tight on the stretcher, as it is almost certain to shrink to some extent, and could split if it is a thin fabric. Sometimes it expands again on drying. It should be allowed to dry quite slowly, and then tensioned on the stretcher very carefully in the approved manner, without getting it too tight.

THE CHOICE OF PRIMER INGREDIENTS

Painters who use oil paint, and those using tempera, have different requirements in their primers; but they share the problem as to the choice of materials for painting grounds. The initial sizing calls for some kind of glue, some of which is also mixed with a powder filler and some pigment, to make the primer. The glue that is used should not be too acid nor too alkaline; and should be tested the first time it is used, with litmus paper. If need be, a little acid or soda solution should be added to correct any lack of neutrality. Cold glues, such as casein (which is a

substance found in milk, of which cheese is made as a modified version) or vegetable glues, should be avoided. Bone glue should also be ignored for this purpose as it has a tendency to be too acid. Gelatine may be used; but tends to be rather brittle when dry, and is only suitable for small paintings.

Glues made from leather and skins are the best —notably parchment glue. The artists' colourmen Messrs Roberson sell a parchment size in packs and in bottles; and also parchment cuttings in packs for making your own size. Messrs Rowney offer a rabbit-skin size by the bag, and also a gesso powder in a tin, for use with it on boards.

Glue size should always smell fresh; and any trace of mustiness or sourness should cause it to be discarded and a fresh batch made. It should not be stored for too long without being heated, stirring it well at the same time; and, in any case, should not be made and then kept for more than a week or so. When it is applied, it should not be too hot or its adhesion is impaired.

For the powder filler, various substances may be used; chalk, whiting, pumice, marble or white talc (powdered steatite or soapstone (magnesium silicate)). None of these has any really good covering power; and of the types of talc, perhaps French chalk is the best. Any filler that is of a greyish tint should be avoided.

Gypsum (hydrated calcium sulphate) is quite good. It is a common mineral named from a Greek word used by Theophrastus to denote not only the mineral itself but also early types of plaster, which result from its calcination. Alabaster is a granular type of gypsum. If gypsum is calcinated so as to remove only about 75 per cent of the water, it yields 'plaster of Paris'; which is not a suitable filler for primers. Gypsum gives a fairly white ground for painting, if a good white quality is used. It is better for wood supports than for canvas, but quite good for either.

Because the most suitable substances for fillers have poor covering power, it is customary to augment them with a suitable pigment in powder form. Without this pigment, the ground tends to discolour with oil paint; and, if left uncovered by subsequent painting (as in white areas of far too many abstracts) it turns yellow after a time, or at least goes very dull.

The white pigments offered by artists' colourmen are

quite good for this purpose; though each has some small drawback. Zinc White is a fine, dense pigment, but will make a brittle primer more so. White Lead is poisonous, particularly in powder form when it might be breathed by a careless user. Titanium White is, to me, a more or less unknown quantity in the long term, as a primer pigment.

Many old masters used tinted ground for painting; and incorporated this into their technique and brushwork. Gainsborough's unfinished full-length *Maid at a Cottage Door* at the Tate can be seen to be on a light pink ground; and Constable's *Dedham Water Mill* there is on a brown ground. The Tate's *Princess Lieven*, also unfinished, can be seen to be on a pale buff ground. The early painters can be seen usually to have favoured a rich dark brown ground. Painting on a pure white ground did not become widespread until the influence of the Pre-Raphaelites and the French Impressionists. It is a comparatively modern innovation.

The tinted ground (called *imprimatura* in art history) can be in the primer or can be laid on as a glaze. For the latter purpose, Rowney Artists' Egg Tempera Colours are available, suitable for many types of surface, diluted with water; being traditional pigments with an egg-yolk and linseed-oil emulsion.

SOME POINTS OF PRIMING METHOD

The initial sizing should be applied with a brush, using a mixture of about 70 grammes of glue to one litre of water, which should be warm enough to dissolve the glue easily, without being at boiling point. When this coat of size is completely dry, the primer should be ready; prepared from roughly equal amounts of the chosen filler and the pigment, made into a thin cream with the right amount of size solution. If some other recipe for the primer is taken from the many examples in the available books on pigments and primers, this should be warmed up and made ready. Some recipes give a primer that will set overnight into a jelly consistency, and this will have to be melted down in a double saucepan or an old-fashioned glue-pot with inner and outer containers. It is very important not to spill or splash primer around the studio, as, when it has set it is difficult to remove, and if it is allowed to dry, a good primer is quite impossible to remove without great

difficulty, hardening to the flexible consistency of tough linoleum.

Whichever mix is preferred, it should be well stirred; using a thinner mix for rough supports and a thicker mix for smooth surfaces. The surplus should be skimmed off with a strip of hard plastic, and two or three coats should be applied, after the preceding coat is dry and has been rubbed down with fine sand paper or glass paper. If you have run out of fine paper, rub two pieces of coarse grade paper together and this will serve to the same effect. The wet-and-dry abrasive paper sold in a variety of grades by motor accessory shops is very good for this purpose. The residue of loose abrasive that remains on the surface should be wiped away with water before applying any more primer, and the support mopped dry with a cloth. If desired the sandpapering can be omitted, relying on the scraping off of the surplus primer to achieve a less smooth surface.

Some recipes for primer add oil, glycerine, beer, honey and other odd ingredients, mainly to give added pliability to the primer and avoid cracking, but this should not be necessary. If your primer, when dry, tends to crack, it probably means that you have added too much glue. If it tends to be powdery, and to rub off on the finger, then too little glue has been used; in a thin mix the size was too watery and in a thick mix, too little size solution was used. I prefer several coats of a medium mix to one coat of thick mix, to achieve a 'heavy' priming result. Linseed oil is harmless if added judiciously to achieve flexibility, but is inclined to yellow.

A few small off-cuts of the support should be primed at the same time, for the purpose of testing the primer when dry. Some pigment should be placed on a test piece to observe whether the medium spreads around it like ink spreads on blotting paper. If this occurs the primer is too absorbent; and should be given a protecting coat. This can be glue-size; but I prefer white-of-egg tempera, prepared with water, which was used as an insulating coat between layers of paint, by the old masters. The absorbent primer should not be sealed with mastic or dammar varnish, which will yellow in course of time. In the same way, it should not be given a coat of linseed oil or the like, for the same reason. In many paintings, a slight yellowing would not really matter, but if the picture involves many white

passages – as in a cloudy sky – done in thin scumbles of thin white pigment, it will become dingy in time, and will be impossible to correct, because you could not get at the yellowed primer, without removing the scumbles and destroying the painting. Similarly, an abstract with passages of pure white, will end up with passages of dingy, pale yellow.

If a picture in which there are substantial areas of white painting is left like that, some of the white areas may be the white ground showing through. This will almost certainly yellow to some extent in time, as even the white pigment used with the filler will in many cases contain a certain amount of oil, unless the artist obtains white powder pigment, for this purpose. I do not recommend the use of powdered pigments, because using them is not a healthy process unless it is done under controlled conditions.

If the artist, however, with due care and good ventilation, makes up pigments from the raw materials, the white powder pigment should be used for priming without any grinding down. The grinding is done in making up painting pigments, to achieve a smooth substance; but a coarse powder pigment mixed with the filler and size will act like the sand in cement and the aggregate in concrete to add strength and minimise cracking. (The artist should not grind pigment too finely, for the same reason.)

Primer that will retain coarse brushmarks can be used on rigid supports such as wood panel, plywood hardboard and even canvas if laid on board. It can be used on simple canvas, but with a thinner and gentler texture. The primer can be made 'thick' in this way by adding alum to the glue size, using about one-tenth of the amount of alum for the given amount of glue. Another useful addition to the glue size is a touch of formalin, obtainable from large chemists in 20% solution. Ten or 15 drops to a teacupful of size is adequate as a preservative, and to prevent or inhibit the growth of fungal mould on the size in store, or on the primer if the primed support finds itself in humid conditions.

For tempera painting, of course, a gesso primer is laid on a firm support such as panel or hardboard; made up from recipes found in the books on artists' painting methods. Acrylic primer can be used instead; but it

possesses different working characteristics that can be ascertained on test samples.

For paintings on toned or tinted primer, the basic primer can be coloured by mixing the required tints with the pigment before adding the filler in 50–50 ratio. Such painting grounds are very useful in portrait painting, for example; indeed an artist who has had indifferent success trying to paint impressionist portraits on a white ground may find it all comes easier using scumbles and glazes on tinted ground. However, this is to trespass on to the subject of artistic style and aesthetics, which is not my present purpose.

Any primed support should be set aside to settle and 'cure' for several weeks before being used for painting. It is, of course, good studio management to spend some time priming a supply of supports, in a slack period, so that in a busy painting sequence, a supply of supports is to hand ready for use.

If an artist obtains a roll of artist's canvas, or manages to make a bargain purchase of a roll of suitable textile, the problem arises as to whether to prime it stretched or unstretched. If the method of painting on unstretched canvas is used, in the way I describe in Chapter 4 for economy in space and in canvas stretchers, and also to permit the artist to extend or restrict the area of the composition without difficulty, it would, of course, be a waste of time to stretch a piece of the canvas on a stretcher, only to take it off again in order to paint on it and store it.

I have to admit that the very best way of priming canvas is to stretch it on a canvas stretcher first; as they do in the Restoration Department of the National Gallery, London. There, however, they require a known size of canvas for a particular job; and they are not short of space. The main problem in priming unstretched canvas – that is canvas not stretched on the mitred, wooden frame known as a canvas stretcher – is that there is no perfect way, without special equipment, of laying a large area of canvas on a flat surface and securing it for priming.

However, it will certainly be adequately stretched and secured by placing it on a flat surface – such as the large flat table I recommend for the framing area of the studio in Chapter 5 – and taping it down all round, using two-

inch, plastic packing tape for big pieces and spray-painter's masking tape for smaller ones. The masking tape, which is usually 2.5 cm (1 inch) wide is obtainable from motor accessory shops; and can also be used for big canvases by using plenty of it, though this can be rather expensive. Whichever tape is used, it should not be taken all round the edges, taping along the entire length of each edge; but should be used in short strips of about 8 cm (4 inches) in length, placed *across* each edge about 8 cm apart. The packing tape, which is in rolls about 4 cm (2 inches) wide, can be placed further apart round the edge.

A piece of adhesive strip of this kind should be used at the middle of each edge, to begin with. Then each corner should be gently stretched and taped down; and after the first corner, tape the one diagonally opposite, and then the two remaining corners. Any 'reeves' (i.e. slight folded ridges in the surface of the canvas) can be taken up at this stage, leaving the canvas completely flat. Then, the edges are taped across at the quarter and three-quarter points along each edge; once again dealing with the first point followed by the one diagonally opposite in each case. Do not work your way all round the edges, taping each point after the one next to it; or you may end up with reeves due to distortion.

This method will hold the material flat and taut. It has the disadvantage that the primer cannot reach the surface under the adhesive tapes, so that a margin would appear to be wasted. However, this is not so; as the canvas will have to be stretched on a canvas stretcher for framing and exhibition; in which case, the margin goes over the side of the stretcher and is tacked to the back. Nevertheless, it is better to trim it off, to avoid difficulties in tacking the canvas to the stretcher, and the slight possibility of uneven tension. If the roll of textile is really a bargain roll, the small amount of waste is set off against this saving.

Another method is to use chart pins, about 2 cm apart, and brush the primer right up to the pin, thus covering the entire area; but the pins draw the warp and the weft of the canvas out of true. Many artists buy their canvases ready-primed; and I have never heard any complaints of the working quality of the primer. I have a ready-primed and stretched canvas that, for a variety of reasons, has

never been used in about 35 years; and it has not yellowed at all; mainly, I suspect, because my storage space is shielded from the light.

If an artist buys a substantial roll of unprimed canvas, my advice is for him to cut enough for each painting and stretch it before priming, if only for convenience. I know of no studio method of holding a very large roll or length of canvas flat for priming without a good deal of trouble. For many years I have been involved with the re-stretching of already painted or primed canvases, old and new; and provided that the stretching is properly done, I have never come across any ill-effects.

One precaution is never to roll up primed or painted canvas with the primed surface inside. This will crush the edges of any cracks made by the rolling. The primed or painted surface should always be outside. It should be rolled loosely, and never in a tight roll. If the priming is properly done, and the picture is painted in a correct technique, there should not be any cracking if carefully handled.

Enlarging a canvas to fit a bigger frame

It can sometimes happen that an artist completes an oil painting, and then has the chance to acquire a good picture frame which is a bit too large in one dimension or both.

If the frame moulding is a simple one, it is easiest to cut down the frame to fit the canvas; but if the frame is, perhaps, of the swept type (i.e. with curves on the edge and ornamental corners) it is not easy to do this; and the solution to the problem is to enlarge the painting to fit the frame.

To the artist who painted the picture in the first place, it is not difficult to paint a couple of centimetres or so all round to bring the edge of the painting to the inner rebate of the frame. In any case, I only suggest enlarging the canvas if it is a matter of it being just a little short in length or breadth.

The need to enlarge the canvas can also occur when the painter decides that the composition, after it has been laid in on the canvas, needs a couple of centimetres more all round, or in height or width, to improve the picture.

Earlier painters were quite accustomed to painting over panels or canvases that had been joined. Rubens's famous *Chateau de Steen* has a join in the wood panel all along the horizon, which the artist doubtless placed along that line to mask the join in the boards that make up the panel.

Similarly *The Festival of the Vintage at Macon* by J. M. W. Turner, in the Graves Art Gallery, Sheffield, is on a large canvas about 1.5 metres or more across, which has a join in almost the same place, right across the background. Artists often used the composition of the painting to conceal such joins.

First, you should obtain a piece of unprimed canvas about 15 cm bigger all round than the painted canvas when it has been taken off the stretcher and flattened out. The width of the border of the original canvas that passed over the edge of the wood stretcher and round the back will be about 6 or 7 centimetres bigger than the painted front surface.

The original canvas must then be stuck down upon the new piece. For a painting of little importance, thin joiners' glue of good quality will suffice; but for anything of more value a blend of beeswax and turpentine should be prepared by gentle heat in a double saucepan, and used as the adhesive.

Before applying it, brown paper should be stuck all over the paint surface of the original canvas with thin joiners' glue. The canvas is then placed face down on a flat surface and the new and larger canvas laid down on it with beeswax, which is ironed in with a warm (not hot) iron. Further wax is applied to the back of the new canvas, and ironed until the melted wax appears at the front through the brown paper.

Figure 25a Enlarging a canvas.

When it is all cool, the brown paper is removed with hot water and the whole job cleaned up. Surplus wax which shows on the front through any thin places or cracks can be warmed and removed with turpentine. This process is called re-lining.

A stretcher to fit the frame can then be made or obtained, and the canvas, thus re-lined, can be stretched on it. It is not recommended that the edge of the stretcher be wider than the original canvas, though it can, without harm, come to the edge.

To protect the edge of the original canvas, if it comes to

Figure 25b The enlarged canvas attached to the stretcher; with an added edging of glued paper.

the edge but does not pass round the sides of the stretcher, strong gummed-strip brown paper all round the sides of the stretcher should be applied. The rebate of the frame will mask the slight overlap of the gummed-strip at the front. When the painting is finished and varnished, this will strengthen the gummed-strip yet more.

Taking a dent out of a canvas

Figure 26 Taking a dent out of a canvas.

Great care, as I have tried to emphasise, should always be taken when handling works of art in the studio. It is particularly needful with unframed drawings and canvases; which can sometimes be damaged even before they are finished. Indeed, many a blank canvas has been needlessly thrown away because of having been dented in the studio by being allowed to knock or fall against a sharp corner which stretches the fabric at the point of impact making a dent or a bump. This can easily happen when a stretched canvas is propped against a chair or some similar support.

The dent or bulge in the fabric may be quite small –about 2 cm across – or can be larger, perhaps up to 5 or 6 cm across. In both cases, the treatment is the same; the repair being effected by shrinking the stretched area back into place. This is done by laying the canvas, still on its stretcher, face downwards on a flat table top which is protected by a sheet of felt or blanket. The treatment has to be applied to the unprotected back of the canvas, because the canvas ground applied to the front prevents access to the actual fibres of the textile by the hot water that must be applied.

The actual area of the dent or bulge should be made very moist, using a sponge. Whilst it should not be flooded or soaked – which might impair the adhesion of the ground or of the paint if the canvas has been painted upon – yet it should be fairly wet in order to be effective. The water should be then given a little time to soak well into the fabric, and surplus water gently mopped away.

After a few minutes, the moist patch should be heated, in order to shrink the damaged area. This is done by holding a hot iron a few centimetres from the surface, so that it steams off the water. It is better to use very hot water for damping the area, so as to speed up the process.

Some degree of judgement is needed to get the canvas as hot as possible without scorching it or damaging the primer or paint. The iron should be very hot, and held at the right distance so as to steam away the water without scorching the dry area around. This is best controlled by the distance of the iron from the surface. I have taken a bulge out of a canvas in this way in one attempt, quite often; but sometimes a certain amount of bulge or dent remains, and the process is then repeated. In the wet area the canvas will shrink if you persevere, and take away the dent. It is most important to avoid trying to hurry the process by ironing the canvas as if pressing a shirt. This will almost certainly risk damage and softening of the primer and paint. In any case, I have found that ironing has a stretching effect which is the opposite of what is desired.

This process is quite safe for linen canvases, if used with judgement and care. With any canvas that has a man-made fibre content a test should first be made with the hot iron held over a small sample of it to ensure that the fabric will not suffer from the heat. If a piece snipped from the edge shrivels under the heat, the process should be discontinued.

Occasionally, in severe cases, an obstinate small area of dent or bulge remains; and this can usually be eradicated by removing the canvas from the stretcher and re-stretching it. Yet again, caution is needed here, to avoid the temptation to overstretch the canvas or overtighten the stretcher wedges. The last of the dent or bulge if extremely obstinate can usually be pulled out by wetting and shrinking the undamaged area surrounding it; even to the extent of wetting and shrinking the entire canvas. If even this does not entirely cure the condition, the canvas will have to be re-lined by ironing it with wax adhesive on to another piece of canvas.

How to repair a hole in a canvas

Sometimes pressure on a canvas can push a small hole in the fabric; this is expensive in a new canvas, and even more so if the canvas has a completed painting on its surface, perhaps an old and very valuable one.

In the latter case – that of an old and costly picture –

Figure 27a A hole in a canvas.

Figure 27b A patch with drawn threads suitable for repairing the hole.

my advice, as always, is to consult a well established and professional restorer. Yet, in the case of an unused canvas or one of your own oil paintings, it is not difficult to mend it.

Firstly, a sheet of strong, brown paper should be cut to the size of the canvas, adding on 2.5 centimetres all round. This should be coated with old-fashioned hoof-and-horn woodworker's glue, good and hot and not too thick, and stuck on to the working surface of the canvas. On no account should modern plastic or similar adhesives be used, as these cannot be taken off again.

The papered canvas should then be laid face downwards on a firm, smooth surface, such as the smooth side of a sheet of hardboard on a table. Some beeswax of good quality should be obtained and melted in a double sauce-pan over gentle heat, and the back of the hole should be painted with this, spreading 2.5 cm or so all round the hole.

A piece of canvas free of primer should be cut in a square or oblong, big enough to cover the hole plus at least 2.5 cm all round. Before this is stuck to the back of the hole, the threads should be drawn for about 1.5 cm all round, to look like my sketch.

The threads are drawn to thin out the edge of the patch and prevent a corresponding shape appearing at the front. The patch should be dipped into the hot, melted beeswax and carefully applied to cover the hole. Additional bees-wax is applied to the patch, which is then ironed into place with a cool (that is merely warm) iron.

If the iron is too cool the wax will set before the patch is properly pressed down; and if it is too hot, it will damage the canvas ground on the other side, or the oil painting if there is any. Beeswax melts at quite a moderate tempera-ture, so there is no need to have the iron too hot. You can find by testing how warm to have the iron to just melt the wax.

There must be no excessive pressure used in ironing the patch to the canvas. This would not hurt an unpainted canvas, but would flatten out all the brushwork of an oil painting, spoiling much of the visual effect of the picture. If the canvas bears a picture painted with a good deal of thick impasto brushwork, it is better to place the canvas on a flat bed of sand in a suitably sized flat wooden box, so that the sand will yield to the uneven surface of the brushwork.

The beeswax should be ironed until it is forced through the canvas to the front surface. This can be seen when the wax stains the brown paper wherever it gets through. The whole thing should then be allowed to cool, after which the glue and brown paper can be removed from the front by the use of hot water. In the case of a finished painting the water should not be allowed to soak between the cracks of the oil paint beyond the area of the waxed patch. Within that area, the beeswax will render it waterproof.

The area of the hole, at the front can then be coated with whatever canvas primer you prefer, and the new canvas is ready for use. In the case of a finished picture you can proceed to touch in the paint where the hole was, and you will never know there was a hole there.

Too much pressure on the iron will sometimes make the square shape of the patch show through the front; so this must be guarded against. The area of the hole, at the front may have to be built up to a level with the rest of the surface, and glue-and-whitening gesso can be thinly applied to achieve this, followed by gentle rubbing down with fine sandpaper, before priming or retouching.

How to wedge the corners of an oil painting canvas when fitting up a picture

Many mistakes are made by artists who make their own stretchers and wedges, but they are not difficult to make with a bench and a few tools. Both with home-made and ready-made stretchers, errors occur when tightening up. These mistakes can all have an adverse effect on the long-term well-being of the painting.

For the artist or student who makes his own, the most likely mistake is to use the wrong type of wood. For the stretchers, the wood should be reasonably straight-grained, and free from knots; and should be of softwood type. Not only is the more expensive hardwood quite unnecessary for this task, but there is likely to be difficulty in the removal of tight wedges from hardwood stretchers, which does not occur with the greater elasticity of softwood.

The wedges, on the contrary, should be of hardwood; otherwise several drawbacks can appear. If a wedge is too

soft, it is likely to break up under the hammering; and, being necessarily thin, it can bend or even break under the final strain of the stretched canvas. More important still, a softwood wedge can become waisted – or dinted at the sides – under the pressure when driven home. It then relaxes, and allows the canvas to become slack. It ceases, in the real sense, to be a wedge at all; so that lightly tapping it home is not enough; and there is the risk of being tempted to hammer it too hard.

In art schools, I have sometimes seen people cutting canvas wedges out of plywood; but this is definitely not a good idea. Plywood is not made for standing this type of strain; and, by its composition, is likely to fray and splinter at the edges, when used in this way.

I have often come across canvases that have been stretched by wedges that were the wrong shape; and even with a mixture of wedges of different shapes. Some of the wedges from old-fashioned canvases are of a narrower angle at the point than I would recommend. Those generally supplied today have a point with an angle of 20 degrees.

In making a wedge, the heel – or shortest side – should be at 90° to the intermediate side; and when fitted, should be at 90° to the adjacent stretcher. Wedges are often to be seen in canvases inserted the wrong way round. My sketch shows the right and wrong ways; from which it can be seen that if the heel of the wedge is tapped by the hammer at a different angle from that in which the wedge is being driven, there is a tendency for the hammer to slip. This can result in splitting the wedge, or snapping off the point, which is then difficult to extract from the stretcher.

Figure 28 Wedging the corners of a canvas stretcher.

In tapping home the wedges, only the lightest taps should be employed. This is more important than ever if the canvas which is being stretched has already been painted upon; and is crucial if the paint has dried long enough to lose its elasticity. Banging the wedges will only crack and loosen the pigment and over-tightening the canvas will have the same effect. It is disastrous with an old painting.

It is important to tap the wedges in turn, tap for tap; and not to drive one too far home without tapping the others. After tapping each wedge, tap the corresponding one diametrically opposite, and so on round the canvas.

If it is found needful to drive the wedges so far in, to

gain the requisite tension, that the mitres of the stretch-ers are driven more than about one-eighth of an inch apart at the most, then the original tacking-on of the canvas was too loose; and should be done again. Too great a widening of the mitres can mean that the stretched canvas will no longer fit into the intended frame.

In tacking on the canvas, before wedging, care must be taken to ensure that the opposite stretchers are parallel and the whole thing is truly square; otherwise it will not fit properly into the rebates of the frame.

As I describe on page 186, an allowance of about a half a centimetre should be left around the stretched canvas, within the frame rebate. The intervening space should be padded with cork inserts, in the way I describe. There is another reason for leaving the canvas a loose fit within the frame rebates; being the tendency on certain days in Britain, for canvases to slacken due to the humidity in the atmosphere.

This humidity is blown ashore from disturbances in mid-Atlantic, and when it arrives, all the paintings in the country sag in their frames. When it goes, they tighten up again. If a canvas, after its first tightening on the stretch-ers, should relax in this way and not tighten up again sufficiently, it is necessary to tap the wedges further home to take up the slack. This cannot be done if the stretched canvas was too tight a fit within the frame rebates in the first place.

I must stress that this should not be done every time there is a damp day, otherwise there is risk of over-tightening.

A canvas should on no account be tightened whilst still in the frame. If the frame is not very robust, it can result in springing the frame mitres; and there is also the risk of the hammer going through the canvas, or dinting it. The canvas should be removed and laid paint-side-down on felt placed on a firm surface, and the wedges carefully tapped in parallel to the adjacent stretcher and not at an angle to it.

Fitting a canvas into a frame

However tasteful frames may be from the front, they are potentially dangerous to the paintings they hold and to

other paintings in the same studio or gallery, if they are not efficiently dealt with at the back.

If the canvas is allowed to become slack, through looseness of the corner wedges in the sliding mortise-and-tenon mitred joints of the stretcher, it will flap when the framed picture is handled, causing cracking and eventual deterioration of the paint surface around the edges; followed by edge flaking and the loss of paint.

The wedges cannot be tightened unless the inside rebate of the frame is of sufficient dimensions to give the necessary room for expansion. Therefore, always allow about a half a centimetre all round the stretcher for this.

To prevent the tightened canvas (do not overtighten) from sitting loosely within the rebate, corks should be used as 'distance pieces' or 'tighteners'; held in place by long panel pins (see sketch). These pins should be long enough to be driven through the cork and into the frame, leaving the head of the pin sufficiently 'proud' to clamp the stretcher. The pin heads must not be large; and any type of flat-headed or thick nail must be rigorously avoided. The pin, after insertion can be lightly tapped down to the stretcher.

Figure 29 Cork tighteners in framing an oil painting.

For protection in the studio, or at a mixed exhibition, the heads of the panel pins must be covered by one, or sometimes two, thicknesses of gummed paper strip, amply wide enough to give firm coverage. In addition to covering the pin head, it helps to hold the stretcher firmly inside the frame rebate.

The cork tighteners are pliable and act as shock-absorbers if the framed painting is jarred. They are made by slicing wine corks with a sharp knife. For large paintings, bigger corks can be obtained from a cork merchant.

If the pin heads are not covered, they might not only scratch the hand of any one lifting the framed painting, but can damage the delicate front surfaces of other paintings and their frames, when stacked against one another in the studio or at an exhibition. The covering of stout gummed paper strip will prevent this.

If you intend to hang the painting for a long time, in the studio or elsewhere, it will collect dust and spider webs at the back. These will fall down between the stretcher and the canvas; and after enough lapse of time, a hard strip of felted dirt and dust will jam the narrow space. This will

cause a bulge; of the type that can be seen on paintings that have hung for a long time in houses, and can hold humidity that will rot the canvas edge, causing it to come away from the stretcher after a number of years; calling for lengthy and expensive re-lining and restoration.

To prevent this, the easy way is to damp and stretch a sheet of stout brown paper over the back of the frame, or screw on a piece of hardboard, covering stretcher, canvas and all. If handled with care at spring cleaning time, it will last for years. After all, if the artist sells his painting for a substantial sum to a collector who wishes to enjoy it for a long time, the buyer is entitled to have the painting protected in a way commensurate with its cost.

In such a case, the artist should always protect the back of the picture by screwing a sheet of clean hardboard, 5 mm thick, on the back of the frame so as to box-in the entire back of the frame and picture. Brass countersunk screws should be used in screwcup washers also of brass; and the screw head should be covered by gummed paper. The edge of the hardboard should be about 1 cm inside the edge of the frame. If necessary, a knot-free, softwood fillet should be glued and pinned to the back of the frame to deepen the rebate, accurately mitred at the corners; and the hardboard screwed to the fillet, and into the frame.

Mirror plates, or other hanging fittings should not be screwed to the fillet, without strengthening it by driving the mirror plate screws through the fillet and into the wood of the frame. If the picture is glazed, a thin fillet should be mitred around the edge between the canvas and the glass. On no account should the glass touch the canvas.

NOTES

[1] See *Suppliers of Studio Materials & Equipment* on page 275.

[2] Vasari, *Lives of the Artists*, (B. Burroughs, ed.), (Allen & Unwin, 1960), p. 130.

[3] Vasari, *op.cit.*, p. 131.

[4] 'Primer' is a noun and refers to the mixture that is applied to the surface of the support. 'Priming' is the present participle of the verb 'to prime'; and describes the process of application.

Chapter 9

Drawings and papers

The nature of drawing papers

Since the introduction of paper to Europe in the twelfth century caused it gradually to replace animal skin (in the form of parchment from sheep and vellum from calves) virtually every artist who has ever worked in Europe has left works of various kinds on paper. For centuries the paper was hand-made, with little attention to its durability; and most old drawings and prints are very fragile for this reason among others. Art works on paper are called 'drawings', which include water colours, pen-and-ink, sepia, silver point, crayon and pencil; being so-called relative to the drawing medium rather than the paper; albeit that for several centuries, virtually all drawing has been done on paper. Some drawing has been done on glass for church windows, but little survives of the great quantity that was produced. In writing of drawings, therefore, it should be taken that I refer to pencil, pen, crayon and water colour. Because they are usually coloured, water colours are often called 'paintings'; but, strictly speaking, they are coloured drawings.

An artist should be very selective in the choice of paper for drawings. Whilst it may not be quite true that, as someone said, 'An artist who has found his paper has found his style', yet, the wrong paper can retard an artist's development of his or her full potential and skill. By the 'wrong' paper, I mean a paper that for one reason or another, is not congenial and sympathetic to the artist's touch and sensibilities. Most art papers are produced for specific purposes; thus, there are drawing papers for pencil, shiny papers with a hard surface for pen drawing, pastel papers with enough 'tooth' to take the pastel, and, of course the water-colour papers, some

of which are of long-established use and are very famous.

Among the most prestigious papers are: T. H. Saunders paper, Bockingford paper, Arches paper, Royal Water Colour Society (RWS) paper, De Wint paper, Turner grey paper, Hollingworth paper, Aquarelle paper, Ingres paper, Mi-Teintes paper, Levis-Canson double-sized water-colour paper, and Barcham Green pasteless boards; to name a few. The only way for a young artist or the older beginner to find out which paper is the most sympathetic, is to buy a sheet or two of each and try them in the studio. Word-of-mouth recommendation by another artist is of no value, as artists differ in their responses to art papers. The list of art suppliers at the end of this book indicates where they can be obtained, and they are also advertised in the artists' magazines. If you write to the suppliers, importers or, if they are in the same country, the makers, they may very likely send you a batch of samples for you to try.

The importance of good paper is not only that it may be congenial to the artist's personal handling of the medium, but also that it may be as durable and permanent as possible. Artists sell their drawings at prices that are quite substantial, and the buyer is entitled to assume that the drawing will not fade or deteriorate quickly but will last for many years, not only as a pleasure in itself but as an investment especially if it has any personal or family connotation.

The enemies of the durability of card and paper are: heat and cold, damp, mould, strong light and, above all, any acidity either in the paper or induced into it from contact with acid mount board and the like. To the working artist, provided that a good paper was selected in the first place, the main, long-term danger to drawings comes from fading – due to excess light – and degeneration due to acid. I have described how to guard against fading, in my discussion of storage of works of art. The best way to avoid acidity is to use good paper in the first place and to mount the work in 'archival' mounting board. This is a type of strong card, which, using the latest technology, provides a board that reaches the highest levels of specification for this material by the preservation laboratories such as that of the United States Library of Congress. Some types, such

as Hollinger International's Archival mounting board, actually exceed these demands. This type of board has a shelf life estimated to exceed a thousand years, and embodies a mildly alkaline minimum of pH 8.5, also a special alkaline sizing and a minimum alkaline reserve of five per cent.

Board and card chosen for mounting drawings should be of the right thickness, and should be carefully examined to ensure that the middle ply, between the two outer plies of white paper, is itself white and not yellow or greyish-brown.

Whilst the papers I have mentioned are all high-quality papers, the artist should remember that their respective makers do not claim equal suitability to all requirements. So in addition to making studio trials the makers' statements about products should also be studied in their catalogues and technical data sheets which are available from either your art supplies shop or direct from the manufacturers at the addresses given in the list of supplies at the end of this book.

The two papers marketed as T. H. Saunders paper and Bockingford paper are both excellent; the former is a pure rag water-colour paper for the finest and most durable work, whilst the latter is made of wood pulp rather than rag and is for making finished sketches and for beginners in water colour.

For pen-and-ink artists and illustrators, there are special types of card – known as 'line board' – of quality equal to the fine water-colour papers. Of these, some of the best are produced by Messrs Colyer and Southey of London. Their 'C.S.10' line board is virtually handmade for line work with a glossy surface. Their 'C.S.2' is less glossy, for gouache and water-colour work with or without line. Another famous type of line board is Bristol board.

British Standards paper sizes

Although British Standards metric sizes of paper in the A and B ranges were first published by the British Standards Institution on 30 November, 1959, there are still people who do not know quite what they are. The quaint

old names of paper sizes – Foolscap, Half-Imperial, Double Elephant, and so on – have been replaced by A2, A4, and similar terminology. However, it was never suggested that BS metric sizes should be used to the exclusion of traditional British sizes; and only last month I bought some mount card in Imperial size, without difficulty.

The main advantage of the BS system is that every size in the main and subsidiary ranges has the same proportion, which means that one large sheet, or two smaller sheets of the same proportion, or four very small sheets, can fit snugly into a drawer, file or plan chest without waste of space. Thus, furniture such as filing cabinets can be designed to fit the system.

The basis of the proportion and the various sizes is the same in both A and B sizes. This is that each size is achieved by halving the size above it, without changing the proportion, the cut being parallel to the shorter side; so that each step on the range is twice as large (in area) as the previous one. This, also, means logically that the short side of one size is the same length as the long side of the size below it. Also, the basic size in the principal series, the A series, is one square metre in area, known as AO.

The number which follows the A indicates how many times the basic AO size has to be cut across in half to produce it. The B sizes are only used when an A size will not do and a size in between any two A sizes has to be used. It is all part of the coordinated standards of the International Organisation for Standardisation (ISO) already adopted in over thirty countries. The A series proportion is 1:1414; one of the comparatively rare geometrical shapes in which one can continue to halve or double the longer side, without altering the proportion. The basic AO is 841 × 1189 mm or 33.11 × 46.81 inches. In practice it goes down to A10, or 26 × 37 mm.

The British Standards sizes have been devised so that the traditional British sizes can be trimmed to it with the least wastage. One day, perhaps, there will be a fully international and exact series, which dictates not only the paper size, but that of the books it produces, the shelves which hold them, the desks and printing or duplicating machines, the typewriters, and even the lorries that carry the paper.

Figure 30 Diagram of British Standards paper standards, reduced.

THE 'A SERIES' OF TRIMMED PAPER SIZES

	mm	inches		mm	inches
A0	841×1189	33.11×46.81	A5	148×210	5.83×8.27
A1	594×841	23.39×33.11	A6	105×148	4.13×5.83
A2	420×594	16.54×23.39	A7	74×105	2.91×4.13
A3	297×420	11.69×16.54	A8	52×74	2.05×2.91
A4	210×297	8.27×11.69	A9	37×52	1.46×2.05
			A10	26×37	1.02×1.46

Clearly the best sizes for folios are A1 and A2; and sketch books come in A2 and A4, small ones being A5. For artists with a stock of Imperial and Half-Imperial frames, the new sizes will be awkward for mounting card, but, as I stated above the old sizes can still be obtained when required. See also page 269 for further information about British Standards related to paper and board.

Stretching water-colour paper

Paper for drawing and water colour comes in a great variety of surfaces and weights, and the first thing to decide is the right kind of paper for your style. The same style and touch on different papers can have completely different results. I suggest that a smooth thin card be obtained, together with some hot-pressed cartridge or handmade paper, completing the range of samples with some rougher or 'not-pressed' paper. Each piece should be cut into four pieces and two pieces of each type placed in clean water for five or ten minutes to soak out some of the size – with the exception of course, of the thin card. The tint of the paper does not matter so much in this context, as it is the handling and quality of the drawing and brushwork that are affected by the smoothness or hardness of the surface, irrespective of the tint.

You will then have a selection of sample papers, ranging from smooth and hard to rough and soft. On these you should draw with pen and ink, pencil and crayon to get the feel of the different characters and qualities of the paper surfaces; and should note carefully which gives the most agreeable result for your particular handling.

It is fairly certain that the smooth, hard papers, or the smooth card will suit many pen-and-ink draughtsmen, but there may be some who find that with a softer pen

nib – such as a goosequill or a thin wooden spill – a new dimension is given to your pen drawing.

The samples should also be tried with monochrome wash and brush-line – with both water colour and dilute Indian ink. The same grey in water colour and Indian ink will behave in quite different ways on any one paper, and differently again on the other surfaces. By the same token, the same wash of dilute Indian ink – or of water colour – will behave differently on a given paper surface, according to whether or not the size has been to some extent taken out of the paper.

When a particular combination of characteristics has made one sample better for your purposes than any of the others, try it with your chosen medium at different degrees of humidity – from quite dry through faintly humid to distinctly damp. The requisite degrees of damp-ness can be controlled by placing damp blotting paper underneath the paper when stretching it and using the paper when the surface is at the desired humidity. The damp blotting paper will slow down any tendency for it to dry out whilst you are working on it. If it is a hot day, use about six or eight sheets of blotting paper underneath.

Of course, I am referring to work in the studio. This is the type of technical finesse to which the old masters worked; and is why they never thought of painting out of doors.

After the chosen range of paper samples have been divided up and half of them soaked to reduce the size content, they should all be stretched. Remember that stretching takes some size out.

The paper should be soaked in a bath tub or large sink of clean water. Creasing must be avoided at all costs; and, with the two leading corners of the large sheet held, one in each hand, the whole leading edge should be slid down the nearer side of the bath and up the far side in one smooth movement. Then the paper should be left lying on the bottom of the bath to soak. Do not float the paper and press the centre under water. If it is large enough to come up the sides, the depth of water should be enough to cover it entirely. Even soaking enables even drying, which is vital to the result. The wet paper, after five or ten minutes should be slid up the near side of the bath in the same way as it went in, and carried over to a flat board where it is laid down without creasing.

The edges should be stuck down with gummed paper tape using the 5 cm wide grade, and left to dry out of draughts and completely flat. No heat or fanning or other hastening efforts should be applied. Any uneven drying can make one part of the paper shrink faster than another; causing the edge of the paper to tear away from the board.

If you like working on a hard, shiny surface, stretching will spoil this; and you should use a strong, flat card instead. Soaking and stretching always takes some size out of the paper; and if you like a fairly hard surface, the soaking must be kept as short as possible. This may mean that a thin weight of paper has to be used, as the heavier weights need longer soaking, and the surface may lose proportionately more size. Conversely, an artist who likes a softer surface, having experimented on soaked paper, may judge by experience how long to soak it for stretching so as to soften the surface at the same time. It should be remembered that, up to a certain point, the longer it soaks the longer it takes to dry; so do not try to soften or stretch very heavy paper in a hurry.

The board holding the wet paper should never be allowed to tilt, as this will drain the water to one edge and cause splitting from the board. It should rest on a flat table overnight if possible. In hot and dry weather, even without any aids to drying, the paper may tend to dry too quickly, causing sudden and enormous tension that tears it. In such conditions the drying should be slowed down by covering the whole thing with a thick sheet of damp blotting paper. On hot days it is better to stretch the paper in the evening and allow it to dry slowly during the night.

It is a good idea to keep a small number of old drawing boards for paper stretching; and if there are none to hand, it is better to use a few specially obtained pieces of 5 mm thick plywood for this purpose, rather than ruin your best drawing board. A drawing board should be completely free from dents or flaws in its surface, otherwise, one day, a vital pen or pencil line will be deflected by some blemish.

After stretching and working on, the paper will have to be cut free round the edge with a straight-edge and a sharp knife; and this alone can ruin a good drawing board.

Thinner plywood or hardboard are quite unsuitable for paper stretching as they are too thin to withstand the great stresses set up, and will bend. With a big sheet of heavy paper, even 5 mm thick plywood will bend, and it is a matter of common sense to use wood of sufficient thickness and strength.

Whilst the studio is geared to the paper stretching process, it is good practice to have several boards ready and to stretch a number of sheets at the same time. It is very frustrating and time-consuming if a mistake or mishap in the middle of a drawing or water colour means that the artist is stuck until another piece of paper has been stretched and dried. It is also useful to have some stretched paper to hand when an idea or an opportunity occurs, to enable instant work to proceed while the moment is ripe.

A quantity of boards enables the artist to paint at the same time several different versions of the same composition or idea, if that is how he or she likes to work. A number of prepared boards can be leaned against the studio wall face to face and will keep clean and undamaged until needed. For humid working in ink or water colour, the stretched paper has to be worked on as soon as it is prepared.

It is important to realise that, when the sizing is reduced, some of the paper's protection against dust and marks will be lost, and the surface is to some extent more fragile. It should be treated with great care, therefore, after it is dry and during working on and framing. Do not put it into a plan chest where it will be abraded by the dusty backs of other drawings. It is less resistant also to grease and the natural oils of the skin; and care should be taken, as with a lithographic stone or plate, that the fingers do not come into contact with the working surface.

Submerging water colours and prints

An artist may have many reasons for submerging a water colour or a print in water; and may hesitate to do so through fear of the consequences to the work of art. A work may require submersion to detach it from a card or wood base to which it has been injudiciously stuck. Another reason may be connected with cleaning the work; and again it may be necessary to bleach out stains.

Properly handled, prints and water colours are remarkably tough in some respects. Wrongly handled they reveal delicacy and frailness that make it unwise to proceed with the operation and impossible to withdraw from it. I have submerged many dozens of water colours and have never known a case where the pigment, properly dry in the first place, smeared, faded or ran, so long as the wet surface was never touched. Conversely, the slightest touch on the surface once it was wetted, was almost certain to do damage.

Provided the work is on good quality paper to start with, an artist may submerge a water colour in the process of painting it; to gain certain effects by rubbing down and overpainting. The parts of the water colour that are not involved in the process of rubbing down, have always, in my experience, stood firm and emerged for drying none the worse for their immersion. Prints are even tougher than water colours. Printed usually in oil-based inks, they are virtually waterproof; though it should always be borne in mind that the thin paper often used for etching and wood engravings can be very fragile when wet.

A work that is to be detached from a backboard or support should be submerged and left to soak. The process of detachment cannot be hurried; and any tendency to pull on the edges to hurry up the process should be sternly resisted.

One should always ensure that the vessel containing the water or other fluid is big enough. It is very easy to fold or crease a work when it is being put in or taken out; and this will always leave a mark that is difficult or impossible to eradicate. A medium-sized work should go in the bathtub, and paper smaller than 61 cm (24 inches) can be immersed in a large dish of the kind used by etchers, though the bathtub will do. When a large work on thin paper is soaked, it is fragile and should not be lifted out by holding two corners. It will be very likely to tear. A sheet of glass, plastic or plywood should be slid under the paper in the water, and used to support it in lifting and draining it.

Pencil drawings do not, in my experience, suffer by immersion, so long as they are not abraded on the drawn surface whilst wet. Ink drawings are another thing altogether; and should never be immersed without careful

testing first, to make sure that the ink will not run and spread when it is wet. Whilst Indian ink is safe, many other inks are far from waterproof, even though they may look black like Indian ink. The practice of some modern artists of drawing in biro is a case in point; and such drawings should never be immersed (for example, *Desire Me* (No. 33) in the Allen Jones Retrospective Exhibition (1978) at the Serpentine Gallery, London was done in 'pencil and *ball pen* on cartridge'.)

I recommend trying enzyme detergent to get blood-stains from a drawing if you have an accident in glazing it. It is always safer, if tests permit, to immerse the drawing than to wet part of the surface with solution, as there may well be a perceptible though very slight change in the surface of the wet portion once it has dried. In the same way, if you are bleaching a drawing or print of suitable type in order to remove 'foxing' or other stains, it is better to immerse the work than to try spotting it, as the spotted parts may be perceptible after drying, as the surface dirt might be removed at the same time.

After immersion, a work should always be laid flat to dry, otherwise uneven drying and shrinking may distort it. A drawing in pencil or Indian ink, wax crayon or the like may be placed between clean blotting paper under pressure, so that it will dry quite flat; but this cannot be done with a water colour.

If there is sufficient margin to spare on the water colour (and I advise doing a water colour in the centre of a large sheet of paper to leave plenty of margin) it should be stretched on a flat board in the usual way with gummed paper tape, from which it will emerge absolutely flat and give no trouble to the mounter and framer when it has been trimmed to the required size.

For bleaching out foxing and other brown water stains and fungus marks from old works of art on paper, the method used by most of the best restorers is immersion in a solution of Chloromine T, obtainable on order from most chemists; at 2g in 100ml of water. The work can be left in for several hours. I am writing purely for the artist dealing with his own works. Old works should not be treated but should be done by a specialist. To test whether your own water colours can be safely immersed in bleach, it is simple to paint samples of all your pigments on a sheet of paper and immerse it as a test piece; with a

second sample sheet kept dry for later comparison as a control.

This raises the whole question as to whether an artist should attempt any restoration.

Cleaning your prints and drawings

I do not think it is a good idea for artists to attempt cleaning or restoration of works of art that are of either a substantial financial value or of an irreplaceable character as records or mementos. Cleaning and restoration are very skilled procedures and should not be attempted without technical knowledge and experience. Having said that, however, I think there is no reason why an artist should not be capable of carrying out some of the simpler methods of refurbishing his or her own work; which may have lost its first freshness after showing it in one or two exhibitions or having it lying around unframed in folio or plan chest.

Any drawing, print or water colour can – like any healthy child – pick up an astonishing amount of grime with seemingly little cause. After several exhibition showings, a work on pure white paper may look quite clean on its return; but if it is unframed and a clean, soft eraser gently drawn over an untouched or palely tinted part of the surface, a lighter line will appear where the acquired film of grime has been removed. This problem is not so severe as it was before the clean air campaign of the 1960s; but, all the same, atmospheric pollution of white drawing paper is astonishing when tested.

Despite the good quality of the soft erasers that are available, I personally find that they are too harsh for a delicate paper surface. Even the heaviest grades of good-quality drawing paper and water-colour paper have subtle surfaces painstakingly produced by skilled craftsmen, which are all too easily spoiled by harsh abrasion. A pencil or crayon drawing and the like should, of course, never be rubbed; as this will destroy the drawing. However, pen drawings, etchings, engravings, and similar work, of which the graphic medium is more robust, may be cleaned by abrasion, with due care.

I never use rubber or similar erasers for this purpose. First of all, one should clean one's hands of all trace of

natural grease; by after-shave lotion on cotton wool followed by several washings in soap and hot water. Indeed, this preliminary step should occur every time an artist uses fine paper; to avoid the tainting of the surface with natural grease to which grime can stick. This degreasing is not particularly good for the hands, and people with sensitive skins should apply hand cream after all work is finished to put the natural grease (or its equivalent) back again; particularly in cold weather.

A fresh but cool loaf of white bread should be obtained and all the soft centre taken out, setting aside the hard crust for the birds. Generous portions of this soft bread should be taken, one after the other and *rolled* – not rubbed – over the surface. The bread will break up gradually into smaller and smaller pieces; ending up as very small dirty grey crumbs, which should be swept from the surface with a soft brush. A soft cloth should not be used; as there is a temptation to rub the surface. I have often cleaned a water colour like this; and have never found the pigment to be disturbed or spoiled. If, as may happen after lengthy storage, this does not remove all the grime, and if there are any signs of 'foxing' – that is the little grey-brown spots due to humid storage – then the work can be bleached by using Chloromine T, unless it is unique and valuable, when you should consult a restorer.

Chloromine T, which is a bleach supplied in powder form for dissolving in water, has been used by such national art museums as the British Museum Department of Prints and Drawings and the Tate Gallery Conservation Department on drawings of the highest importance, up to 1982. I should add, perhaps, that the very latest conservation opinion is that it is harmless and effective in the short term; but it may well have long term bleaching effect.

To bleach a print or a *thoroughly fixed* drawing, however, it is not necessary to submerge it in Chloromine T. It usually suffices to lay a light wash or spray of the right strength of solution on the paper and leave it to work. If the first application does not suffice, repeat it. The best method is for the solution to be sprayed on; repeating it if necessary. It can be left for one or two hours to bleach the paper. It is important that afterwards the paper should be thoroughly washed, in the same way that a photographic print has to be washed after developing

and fixing a print. If sufficiently large photographic print-washing equipment is available, all is well. Otherwise it should be submerged in gently changing water in a sink, just like photographic prints and for about the same length of time. It should then be dried between blotting paper under very light pressure overnight.

Opinions differ as to the correct strength of solution of Chloromine T within fine limits; but the Tate Gallery Restoration Department use 2g in 100ml of water.

If, when working on or retouching a wash drawing, it is found that a grease film is impeding the flow of the wash, this can be rectified by the use of Ox Gall, a transparent liquid (from Roberson) added to the medium. A few drops of detergent would do it, but it generally contains added soap.

How to repair tears and holes in drawings and water colours

If a work done on paper is badly torn there is usually no alternative other than mounting it by adhesive on to suitable card. However, there may be something drawn or inscribed on the reverse of the drawing, print or water colour which would be concealed by mounting, to the detriment of the provenance and value of the work in question. The remedy in such a case would depend very much on the circumstances; but if the tear was a simple linear one for an inch or two at the edge of the paper it can be joined again, provided that the paper has torn obliquely through its thickness and is not the hard-edged type of tear that resembles a knife cut.

If there is a degree of 'feather' at the two edges of the tear, they will overlap and it is not difficult to apply a suitable adhesive to the inside surface of each feathered edge, and bring them together under mild pressure between boards and blotting paper to fix the join until dry. Needless to say, the blotting paper should be clean and white, and if any lint from its surface adheres to any surplus adhesive that seeps out from the join, this can usually be removed with the finger tip by gentle abrasion. If the paper being repaired is not white, any blotting paper lint that cannot be rubbed away can be carefully tinted to match.

Proprietary adhesives – such as rubber solution in various forms, latex preparations or plastic glues – should not be used, as they affect the absorption properties of the paper surface and hamper further painting or any retouching. Some of these adhesives do not dry fully transparent or white, and can leave a discernible mark. Opinions differ as to the best adhesive for paper works of art; but one safe type is flour paste, with a few drops of formalin type preservative to prevent any mould or foxing under humid conditions (consult your pharmacist about this). If the work is valuable, do not tamper with it but consult a reputable restorer, and if in doubt, consult the nearest large art gallery, or the Regional Museums Association in your area for advice. A clean-edged tear in a paper work which you do not wish to mount on card provides difficulties which you would be wise to leave to a restorer if the work is of sufficient importance – as the method of repair would depend on the circumstances.

A hole in a drawing means that some of the art surface will be missing and must be replaced. A piece of matching paper (if need be, taken from any spare margin of the work if none is available otherwise) must be cut so that its edges overlap the edges of the hole. The edges of the hole should be abraded into a tapered or feathered edge by gentle rubbing with the finger, aided by a little fine abrasive such as pumice powder. The same should be done to the edges of the patching piece. Then the overlapping and tapered edges should be pasted and stuck down as with a tapered-edge tear. Any visible edge, after drying, can be gently rubbed down with the finger. The patch should, of course, be applied to the back. Then the missing passage in the drawing or water colour should be painted in over the patch. I know of a Girtin water colour with a hole several inches across repaired and retouched in this way so that you would never guess that it had ever been damaged.[1]

NOTE

[1] It is *Fountains Abbey, Yorkshire* by Thomas Girtin, painted in 1798, and in the Maleham Bequest at Sheffield City Art Galleries.

Figure 31 Repairing a hole in a drawing or water colour.

Part Three

The Presentation of Work

Chapter 10

Frame making

Equipment and method

An artist who has a good workshop space and the modicum of tools that I describe in Chapter 6, can make the whole of the picture frames required, from start to finish. However, this would mean acquiring a Morso mitring machine, or something similar. This works on the guillotine principle, by means of a foot treadle, and chops mitres out in seconds. Even the artist who does not make the actual picture-frame mouldings, either in the way I describe on page 208 and subsequent pages, or by routing the mouldings from a plank using a powered hand-router, can buy ready-made mouldings in hundreds of designs, in fairly long lengths, and can cut them up and mitre them for frames. An artist who does not desire the expense of a mitring machine can saw-cut the mitres using a mitre box, but these will have to be planed clean and flat, using a plane and a 'shooting board', as I describe on page 213.

Many artists today buy frame moulding already cut to size and mitred, and provided with dowels and holed for self-assembly. With fairly small paintings and drawings, these do not need to be glued, and will hold together well enough without. For heavier works and large drawings, however, it is safer to glue the dowels. The Daler system is a well-tried version of this method, available at most art materials suppliers. The easiest way to make frames is for the artist to use these ready-mitred frame mouldings, with dowels, and obtain glass cut to size by a glazier. This will save a considerable amount of the cost; and the work can then be mounted and framed without special skill.

It is not always easy to find the right woods for frame making. An artist who feels adequate to make simple

frame mouldings, like the plain bevelled or box frame, will find that it pays to search around and find a good timber merchant who stocks a wide range of specialist sawn and planed stock (see page 116). Woods that should be examined with framing in mind include home-grown hardwoods, like ash, chestnut, elm, oak and sycamore, and the exotic hardwoods for special, polished frames, such as laparchio, padauk, purple heart and Indian rosewood. For well-polished heavier frames, even soft-woods such as parana pine and Russian or Swedish redwood are suitable.

Tools for picture framing

If the artist has the space to set up an area for picture-frame making and the fitting up of drawings and paintings for exhibition, there is a wide variety of tools and machines to use in this connection. For example, a mitring machine will cut mitres quickly and accurately, and a horizontal borer will enable the mitres to be accurately and quickly dowelled together into frames. Machines such as this are, of course, costly; and, unless the artist is setting out to make a great quantity of frames, will not cover their cost. Also they take up quite a lot of working space.

I am writing, particularly, for the art-school leaver and the amateur, who will not, I suggest, be thinking seriously of acquiring sophisticated machinery of this kind. However, if the attempt to cut accurate mitres by hand in the way I describe on page 213, proves to be a little beyond the artist's skill, I would suggest that attendance at the nearest technical college or art college evening class in woodwork may well give you the use of some machinery, with tutors to show you how to use it and to give help and advice. Whilst many students attend classes to learn the general skills of woodwork, I have always found tutors quite happy to assist a student who has a particular purpose in mind, and who comes with a firm project, seeking advice. In the same way, any artist not yet experienced in woodwork who considers fitting out a studio with furniture and equipment of the kind I describe elsewhere in this book, would be well advised to join an evening class, where his studio furniture and so on

can be made with skilled advice. It is not always easy to handle lengths of timber and large panels of chipboard or blockboard single-handed; and at an evening class, there is always someone to 'hold the other end' occasionally. You can also use a circular saw, pneumatic or electric sander or similar machinery among other people, where it is safe to do so. You will need to acquire a roof-rack on your car, of course, if you do not have one already, to take your work home.

If you intend to make your studio furniture in the studio and home workshop, some of the tools already described will, of course, be used for this; such as the panel saw and the tenon saw. For mitres that are cut using a wooden mitre box and the tenon saw, and planed true using the plane and a home-made *shooting board*, pinning and gluing is the easiest way to secure the corner joints. Dowelling, as described above, is also possible; but this requires well-made jigs for accurate drilling of the dowel holes, and even then, calls for a certain skill. Once the dowel holes are drilled – rightly or wrongly – they cannot be changed, and if they are inaccurate, the piece of frame moulding is wasted. In pinning-and-gluing, however, the joint can be taken apart again if it is faulty, and you can have a second try – or a third.

The *pin hammer* is quite adequate for driving in the pins, with the moulding held in the bench vice. A tool called a *sliding bevel* is used to mark out the mitres and the *pin punch* (sometimes called a '*nail set*') is used to punch the pin-heads just below the surface. Many wood-workers use a *marking knife*, but this calls for certain and accurate marking, otherwise the mark has to be planed out if it is going to show. The amateur is better advised to mark lightly with a soft pencil grade B; so that inaccurate marks can be removed with an india-rubber eraser (not sandpaper) and re-drawn. Do not use a hard pencil, and do not press on so as to score the timber; and sharpen the pencil frequently during work.

Using this simple framing method, these are all the tools required. If the artist has a good workshop area, and access to a *rebate plane*, which today is made of metal and is obtainable at the tool shop, he can try shooting his own frame mouldings for drawings and water colours; using ramin wood, as being easily worked and knot-free. On no

account must a strip of wood be sawn off the plank or obtained in this form from the woodyard, and then an effort made to rebate it; as it will be impossible to fix it on the bench so as to hold still and not bend. The edge of the plank must be rebated first; a modern *combination plane* (successor to the old *moulding plane*) with assorted cutters, can then cut a moulding the right distance from the edge; with the plank held all the time on the bench with two *G-cramps*. After this, the strip of rebated moulding is sawn off the plank and the edge of the plank again rebated and moulded for the next strip.

It is possible to obtain power *routers*, hand-held, with a range of *spindles* that will cut a variety of mouldings; but as I have advised against studio use of power tools, I do not suggest this should be tried, except at the evening class with skilled assistance.

How to make your own picture frame mouldings

It is possible to make your own picture-frame mouldings with little difficulty, though the task of mitring and joining them together calls, as described, for certain tools and a little skill. However, if the moulding is made to the required section and design, a joiner can mitre and fit up the frame if you cannot do this yourself.

Picture-frame moulding is very expensive to buy for making up at home; and is rarely of the precise design and section that the artist would like for a particular kind of picture. This gives two good reasons for designing and making your own mouldings.

Moulding machines are too expensive for the home frame-maker; so I do not suggest that the artist design all kinds of mouldings. The method I wish to describe here depends upon gluing together, in different combinations of section, the mouldings that are available ready-cut in any woodyard. These range from thin and light sections to bigger and heavier stuff. Depending on the size of the painting you wish to frame, a selection of ready-cut mouldings can be assembled together in many different ways; giving a wide range of available designs. Some of the ready-cut mouldings are shown below, and a suggested frame moulding made up from them.

To glue the wood together, one of the modern adhesives available in plastic containers from Do-it-Yourself shops is satisfactory, such as Cascamite or PVA. From the same shop – or any good toolshop – some small G-cramps should be bought for screwing-up the wood during the drying of the glue. If you do not want to invest in G-cramps (which are not very dear, and are useful in all sorts of other ways around the studio) the wood can be glued-up by strong cord and tourniquet, provided something is placed under the cord to prevent it marking the wood.

The ready-cut mouldings in use may be softwood, hardwood or a blend of the two. For unpainted frames two different tones of wood can be combined with good effect. Otherwise the staining, painting or other surface method of finishing is discussed later in this chapter.

The bought mouldings should be lightly sandpapered before assembly, taking care not to remove the sharp edges or 'arris', which would give the finished moulding a soft and woolly look. Sanding before assembly allows the sandpaper to get at areas which – after assembly – get tucked into recessive angles where it is difficult to reach. Lengths of ready-cut timber-yard mouldings should never be pinned-and-glued together to make frame mouldings as this will interfere with the cutting of the mitres. As I have stated, any competent joiner can assemble the frame for you, from the mouldings supplied, and his charges will be far less than the cost of a professionally made picture frame of the same size; the more so with the larger oil painting frames.

I know of at least one art gallery in Britain where very important paintings are in frames made out of ready-made mouldings in this way; and their frames are every bit as agreeable as the expensive professional ones.

Some tips on routing picture-frame mouldings

The fairly experienced frame maker who has a small bench where he may make his own picture-frame mouldings may be interested in going on from the building up

of mouldings from those ready-cut at the builder's yard, to the cutting of his own mouldings. I have stated earlier that I do not, in general, advise the use by the solitary worker, of power tools; and repeat this advice here. If assistance, or even a companion within easy earshot is available, however, the danger in case of mishap is lessened. I mention this because, for cutting your own mouldings a powered hand router is required. This has a base plate with a handle, below which protrudes the spindle that cuts a groove into the wood according to the shape or profile of the spindle. A variety of spindles is available at tool shops. There are several types of small powered router on the market, such as the Black and Decker DN65; and a good tool merchant will be able to show such a tool with an array of cutters for routing, grooving and slotting, so as to produce a variety of mouldings.

The first thing to grasp in this task is that as I have described it is a mistake to think of trimming off a thin strip of wood from a plank and then trying to rout it into a moulding. Without considerable effort, it is not possible to hold it steady on the bench. It is far easier to obtain the wood that you wish to use in a plank about 2 or 3 cm thick and 20 cm or so wide. The length depends on what length can be accommodated on your bench; but as the frame to be made from such a thickness of moulding would not be above 1 metre in the longest dimension, the plank should be just over 1 metre (say 1.20 metres) which is about the shortest length most timber merchants will willingly sell. This leaves room for mitring the ends. If smaller frames are required it is well worth while to set the bench up on a shorter basis to begin with.

The plank is fixed on the bench, overlapping the front edge by about 5 cm, and held either by small G-cramps or two *bench-hooks* (these are cramps with a thick stem that goes down through a hole in the bench). The bench must be very firm as there is considerable vibration, and, if you live in a terrace, the routing should be done away from the house, or at evening class, to avoid your being a noisy neighbour.

The router, set up with the chosen spindle, is taken along the edge of the plank to cut the moulding. Sometimes two passes are required with different spindles according to the design of moulding desired. Then a

similar cut is made the other way round, setting the plank further out over the bench edge to get at it. The resulting profile should look something like my illustration. When completed, the moulding is sliced off with a small circular saw, as shown. Do not forget with a slotting spindle to cut the rectangular slot to form the frame rebate. The plank can then be set up again and the process repeated until there is not enough of the plank left to continue; and the moulding mitred and made up into frames.

Figure 32a Routing mouldings from a plank.

Some of the mouldings possible are shown in my sketch, indicating the profiles before cutting off the moulding from the plank with the circular saw. When using the power tools set up for circular sawing, make sure that the base plate for the saw is accurate and absolutely firm; and *never* saw without using a *pushing stick*, as shown in my sketch. The wood for offering to a circular saw should never at any time be held on the base by the bare hand. If you are not experienced enough to know for certain how this should be done, *do not use the circular saw without skilled advice*. A suitable circular saw for such a small workshop is the Black and Decker Type DN61, with a cutting depth of 33 mm. A bandsaw or a hand-held powered fretsaw is not suitable; and will 'wander'. The best wood to use is *ramin*; the knot-free wood of hard texture and great strength. It is usually no dearer than knotty deal and sometimes cheaper.

Figure 32b Use of the push-stick with a circular saw.

In my illustration, the circular saw cuts are shown at A and B. The bevel in figure 36b is cut afterwards with a dovetail plane after the moulding is sawn off; and for this it is best to make a *jig* to hold the moulding as shown in figure 32c. It is bevelled on both sides before being cut in two by the circular saw.

Figure 32c A jig for bevelling a simple moulding.

I have said that there is considerable vibration when using a router. This can cause difficulties in less practised hands, and if routing wood in the plank is for any reason difficult, it can be routed by cutting the wood into thin, measured lengths of the required dimensions and routing it in a specially made jig with a spring grip. This is not as hard to make as it sounds.

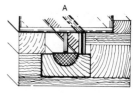

Figure 32d A plywood spring for a routing jig.

To begin with it should not be made for very long moulding; until experience has been built up. One metre is a good start. Lengths of softwood are pinned and glued together to the dimensions shown in my actual-size

Figure 32e Holding the jig firmly on the bench.

sketch (figure 32d) and held on the bench by small G-cramps. The piece of wood to be routed is fed in at the end and pushed in so as to be held along all its length by the jig. The clever bit of the jig is the strip of 3 mm plywood shown at A in figure 32d. This is glued and pinned to the jig as shown; but, firstly, it is slotted with a dovetail saw or tenon saw with cuts 15 mm long and 1 cm apart, sloped at forty-five degrees as shown.

This is done, because if the jig, as it is, holds the length of wood firmly enough, you will not be able to push it in to begin with; and if the grip is slack enough to allow a sliding fit, the wood will not be held firmly enough during the routing. With the slotted plywood strip, pressure is made to bear down on the upper face of the wood, and the slotted plywood is springy enough to hold it firmly whilst having enough 'give' to admit it into the jig. Also, the spring absorbs much of the vibration and makes the routing smoother. If there is too much spring, you have cut the slots too close together or too deeply (or both) and another piece of slotted plywood must be cut. This may seem time-consuming; but it should be remembered that, once made, this jig will help to make moulding for a long time.

Whatever lengths of wood are routed in the jig, the latter must be at least 15 cm longer at each end to allow a G-cramp to hold it without obstructing the router. The centre of the jig can additionally be secured by a bench hook applied from the back as shown in figure 32e. Of course, different-sized jigs can be made for different thickness of moulding; but within any one thickness, a range of designs can be cut.

How to mitre picture-frame mouldings to make frames

A wide selection of attractive ready-surfaced mouldings of various dimensions is available today, with which artists can assemble their own picture frames at a fraction of the cost of the professionally made product. There are several books available which describe frame-making and the technique involved; but most of these assume that the reader has had some experience. There are several pitfalls, however, which the absolute beginner

should be told about; though the methods are quite simple in themselves.

I am assuming that the reader will make the mitre by hand; and will not have the benefit of one of the several types of mitring machine available. The evening class in woodwork at many colleges, as I have said, will include among the equipment provided, a mitring machine; and it is worth while enquiring whether your picture frames can be made in the class. At home, the only way to cut a good mitre is by using a metal mitre box, or a *new* wooden one. After use, old wooden mitre boxes become worn and inaccurate, except for undemanding work.

After the frame moulding has been cut to length, and the mitres have been cut, it is still too soon to try to pin and glue them together; although many novices make this mistake. The mitres must be trued-up, as described above, by being shot on a 45 degree *shooting board* by a sharp plane. It is quite easy to buy a board; but almost as easy to make one for yourself by accurate gluing and screwing. The board should look like the sketch, and, for most framing, two or three feet long is sufficient.

The plane is used on its side, and the mitred surface should be very lightly skimmed with the moulding firmly held in position. For greater firmness a G-cramp can be used to hold it.

Figure 33a Making mitres; a shooting board for trueing-up a mitre.

After both faces of each piece of moulding have been trued-up, there comes the assembly. But first, the moulding should be drilled to take the panel pins; certainly with thin moulding to avoid splitting, and preferably with all mouldings, to ensure the pins being driven home straight and true without wandering. For thin mouldings a 1/16th inch high-speed drill is suitable, and for heavy moulding for oil paintings, a drill up to 3/32 inch can be used, with pins of appropriately heavier calibre.

To assemble a mitre, one piece of moulding should be held in a vice, with the angle of the mitre exactly on the end face, as in my sketch. Only the rebate portion of the moulding should be gripped. The other face of the mitre should be offered up to it after they have both been lightly smeared with one of the modern woodworking adhesives.

There are three things to watch. Firstly, not a single speck of adhesive should go anywhere on the surface of the moulding, or it will ruin the finish, especially if the grain is to be merely sanded and polished or stained.

Figure 33b Assembling a frame corner in a bench vice for glueing and pinning.

Secondly, you must take care that the two mouldings are brought together in the same flat plane; otherwise your finished frame will not be flat. The third point is most important; when bringing together the faces of the mitres for pinning, the loose face must be placed proud of the fixed face, so that the tapping in of the pins will slide it along inwards to the exact position. Unless this is done, the corner, when tapped tight, will not be correctly positioned.

A method of cramping mitres in assembling picture frames without buying special equipment

One problem for the home picture-framer is how to join the mitred corners, tightly and strongly, during glueing and setting of the joint, and to hold the four pieces of the frame together during this process. There is quite a variety of instruments on the market for use in this connection; but, as is so often the case, the simplest and least complicated method gives good results with the least difficulty; and, of course, costs far less. These more elaborate pieces of equipment, obtainable at the tool dealer's are quite good value for what you get; but, at the same time, they are not inexpensive; and one virtue of the method that I am going to describe is that it uses materials that would otherwise be thrown away; and therefore can be said to cost nothing. As with the other aspects of picture framing mentioned above, I have followed this process many times with perfect success; and the results have appeared in quite professional art galleries, without anything amateurish about them. The fact that the method is home-made does not mean that it is rough-and-ready; indeed, it has been used by skilled cabinet-makers for centuries for their finest work. Before detailing the method, I would like to refer to one or two of the tools available for this purpose on the market; and mention their good points and their occasional drawbacks and failings.

There is the Stanley No 400 Double Vice, which has two 'thumbscrews' which grip the two pieces of moulding to be joined, and hold them at right angles. One drawback with these is that they are only good with fairly heavy

moulding. In addition, there is the risk of over-tightening, and thus marking the surface of delicately finished mouldings so as to crack the lacquered or plasticised surface in a way that is not easy to repair. Conversely, if such fine material is not cramped so as to bring the mitres together fairly strongly, you will end up with a weak joint; and you cannot press them strongly together unless you then cramp them fairly tightly in the screws.

If the mitred joints are not strong, a picture frame holding a sheet of glass, a mounted work of art and a back board, will spring at the joint if lifted wrongly, one-handed, by taking hold of it at the centre of the top moulding. This danger is specially present with large drawings or water colours framed in the slender type of moulding. Also, if the picture is placed on the floor in the same way, with a one-handed grasp of the top moulding, quite often one bottom corner hits the floor first, which can spring the joint. Only very small, light picture frames, containing artwork and glass, should ever be lifted one-handed. However fussy it may seem, the only correct way is with both hands, one at either side, in either lifting or putting down. They should be put down slowly and gently. I have spent anguished hours at art exhibition sending-in days and selection or hanging days, seeing frames being lifted one-handed and dumped down on the floor; and have even heard the faint cracks as the mitres sprang to the right and left of me.

Another difficulty, in using the double-vice type of cramp, is that it is not easy to force the two pieces of moulding firmly together in the first place. Having another mitre at the free end of each piece instead of a flat end, it is not possible to tap them together with a small mallet or hammer, as this will damage the mitres. At the same time you cannot tap them home and then cut the free ends into mitres. The only way that you can tap the mitres together is to dispense with the double-vice clamp and proceed by pinning and gluing; in which the pins go some way towards providing a strong holding pressure. In my view, however, even this is not firm enough on its own, for heavier frames.

There are types of spring cramp that you can use to hold mitres together whilst the glue sets; but these make marks on the moulding, and it is difficult to work out any

way to protect the surfaces against this. These tools are certainly used by professional framers; but the latter are highly skilled and very experienced. They know how to avoid difficulties, and overcome any ill effects.

Stanley Tools make a 'clamp-web' which can be used in this connection. It consists of a 3.5-metre loop of black nylon webbing of about 2 cm width, and a pressed-steel cramp unit which, when the webbing is passed round the outside rectangle of a newly assembled frame, will tighten and tension it by means of an easy-action ratchet, in the form of a tourniquet. One of these will hold a frame together during gluing up, whether it be big or small (though not too small), at any desired tension. It is very efficient; and is much used by cabinet-makers.

For picture frame making, it has the drawback that, when excess glue extrudes from the mitres under pressure, it cannot be cleaned away from between the webbing and the frame moulding; with the result that, at the best, there is dried glue on the outside of the mitres when the cramp is taken off, and, at the worst, the webbing is firmly stuck to the moulding, so that, in detaching it, there is grave risk of pulling away some of the surface finish of the moulding. If it does not actually adhere in this way, and any hardening glue has been carefully sanded off the mitre, the dried glue will prevent any further finishing of the surface by staining, varnishing and the rest, as the glue resists the finish and leaves a whitish scar that has to be carefully touched out with paint. In addition, when the clamp-web has been used for a number of jobs, the dried glue on the tape forms small lumps that can damage the fine surface of a finished frame moulding under pressure; and calls for fairly frequent renewal of the tape.

Stanleys also produce a 'Clamp Frame', which is four right-angled jaws in polypropylene plastic to put over the outside of the four mitres for protection, together with 3.5 metres of terylene cord with a securing cleat. The corner jaws protect the mitres, but there is still the risk of extruded glue sticking the jaws to the mitre. That risk is minimised because the plastic of which they are made has a very poor adhesion with most – if not all – glues; indeed, hardly any adhesion with the usual range of woodworking glues. An experienced practitioner will

learn to assess the right amount of glue to use, so that the joint is not under-glued on the one hand, and does not suffer extrusion of excess glue on the other.

The method I have used for a long time with success is done with: four pieces cut from a small plastic refrigerator box of thin polythene; eight small pieces of wood about 1.5 cm square section and about 4 cm long (any spare wood will do); and a piece of string. The plastic pieces are cut as shown in my sketch from a plastic box (which may well have rounded corners but a right-angle between the bottom and sides of the box). These are for protecting the mitre. I use polythene because it will not stick. The pieces of wood may be hardwood or softwood; and should be clean and smooth. The string, which is used to tie round the outside rectangle of the assembled frame *must not stretch*, or it will never be tight enough. It should be thick, not only so that it will not break when tightened, but will not cut into the frame surfaces so much as thin string. Sisal string, used for parcels in packing-shops is the best; it is strong, thick and soft and will not stretch. Another very good type is the woven curtain cord of man-made fibre sold at most department stores for the various systems of curtain rails and runners. As it is a woven cord, and not just twisted, it does not stretch.

The method is to glue the mitres at all four frame corners; place the cord round the frame and secure with a slip-knot and two half-hitches. The final half-hitch should not pull the cord end right through; but leave it looped back for easy and quick untying. The cord is only put round in a fairly slack tension; there is no need for pulling and straining. Then, a piece of wood is inserted on either side of each mitre, towards the centre of the moulding, and slid towards the corner. This tightens the tension on the cord in a very controlled way; and the wood pieces additionally grip the mitre squarely together. The four pieces of plastic should be inserted between the cord and the mitres before sliding the wood-pieces tightening the cramp.

The frame should be on a perfectly flat surface; and held lightly down with some sort of weight at each corner; and checked carefully for squareness with a carpenter's square. Frames so treated, if of equal size, can be stacked on top of each other for the glue to harden; preferably all night.

Figure 34a A simple cramp for glueing-up a frame.

Figure 34b Tightening the corners with the sliding blocks.

Figure 34c How to cut polythene corner protectors from a plastic freezer box.

Figure 34d The slip knot used for the tourniquet.

How to tint picture frames

I have explained how it is possible to use standard soft-wood mouldings from a timber yard for building up composite mouldings which can be cut and mitred into picture frames. I would like to go on to explain a good way of giving these raw wood frames an agreeable finish and colour, in sympathy with the respective paintings or drawings they will hold. This type of softwood is sold for use by joiners and builders; and is meant to be painted. It rarely looks very nice if left in the raw state with merely a coat of polish; though, in certain cases this can be done, if the timber is sorted out first to get rid of lengths with too many knots.

The frame should first of all be given a coat of white primer, after any blemishes have been carefully sanded out or filled with 'Brummer' stopping of the right pale tint, obtainable from your ironmonger. The frame should then be given a coat of flat-white oil paint; followed by a second coat when the first is thoroughly dry. The surface should be lightly smoothed with fine sandpaper between each application. Any 'nibs' should be carefully removed.

Having produced a soft, smooth surface, without any of the 'tooth' left by unsanded undercoat, the texturing and tinting can begin. You have to decide what is the dominant tint in the picture that the frame is to hold, and which is the main supporting tint. For instance, a plate of oranges painted against a blue curtain would have orange as the main tint and blue as the chief supporting tint.

In a kitchen pudding basin, prepare a 50:50 mixture of linseed oil and turpentine. Use a little of this to mix (on a saucer or glass slab if you have one) with oil pigment from the tube; blended to match the *supporting* tint of the painting. When the stiffish, oily paste of blended pigment is ready, stir it into a small amount of the oil and turpentine mixture and brush a little on to a few inches of the frame. The surplus should be immediately wiped gently away with a piece of muslin free of lint folded into a soft pad (rather in the way french polish is applied.) You must judge how much to remove, as this affects the texture.

This is really applying a glaze; as used in oil painting by the old masters (and some modern masters). The glaze

stays in the texture of the surface more than elsewhere, with agreeable effect. The frame now has a tinted and textured surface which cannot be obtained in any other way; with a transparency and quality that has depth and lustre. If you have wiped too much away, apply some more and try again.

If the colour is not just what you want, mix new pigment with some medium and add to the first batch to correct this. Such glazes need very dark, strongly tinted blends in the medium, which become very pale and delicate when wiped off again, after being applied to the frame. When you are satisfied with the test, wipe the frame clean with turpentine, and then apply the treatment to the whole of the front surface.

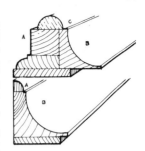

Figure 35 Tinting frames: A = the main tint; B = the secondary tint; C = gold surface.

The next stage is to mix a much paler blend of the *dominant* tint of the picture. This can then be applied judiciously when the first glaze has dried bone hard (which takes time as the medium contains no 'driers'). My sketch indicates some of the ways in which the slighter amounts of the dominant tint can be applied to different types of compound moulding. Like the former, this looks best if 'too much' is applied, and then the excess paint wiped gently off; leaving a *rubbed*, semi-transparent line, stripe or band of this stronger tint.

The raised, outer facet of a moulding or some other appropriate edge or fillet, can be gilded. This should be limited in amount and done with discretion, by using gilders' wax (Goldfinger, obtainable from your art shop) applied with very thin rag or even the finger.

When all this is dry, it is attractive but very fragile and impermanent; and should be varnished thinly, in several coats, with picture varnish. Do not be tempted to use harder varnishes, such as floor varnish or polyurethane varnish, as the former gives a sticky effect that ruins the soft lustre of the glazes and the latter actually can change drastically the tone and the tint, losing all your carefully adjusted effect.

If the first glaze is not quite what you want, wash it off with turpentine and try again. Similarly you can wipe off the second tint if you do not like it the first time; but be very careful or you will easily wash off some of the first glaze even though it is dry. I have tested this method thoroughly over literally hundreds of frames, large and small; and they stand up very well to everyday wear and

tear in galleries and studios, or wherever they are ulti-
mately hung.

Ensuring strength in slender frame mouldings

For better or worse there is a fashion at present for framing
quite large drawings, water colours and graphic prints in
very thin frames. Where these are of metal, no problem of
the adequacy of strength of the moulding arises; unless a
soft aluminium extrusion is used for a large work under
glass, with a liability to bending of the frame moulding
when the frame is wrongly lifted by one edge. With
hardwood mouldings of slender dimensions, there is a
constant risk of distortion or even breakage when lifting
the framed work.

The problem is that if a thicker moulding is used for the
sake of greater strength, the elegance of the thin frame
moulding is lost. This can be solved by wise choice of frame
moulding; whether it be one that the handyman artist
makes for his or her own requirements; or whether it be a
commercial moulding chosen at the framemakers. An
experienced framer will always advise against an injudi-
cious choice; but many art shops perform a useful function
as agents for framing workshops; and the person in the
shop may know little or nothing of the finer points of frame
construction. Whether the moulding is purchased or made
by the artist, there are certain principles that govern the
choice of dimension.

Figure 36a Design for strength in slim mouldings; this is a weak moulding.

My sketch shows (36a) a typical slender moulding; which
will give no trouble when used for smaller frames; but
which would be too weak for frames over about 46 cm in
height or width; and would be dangerous for large frames.

The same effect of slenderness could be obtained if a
moulding as shown (36b) were to be used. The only
difference at the front of the frame is the inclination of the
inner slope and this does not, in practice, have a noticeable
effect on the look of the frame. The leading edge in both
mouldings is 3 mm, which catches the light and gives the
slender effect.

Figure 36b A stronger moulding that appears equally slim in use.

At the back of the frame, it is a different story. The
rebate of the moulding is 9 mm in each case, but the
moulding at the back is only 9 mm wide at 36a, but is

13 mm wide at 36b. Also the depth, from side to side, is greater at 36b than at 36a; being only 2.5 cm in the weaker moulding and 3 cm in the stronger.

This slight difference in depth is, again, not noticeable on a large framed work; but the increase in strength is considerable deriving from the greater depth and width at the back of the moulding, whilst the visual effect from the front of the picture is much the same.

Making stronger mitres for heavier frames

I explained earlier how to assemble the mitred corners of picture frames using the pinning and gluing technique; with a few pointers as to how to avoid inaccurate assembly of the mitres. In the case of larger water colours and drawings, requiring bigger picture frames, or in the case of oil paintings with heavier frames which, for one reason or another, have to be glazed with the heavier glass used for large oil paintings, the pinning and gluing method is not necessarily strong enough.

It should be borne in mind that a heavy frame, possibly holding heavy picture glass, has to support its weight when hung on a wall, largely by the strength of the corner-mitred joints. For larger water-colour frames, or heavy oil paintings, a stronger mitred joint is required. I should stress at this point that I cannot recall an instance of a pinned-and-glued frame falling apart; but there is always the risk. The technique of using 'cerfs' is well within the capabilities of the do-it-yourself framer and should be employed for the heavier jobs.

First of all, two of the four frame members should be cramped in a vice at right angles to each other; checked by a carpenter's square. Using a tenon saw or the smaller dovetail saw, which has a stiffened steel or brass back to the blade, two cuts are made across the join, at right angles to the mitre (or 45 degrees to the side of the frame, which is the same thing). Two small squares of veneer are glued and inserted into the cuts (the cerfs) and allowed to dry. Then, the same operation is followed for the other three corners of the frame. When all the cerfs have set hard, they should be carefully trimmed off with a chisel, and lightly sanded flush with the surface of the frame

Figure 37
Strengthening mitres in heavier frames by the use of cerfs.

moulding. These give a strong joint capable of with-standing hard usage in transport and hanging.

Whilst it is usual to take care to make the cuts parallel to each other, this is not a critical factor; indeed, if the cerf cuts are sloped inwards towards each other, this gives a firmer grip – being like the jaws of pincers; but for aesthetic reasons, should only be used for frames which are to be sanded and painted; and should be avoided in plain wood frames as they give a muddled appearance to the mitred corner.

Points to watch are, firstly, the accurate checking that the frame sides are cramped at right angles, when inserting the cerfs, and that the whole frame stays at right-angled squareness whilst the glue is setting. For the final stage, when all the cerfs are inserted, the frame should be laid flat on a bench top, checked for right-angled squareness, and tied-in with a thick cord tightened by a tourniquet, to bring pressure that holds the four members hard together. The edges of the moulding should be protected to ensure that the cord does not dent the moulding under pressure. Too much pressure should be avoided in any case as glue sets better with moderate pressure.

Repairing damaged ornament on frames

The old-style gilded and ornamented picture frame, which is still used by some eminent contemporary painters for framing their work, was sometimes made entirely by wood carving; but in most cases, the ornament was applied in the form of composition or gesso on a simply moulded wood base. These frames can be found quite cheaply in second-hand shops and auction sales; but, usually, some repair is needed, and refurbishing with either gold leaf, or more cheaply, by Goldfinger wax-gilt, which is wiped on and then buffed up like boot polish, followed by two or three coats of picture varnish. They are easier to find at low prices in country junk shops; many being fine period examples of the eighteenth or even the seventeenth century. In London these bargains seem to be quickly recognised and are harder to find in consequence.

It is quite easy to repair the damaged part of either a carved or a gesso frame; and to achieve an impressive effect with little cost or effort. The parts that are damaged are usually the corner ornaments, or *cartouches*, and sometimes a piece of the edge moulding has been knocked away. The straight-sided frames have a cartouche at each corner, and those with incurved sides, known as *swept frames*, also have a cartouche in the middle of each side.

It is not wise to buy a frame with too much damage; as it will take time for repair that should be devoted to creative painting; and it is perhaps best to begin with a straight-sided frame with not much damage and large forms in the decoration, rather than one with fine or-namentation. Paradoxically, it seems to be the older, eighteenth-century frames that have the handsome, fuller handling in the ornament; and the less valuable Victorian frames that are more exacting to repair. However, both types are easy to restore with a little practice.

First of all, the damaged part should be tidied up by trimming the edges of the damaged gesso or carved wood to a clean line with a strong, sharp knife, aided by a small file or a manicurist's emery board for small frames. The gesso should be scraped off the wood base, and all gesso dust removed with a slightly damp sponge, so as not to impair the adhesion of the repair.

For a wood-carved frame, a piece of knot-free softwood should be shaped to fit the space; and, when glued in place, should be 'whittled' into the shape of the missing ornamentation, using the part directly opposite on the frame, for a model. I have watched craftsmen at the National Gallery, London carving the newly inserted piece of wood on a fine, antique frame.

For a gesso frame, some dental wax should be obtained from a firm of dental materials suppliers, (British readers look in the Yellow Pages of the telephone book under 'Dental Materials and Equipment'). In case of difficulty, ask your dental surgeon where he gets his. Dental wax is supplied in boxes of several thin slabs, and, if you tell the suppliers what you want it for, they will give you the right kind.

The dental wax is quite hard and tough when cold; and should be softened in hot water. When it is pliable, it should be pressed over the undamaged ornament on the

other side of the frame, which is the exact equivalent of the portion you wish to replace, and a firm pressure until it is cool will provide a clear impression that serves as a mould. It should be lifted off again before it becomes cold and hard, so as to be flexible enough to disengage from the modelling. If any part of the modelling is undercut, the wax impression can be bent to release it and then formed accurately again before it cools.

It will then serve as a mould for a cast made from specially prepared composition. A mixture of whiting and old-fashioned carpenter's glue serves very well; mixed to a stiff paste. I have never used commercial fillers, such as Polyfilla, as I have never had the time to test their long-term durability under these conditions, nor their working properties in this application; although I have no reason to think that they would not be quite suitable.

The composition should be worked well into the crannies of the mould; and built up at the back to form the right thickness matching that of the gesso composition on either side of it on the frame. When it has set hard, its edges should be trimmed and filed to fit the edges on each side of it. The reverse of the cast should be filed and sandpapered to the moulded shape of the wooden base to which it will be glued on the frame; which is likely to have a double curve from edge to edge.

The cast is then glued into position in the gap on the frame modelling, and the join around its edges is carefully filled with some of the same composition, and *gently* sanded smooth. When it is all set and quite dry, the modelling of the cast may be found to be a little softer than that of the frame; and should be sharpened up by skilful application of a sharp knife blade, such as a penknife, and any woolly edges or angles cleaned up. It is now ready for regilding; either in the traditional way, with an application of red bolus ground, and then gold leaf adhering to gold size; or by an application of Gold-finger wax gilding, which is then polished with a cloth and varnished. Before gilding, it may be advisable to clean the rest of the frame, with a shaving brush and fine soap. The cleaning should not be allowed to flood the frame with soapy water; but rather a small patch at a time should be gently cleaned with the soapy brush, and the soap then swabbed off with a small, fairly dry sponge, a little at a time.

The working over of the new cast to sharpen up the modelling should be done with it glued in position; and the resulting character of the ornamentation should match that of the original as exactly as possible. The regilding may not be of the identical gold tint and degree of surface shine as the original gold leaf; and some work with gilder's wax over the whole of the raised parts of the frame may be advisable, to give the same character of highlights to the whole frame. On no account should new gilder's wax be rubbed into the crannies and background of the original frame, as this will remove all the aged patina and spoil its quality. Indeed, some 'dirt' should be worked into the crannies of the new gilding to simulate old patina. This is called '*distressing*', and can be done before the final varnishing, using brown and black shoe polish or a mixture of the two to match the old patina of the original.

If the restoration has involved the use of gold leaf, this can be distressed by using old-fashioned stove grate blacking, which is water-based, obtainable at the household-supplies shop. They use it for this purpose at the National Gallery, London. Many old frames have flyspots, which are little black spots dotted about the surface. These can be imitated by spraying stove blacking sparingly with a toothbrush, by dipping the brush into the blacking (which should be slightly diluted) and then drawing a paper knife or something similar across the bristles to splash on the spots.

Chapter 11

Mounting drawings, water colours and prints

Tools for mount cutting

There is a wide range of elaborate machinery for fast and easy mount cutting; but, as before, it is not really worth the investment in such equipment, unless there is a large quantity of work to be done. For artists who merely intend to make mounts for their own work, doing it by hand is quite adequate. The skill is easy to acquire if the right method is used. A *mount* consists of a backboard made of stiff card, to which is hinged by paper hinges a *mat,* which is a piece of card with a rectangular (sometimes oval) hole in the centre, the edges of which are usually cut with a bevel; and is sometimes called a *window mat.*

The only process requiring any skill is the cutting of the hole in the mat. Artists use different knives for mat cutting, of which a popular one is the Stanley knife, obtainable at most ironmongers and toolshops. Various shapes of blade are available with this, which fit into the knife handle, secured by a turnscrew. Some of these are penknife shape and others have a straight cutting edge. I have observed that many artists use the penknife-shaped blade for mat cutting; apparently forgetting that in previous centuries, when penknives were used for cutting goose and turkey quills for use as pens, they, too, started off with straight cutting edges; and only acquired the curved cutting edge after years of being sharpened on a little whetstone that wore the point away, in the same way that an old steel carving knife or butcher's knife becomes worn away with sharpening. The moral of this is that the 'correct' shape is the straight cutting edge! If the

Figure 38a Mount-cutting blades: the correct types.

Figure 38b Mount-cutting blades: the wrong types.

reader tries with a straight blade and then with a curved, the greater efficiency of the straight cutting edge will become apparent.

For marking out mounts and for general use in the studio where drawing is done, a good T-square and a plastic set-square are required. The T-square, for an artist, should be fairly small. T-squares range from the engineer's super T-square, of African mahogany with black, hardened plastic edges, of length up to 136 cm (53¾ inches); to the studio type of steamed beech with a maple edge to blade and stock. The latter is all that the artist requires; but it should be carefully maintained. The fixing screws should be tightened every so often and regularly it should be washed with warm, soapy water, well rinsed and dried and hung up on the wall to keep straight. The washing prevents the build up of grease and pencil lead on the surface of the T-square, which, otherwise, will soil the paper surface. The user should not finger the blade, or allow paint, grease or dirt to soil it. The T-square should not knock against anything; as this may knock it out of true; and will very likely dent the bevelled edge of the blade so that a clean line cannot be drawn with its help. After use over soft pencilling or charcoal, it should be rubbed over with an india rubber or gum eraser, before washing it. Do not stand it on the floor resting on the stock.

Similarly, the plastic set-square should be kept clean, or soiled work will be the result. Unlike the T-square, which need only be a fairly small one in most artists' studios, the set-square should be fairly large. There is nothing worse than fiddling about on a large drawing with a tiny set-square. Like the T-square, it should be protected from damage to its edges, which affect its efficiency as a drawing aid.

A final requisite for water-colour drawing, and for mounting drawings, is a supply of clean blotting paper. This is available from office suppliers and stationers, in packs of large sheets; and the artist should keep a stock of the largest sheets obtainable. These can be used whole, for damping down a drawing in the way described elsewhere in this book in connection with the stretching and securing of drawing and water colour paper; and can be cut into conveniently small pieces for use during the painting of a wash drawing or water colour, for cleaning

brushes during the work, mopping up blobs and washes and the like.

How to make your own superior mount-cutting knife

I have discussed the minimum tools needed for cutting your own mounts without buying expensive equipment to do it semi-mechanically, and among other things, the choice of your cutting knife. Even a large tool shop may not have the type of knife that suits you – the selection available is very small. You can, of course, grind a knife to a different type of edge, to suit yourself; such as a cabinet-maker's marking knife or a veneer knife. However, the steel of these blades may not hold its edge very well in cutting mounting card.

An easy way to make your own knife from superior steel of great hardness is to obtain a broken 1 inch hacksaw blade from an engineer friend (or as a last resort, buy a new one and break it in two). Then grind the teeth away, to begin with. The steel along the toothed edge is very hard indeed. The broken end of the blade can be ground on a wheel to about 45 degrees angle along the edge, and then bevelled on one side only to give a cutting edge. The point of the new edge should come at the side where the teeth used to be; and if so, it will cut many mounts without needing re-sharpening and honing.

As mount board is usually only about 3 mm thick, it is only the bit of the edge near the point that does the cutting. There is no value, therefore, in having a sharp edge more than several centimetres long. Cut away the surplus edge, by grinding, as shown in my sketch.

The penalty for great hardness in steel is a lessening of flexibility; which is why hacksaw blades snap easily. If you fit your new knife with a wooden handle, you may be tempted to grip it in your fist and press on it when cutting so hard as to snap the blade. It helps to prevent this if you simply do not bother to fit a handle; and the hard thin blade is just a bit uncomfortable if you bear down too hard with it in cutting; which discourages too great a pressure and the resulting breakage. At the same time, the large hacksaw blade is thicker and less flexible than the Stanley type of blade, and is less likely to 'wander' in cutting.

Figure 38c Making your own mount-cutting knife from an old hacksaw blade: (top to bottom) – the broken blade trimmed at the end by filing; the same with the teeth filed off; the blade with the end shaped by filing, and sharpened on the grindstone and whetstone.

Whatever knife you use should be honed every time you start work; and whenever it feels a little dull in cutting. For honing it, select a small flat carborundum block at the tool shop; of the kind used by woodworkers for sharpening their chisels. It will hopefully have a coarse and a smoother texture on the respective sides; and to hone your knife you should normally use the smooth side. The coarser side is useful if you nick the edge of your knife for any reason and have to rub it down to a smooth edge.

For a right-handed user, the bevel of the edge should be on the right when in use with the straight edge on the left – and vice versa for left-handed users. The opposite face should be, in either case, left quite flat.

A light rub of the bevel of the cutting edge on the stone will turn up a 'burr' along the edge. When this is quite distinctly felt by gently rubbing the thumb on the flat side *towards* (*not* along!) the edge, then rub the flat side gently along the stone to rub off the burr; and your knife will be razor sharp. For maximum sharpness repeat the process two or three times on both sides.

The important thing for good, clean mount cutting is to hone the blade every time you start a new mount; and oftener if needed. You will never cut good mounts – especially in those inside corners – with a dull knife.

Two other tools are required for mount cutting, in addition to the pencil, and T-square (for marking out the mat to begin with) and the knife. These are a one-metre or three-foot steel straight-edge with one bevelled edge, and a weight to hold down the far end of this when cutting the bevel in the card mat. The straight-edge is obtainable at any good tool dealer's; and does not cost very much. It must be a good metal straight-edge about 3 mm (⅛ inch) thick. Keep it clean and dry at all times; otherwise the shiny steel surface will soon acquire rust stains that hold dirt and can soil the mounting card. Water easily gets on to things in the studio; and when not in use, the straight-edge should be hung on the wall on a nail for which it always has a hole thoughtfully provided at one end, so as to be out of harm's way.

The weight should be made in the workshop, by filling a soup can, with the lid removed at one end, with any heavy, hard-setting substance; into which a U-shaped piece of strong wire has the ends inserted to provide a

Figure 39 Tin-can weight for holding the straight-edge firm in cutting mounts by hand.

handle to carry it by. In the past, we used to fill the can with lead melted on the stove top; but that metal is now too expensive. A useful substitute method is to fill the can with old nails, nuts and bolts and similar iron scrap, within 5 cm of the top; and top it up with the plastic filler used for repairs to the metalwork of cars, known as *plastic padding*; which can be found at any car spares shop, in a twin pack containing base and filler in one and activator in the other. When these have been mixed in the proportions advised by the manufacturer, the resulting paste should be pushed into the can so as to hold the contents from rattling, and filled up to the top of the can and levelled off smoothly. Lastly the wire is inserted and it is left to harden; which takes about half-an-hour.

In use, the straight-edge is placed on the card, with one end towards the user; the weight is placed on the other end to help to hold the straight-edge firm, and the cutting knife is drawn along the straight-edge at a bevel. The stroke should be light, so as not to move the straight-edge. If there is difficulty in holding it still, the nearer end should be held with a small G-cramp, the far end with the weight, and the middle with the hand that is not holding the knife. If it still moves about, you are pressing on too hard and perhaps your knife needs sharpening. Two chart pins can be used, against which to hold the straight-edge steady.

The heavier the straight-edge is, the better it will work – within reason. A light, thin straight-edge is far harder to keep in place when cutting than a heavy one.

Some people fix the straight-edge to a base board at one end, so that it merely has to be held down at its free end, when cutting. This certainly can be done by a handyman with a drill and a few small nuts and bolts, but is not really necessary. I have always found it sufficient to have the small weight to hold down the far end of the straight-edge during use. For large and small mounts, it is advisable to have large and small straight-edges; and to make large and small weights accordingly. Another type of weight I have made, for studio use with large sheets of cards and paper, is provided by obtaining a length of 4-cm (1½-inch) square-section iron bar from a blacksmith or scrapyard, and having it cut into 30-cm (12-inch) lengths, which are then painted with gloss enamel over a suitable ground paint. These have many

uses, and can be wiped perfectly clean with a damp cloth before use, as cleanliness is essential in handling white paper and card.

Lastly, a base is necessary for cutting; and a suitably-sized sheet of plywood or hardboard 3 mm thick, is suitable, and can be replaced when the surface gets cut up.

So much, then, for the simple mount-cutting equipment.

How to cut your own mounts

It is more than half the battle to find the kind of mount card that suits you in cutting. It is not really a good idea for me to try to recommend a particular card made by a certain manufacturer, as, what suits me may not suit my reader. There are many types of mount card available; and the best idea is to try; firstly, at your local art-supplies shop, and then, if need be, at your local printer's, to obtain a selection for experiment. .

The important thing is that it should be a *white-centred* card; as there is nothing worse than a mount with a yellowish bevel. Paper board and card is often – indeed usually – made in layers; with good quality paper on the outside and a filler layer in the middle. For the purposes of mount cutting, this middle layer should be of good quality white paper which will not go yellow in time. The surface of the card comes in a variety of tints and textures, both rough and smooth. It should, normally, be at least 2 mm thick. Some works of art look better in the mount that is thicker than this; and card can be obtained up to about 4 mm thick. It is better, for a start, to try with a soft-centred card of about 2 mm, as it will be easier to cut cleanly, especially in the bevelled corners, than harder and thicker card.

The type of mount cutting knife may vary; but it is not really advisable to use the 'Stanley knife' type of blade for this particular purpose, as the blades are a bit too thin for the pressure that might be applied. Experienced hand-cutting experts often use a specially thin chisel, with a tapered blade, which has been sharpened across the end, obliquely, and with a very thin bevel for the cutting edge. This type of cutting chisel is held in the fist. I have never

seen a mount cutter hold the cutter like a pen, in the fingers; though this style may suit some people. Also, any good toolshop will show you a selection of strong, wooden-hafted knives, any one of which may suit your style, when sharpened to the best shape. Whichever type of knife or chisel is used, it is important that the cutting edge be always sharpened quite straight; and not with a curved edge like a penknife.

If you find hand-cutting too difficult, the mechanical mount-cutters are very efficient; notably the type where the blade holder slides along a specially grooved jig like a slotted ruler. After a little practice on some spare mount card, almost anyone can get a good result with one of these; and it might be the first piece of special equipment the artist beginner buys, after selling a few pictures. If cutting with a knife, the next thing, after finding the right type of knife, is the method of using it.

CUTTING THE OUTSIDE OF THE MOUNT

Assuming that the marking-out of the mount card is accurately done, to the size required, and the inner rebate of the picture frame has been measured for this purpose, in length and width and the measurements marked on the mount card with a well sharpened 2B pencil and a T-square, the card should be trimmed on the guillotine, if you have one, or, failing that, cut to the outside dimensions with the cutting knife. It is well to have a spare knife for this, so as to preserve the sharp cutting edge of your bevelling knife. For the outside of the card, of course, the knife is used upright, to give a square edge.

Draw the blade along the pencil line with a smooth, light touch. Remember that if you have to press too hard, this means that your knife is blunt and needs honing on the whetstone. Repeat the action, until you can feel the texture of the base board on which the card rests, as the blade cuts through to it. If you are tending to press on too hard, you will take off the sharpness of your cutting edge on the base board, and will have to resharpen it. It should only require three or four strokes of the knife along the line to cut through the mount card.

Meanwhile, a word is needed as to how to place the straight-edge and the knife blade in relation to each other when cutting. You should dispose the mount card so as to

have the pencil line for your first cut on your right (unless you are left-handed). The steel straight-edge should be laid along the left of the line, with its bevelled edge exactly on the pencil line. At the far end of the straight-edge, place your specially-made weight, as described earlier, and hold down the nearer end with the left hand. If desired, two chart pins can be inserted beyond the top and bottom edges of the card, at the edge of the straight-edge, to help to hold it quite steady against any sideways pressure from the knife.

Press the point of the knife firmly but gently well into the far end of the pencil line, and draw it smoothly to the nearer end. Finish the stroke a little beyond the end of the line, past the point where it crosses the pencil line at right angles to it, to ensure the card coming away cleanly at the corner, and conclude the cut with a similar firm pressure into the card surface.

HOW TO SET OUT AND CUT THE INSIDE BEVEL OF A CARD MOUNT

Having discussed how to cut mount card, I will deal with the setting-out and the cutting of the rectangular hole in the middle of the mount. The central aperture is, of course, rectangular in most mounts; and if you require a circular or oval aperture, I suggest that you consult a professional mount cutter.

The central aperture should be a trifle smaller than the sheet that is to be mounted – about 3 mm on all sides where the work of art does not allow any greater overlap; but much more than this, if possible. You must consider carefully how much surrounding area of the mounted specimen is to show inside the bevel, and measure accordingly. When you have decided the all-round overlap – say 6 mm – then double this amount should be subtracted from the size of the mounted sheet to give the size of the bevelled aperture. For example, if a drawing is 30 cm long, and you want a 6 mm overlap, you must provide an aperture 12 mm less in length at 28.8 cm.

The next step is to centre the rectangle correctly, to leave the best width of margins within the outer dimensions of the mount board. Whether the work to be mounted be vertical or horizontal, it is usual to leave less margin at the top and sides than at the bottom; otherwise

Figure 40 The proportions of a window mat system: (top to bottom) (a) the cover card for ruling; (b) the bevelled window mat; (c) the lower card; (d) the drawing; (e) the mount board.

the mount will appear top heavy. Usually the top and sides are the same (though not always) and the bottom about half as wide again. Each example must be judged in its own right. Having decided on the width of the aperture (not forgetting the overlap) subtract this dimension from the overall width of the mount board and divide by two. This gives the measurement inwards from the outer edges on each side, which can be marked on the upper and lower edges of the board on the front.

For the height of the centre aperture, whether for a vertical or horizontally mounted sheet, mark from the top edge the same distance as you have already marked for the side margins; and mark from this the vertical dimension of the sheet to be mounted. If the lower margin remaining is too great or too small adjust the top margin accordingly.

Then, with the mount board set squarely on a drawing board, draw in the inner rectangle according to your marks; using a soft 2B pencil well sharpened. This will provide your guidelines for cutting the aperture. It is important to remember that, as the inside edges of the mount are to be bevelled at 45 degrees, this means that, in cutting, the blade must travel as far outside the guideline as the mount board is thick; so, for mount board 3 mm thick, you draw the blade along 3mm outside the guideline.

It is not usually needful to draw additional guidelines for this; as it is quite easy to judge. The use of soft 2B pencil allows any superfluous lines to be easily erased after the mount is cut. If you forget to allow for the bevel in this way your mount will be slightly too small all round.

As before, start your cut with a firm pressing of the point into the board, having set up your straight-edge as previously described. Draw the knife along gently but firmly to the opposite guideline and finish with a gentle pressure into the corner once again. You must feel the edge of the blade cut firmly into the corner of the bevel. Repeat the stroke until you feel the knife is through; and repeat the process for the other three sides.

In a well cut bevel the waste should jump out of the mount board leaving your finished mat behind. This may not happen at first, however; and gentle pressure into the stubborn corners is needed. Do not hack and saw away at the corners with a blunt blade. Practise on waste card cutting into the bevelled corners until you have the

knack. Take care not to cut the bevel in steps; and keep the blade at a steady angle of 45 degrees.

Repeat each cut three or four times, resisting any temptation to rush it by pressing down too hard on the knife. On the final stroke, feel the point of the knife as you draw it along giving signals of the texture of the base board. Where you feel that it is not quite through, draw it a few more times over that part quite gently.

The mistakes to avoid arise mainly from loss of concentration; and mount cutting should be done somewhere that is free from interruptions. The main mistake is to press too hard on the knife. This can often have the result of causing your straight-edge to slip sideways, as for some reason the downwards pressure usually accompanies an equivalent pressure against the bevel of the straight-edge in a sideways direction. Some sideways pressure is unavoidable, to guide the blade along the straight-edge, but this should be counteracted by the specially-made weight at the far end and your firm hand pressure at the nearer end. Anyone who is an incurable side-slipper should fix the straight-end with a hinge at the far end to prevent all movement. Another bad result of pressing too hard is to snap your blade. It can also cause your blade to wander, cutting its own track through the mount card away from the straight-edge – but this does not happen with a lighter pressure.

Impatience is the great enemy of efficiency in this sort of thing. If you think you are through the mount card before this is actually the case, do not lift off the straight-edge and raise the mount to remove the waste or turn the card round as this can damage the incomplete cut. Do not niggle and hack at the stubborn bits where the knife seems to hit a hard stretch. Simply continue gentle and slow strokes along a good length of the card and leave the whole thing in position until it is clear that you have completed a smooth cut right through. This is vitally important in cutting the inside aperture.

How to do ornamental rulings on mounts

A drawing or a water colour almost always looks more effective if the mount within which it is shown is specially

ruled to suit it. These ruled mounts are fairly expensive to have done by a professional mount maker; but any artist should have the necessary skill to make them in the studio. There are very few tools needed for the task: a drawing board, a steel straight-edge with a bevel, and a draughtsman's caliper pen, which can be bought quite cheaply at the art shop.

There are two important points to study in order to become proficient. The first is the way to set out the ruling on the ready-cut mount card; and the second is the type of medium in which to do it. We will assume that you have set out and cut your window mat in 3 mm mount card, with the inside aperture cleanly bevelled. Now you will have spent a fair amount of time making this mount, and if you make a mistake in ruling it – perhaps a smudge or a blot – it will be ruined and you will have to make the mount again from scratch. The first advice I offer, therefore is 'Do not make your ruling on the mount itself'. Take a piece of white, stiff thin card, as smooth as possible, and cut it to the *outside* dimensions of your bevelled mount. Then measure and set out the centre aperture in the thin card so as to be something between 6 mm and 1.5 cm bigger all round than the window in the mat.

If you do your tinted ruling on this 'cover' card, it will be just as effective as if done on the bevelled mount card; but if you make a mistake, or do not like the ruling, it can be discarded and done again without wasting more than a small piece of thin card. If it is satisfactory, place it over the bevelled mount; it can be secured with Copydex rubber adhesive, and the work of art can then be secured to the back of the mount ready for framing.

An even better system, which I use myself in framing water colours is always to cut my bevelled mount large enough to allow for a 'slip' of white thin card to show beneath, about 3 or 6 mm smaller than the bevel all round. I then prepare a similar piece of thin card to go on top, about 3 or 6 mm bigger all round; on which I do my mount ruling.

The lower 'slip' mount is stuck to the bevelled mount with Copydex adhesive; but the 'cover' mount with the ruling remains free. This means that if I wish to use the mount for another water colour of the same size, I can change the ruled cover card for another specially ruled to

suit the water colour. If a bevelled mount becomes soiled or grubby it has to be thrown away; they never clean satisfactorily. With my system, all I have to do is to discard the soiled cover card and make a new one at trifling trouble and expense. If, after some years, the bevel of the heavy mount turns yellow, it is easy to remove the slip card, and trim a fraction of the bevel away to white card, and cut a new, thin slip card to fit the drawing. As the cost of mount card with a fine, white core is rising steeply, this is a good bit of counter-inflation.

Figure 41a Section of a multiple mat.

Another advantage is that you are never caught, with an exhibition submission-day looming near and no mount of just the right size for one of your works. The slip card will take care of that by acting as a sort of 'adaptor' to make a mount that will fit. In cutting the thin card with your mount-cutting knife, cut the edges square, without any bevel; they are too weak otherwise and can get woolly. It is best to keep a special knife for bevel cutting and have a spare for these run-of-the-mill jobs.

It is not difficult to set out the rulings for your washed and lined window mats, but it calls for accuracy. If well done, it will enhance the framed work at trifling cost; although ruled mounting done by professional framers is quite expensive.

Having measured and cut the thin, cover card which I recommend, at a size slightly larger than the sight-aperture of the finished mat (say 1 cm larger all round), the next thing is to design your ruling, in a blend of ruled, pencil or grey ink lines, and thicker lines either ruled with a wide calligrapher's pen or caliper pen, or washed in with a water-colour brush.

The corners of the ruling are of course mitred at 45 degrees; and it is at these points that errors can creep in. These mitres must be set out first.

Figure 41b Designs for ruling window mats, with method of mitring.

Take several strips of the same thin card; each about 15 cm (6 inches) long and 4 cm (1½ inch) wide. On these draw an assortment of rulings as shown in my sketch; and pick the one most suitable to the work to be mounted. Keep the others for future use. With a sharp knife, trim the end of each strip at 45 degrees. Ensure that the shorter edge of the strip gives the same margin as the longer edge.

Take the window mat which you have cut, and lay the shorter edge of the strip along the bevel, so that the mitre fits in line with the mitre of the mat bevel. With a sharp

point, gently prick the position of each ruled line, along the 45 degree line of the card, into the bevelled mat. Repeat this at the other corners.

It is then simple to rule across from one pricked mark to its counterpart along the edge of the mat window, with a very sharp, B pencil and a light touch.

With a caliper pen and your chosen tint of water colour, rule your lines at the varying widths; which should differ, symmetrically, across the rulings. Never use black ink for these lines as it is too heavy in tone; water it down with distilled water; remembering that you may not only differ in the thicknesses of the rulings but in their tone also.

The centre of the ruling should always have a wider band, with grey ink or pencil margins; and should be washed in with water colour. I use a square-ended sable lettering brush for this. You will have to practise to avoid blobs at the mitres; which should be lifted off with a dry brush. Each water-colour band should start whilst the one which it adjoins at the mitre is still wet; otherwise you will get a tonal overlap; giving unsightly darkish areas at the mitres. Never use diluted ink for this wide ruling in wash but always use fairly thin water colour; and always aim to do it in one go, as superimposed washes give untidy edges. The latter, if they occur, can be disguised by heavier pencil lines ruled along the edges of the wash band; but an expert will spot that you have done this when your work is on exhibition.

Keep your best ruling strips carefully. They can be used for years. A really good design is difficult to repeat; and you may have sold the works with that ruling on them.

How to set out an oval mount

The setting of a circle is, of course, easy with a pair of compasses, but the setting out of an oval or ellipse takes us into practical geometry as used by engineers and architects. However, it is not difficult and there are several ways to do it. The easiest way both to explain and to understand is that of constructing an ellipse using the *auxiliary circles*. These are circles described about the two axes or diameters of the ellipse, which pass through and are bisected by the centre of the ellipse and the circles.

It is assumed that the drawing to be mounted calls for a window mat with an aperture of a given length and width, which gives us the major and minor axes of the ellipse. These should be drawn with the minor axis bisecting the major at right angles. Then, the two circles should be drawn with the axes as diameters. Radii should be drawn – any number will do but three in each quarter is sufficient – and, where each radius cuts the minor auxiliary circle, a horizontal line is drawn towards the major auxiliary circle; and where each radius cuts the major circle, a vertical should be drawn towards the minor circle. The points where the horizontals and verticals intersect are then joined by a line which describes the required ellipse.

Figure 42a Setting out an oval mount.

You also can achieve this by using what are called the major axes and the foci of the ellipse, and another method uses a *trammel*, and relies on the fact that, if a straight line be moved so as to have two points on it always in two, fixed, straight lines, with one point on each line, then the locus of any other point on the line will be either an ellipse or a circle.[1]

HOW TO CUT AN OVAL MOUNT

Most professional mount cutters can cut a perfect oval mount by hand; but there is an increasing tendency to use machinery. Various machines have been patented since the early nineteenth century. A complicated apparatus for forming, drawing and cutting elliptical mounts was designed in 1855 by E. B. Hutchinson; and a cutting machine for picture mounts was invented in 1893 by T. W. J. Exenden; and a mount-cutting machine for rectangles with rounded corners in 1894 by B. McHugh. I do not know whether these were ever manufactured. However, there are a few modern machines (see page 276).

There is no reason why an oval mount should be any more difficult to cut than a rectangular one. The main danger is the risk of the template slipping. Careful technique is advisable to prevent this.

When the oval has been drawn in the way I described previously, a template should be made; from thin metal or hard plastic. A metal one is simple to cut with tinsmith's 'snips', and smoothed true with a file. To prevent the template slipping when held by the fingers during cut-

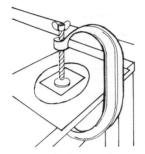

Figure 42b Cutting an oval window mat.

ting, it should be coated with rubber-based adhesive on the underside, which is allowed to dry. Copydex is a possible medium for this; or a coat of completely dry contact adhesive, which gives a non-slip, rubbery surface. Alternatively, a sheet of fine glass paper can be stuck to the underside.

Even so, the template might slip as you work the knife round it by turning the template and mount card. To prevent this, do not turn them but hold them at the corner of a table and walk round them.

The card and template should be held down by a woodworker's G-cramp. This should be fairly large; at least 24 cm (10 inches) long. It should be used upside-down; that is, with the butterfly screw at the top. This leaves the G-cramp mainly above the working surface out of the way. Place a small piece of hardboard between the screw and the template to prevent dinting by overtightening.

The G-cramp should only be screwed down finger-tight, which is firm enough. Cut one side of the oval, then swivel the G-cramp to that side to get at the other side. Slow, gentle cutting is called for, and you should practise on a spare piece of card to start with.

NOTES

[1] For fuller information, *cf.* W. Abbot, *Practical Geometry & Engineering Graphics*, (Blackie & Son).

Chapter 12

Framing drawings, water colours and prints

When a picture frame is made for you by a framer, perhaps to a given size, it will be handed over complete with the right type of picture glass duly fitted; together with a backboard of hardboard, plywood or other suitable material. Normally, unless specially asked to do so, the framer will simply place the glass into the frame and lightly pin down the backboard, pending the insertion of the mounted drawing, water colour or print in due course, after which the backboard will be sealed with gummed paper tape over the panel pins that hold it in place. This means that the work of art is framed so that it is sealed at the back but not at the front. The rebate of the picture-frame moulding is regarded as sufficiently well fitting around the edge of the picture glass to prevent small particles of grit or other alien matter from entering and getting between the glass and the window mat of the mount.

If you wish your work of art to be completely protected, you should seal the glass into the frame at the front before the work of art is inserted and the backboard fitted. This protection may not seem very necessary under normal conditions, but it is not over-cautious, as experience can prove.

I have sent a newly mounted and fitted drawing for inclusion in a London exhibition, with a pure white, new mat to the mount. Around the edge of the drawing, it was fitted for about half a centimetre or so under the aperture of the mat. For some reason, it was reframed on return from loan to the exhibition, and when the mat was removed, there was a clean margin all round the edge of the drawing which, on the rest of the surface, was no

longer on white paper but was filmed with pale grey. Admittedly, this was before the days of smoke abatement; but it must be remembered that the work had only been on show in London for about four weeks.

The sealing of picture frames for drawings and paintings

So many enemies of the durability of a work of art are in the air, in addition to such perils as excessive light, that some attempts have been made to seal picture frames hermetically, in order to keep them out. Thus, protected in its sealed frame, the work of art is seemingly safe from water vapour, dust, moulds and fungi, acids and other pollutant vapours and so on. Unfortunately, it is virtually impossible to seal a container of any kind, including picture frames.

For the artist, framing his own works in his studio, it is quite impracticable to try to seal a frame efficiently. I only know of one picture frame in the world that has been effectively sealed in this way, and that curiosity is in the Victoria and Albert Museum, London, in the gallery devoted to the pictures of the Sheepshanks Collection. The fortunate painting which it contains is *Venice* painted in oil by J. M. W. Turner. In consequence, this is, without doubt, the only oil painting by Turner that can be seen today looking exactly as it did when it left the artist's studio when it had been painted for the collector John Sheepshanks in 1840. It hangs alongside comparable oil paintings by Turner, with which its condition may be compared: *St Michael's Mount, Cornwall*, and *Line Fishing off Hastings* appear in comparison to be decidedly yellow; whilst *Lifeboat and Manby Apparatus Going off to a Stranded Vessel*, which was exhibited at the Royal Academy in 1831, appears today to be very dingy indeed.

Turner's *Venice* was placed under sealed glass in 1893 in a special airtight frame made by the Royal Engineers of the British Army for the V & A Museum under the direction of Sir Henry Cole. The procedure involved a copper box to which the glass was sealed with the painting inside. The process was under the supervision of Col. Harold Knight. It appears that it was completely successful; though not, perhaps, without some difficulties; and

the fact that the process was never repeated leads one to suspect that the official reaction was 'Never again!'. The whole process was carried out under the direction of The Painting and Drawing Preservation Syndicate, Ltd, and called for special glass and other research products. The idea was first agreed by the V & A Museum as long ago as 1857.[1]

The result is a painting that has never been cleaned or restored, yet has whiter-than-white clouds, intense blues, rich reds and so on; compared with the same tints in the adjoining paintings; in which the clouds are a dingy yellow, the blues are greenish and the reds are browning. The task was evidently extremely difficult. If it were not done really well, the frame would still admit air, and in addition to the accumulation of very fine dust, there would be a build-up of condensation due to the lack of ventilation.

Experts such as Ralph Mayer advise that, whilst a frame should be sealed with tape at the back, where the backboard fits into the frame rebate, to keep out dirt, that ventilation should be allowed for, even to the extent of drilling a few holes in the backboard.

The best material for lining the glass into the frame rebate is adhesive plastic tape ('Sellotape', 'Scotch Tape' or similar) 24 mm (1 inch) wide. The same width of gummed brown-paper tape will serve instead. Neither of these materials is ideal; though their shortcomings are different; (plastic tape becomes yellowed and brittle after a few years and tends to crack and peel away, and gummed paper tape dries out its adhesion in hot dry conditions and comes away from the rebate, and is also liable to damage from the edge of the picture glass).

Figure 43a Lining-in the glass into a frame.

The strip should be stuck along the edge of the glass in the frame, at the back. It should overlap the edge of the glass by a few millimetres, cover the inside edge of the frame rebate, and turn outwards to stick down over the back edge of the rebate; as shown in my sketch. At the corners, the strips of adhesive tape should go well into the inside angle of the rebate; and the two strips meeting at 90 degrees in the corner should overlap as indicated. If this overlap is not done, there will be a pinhole-sized aperture at the corner through which dust will penetrate.

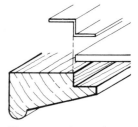

Figure 43b Sectional view: (a) tape; (b) glass; (c) frame.

A work framed up in this way should be dismantled, and have the lining tape removed and replaced about every two or three years to maintain the seal.

When the backboard is in place, and the edge taped over all round where it fits the frame rebate, the work of art will be almost hermetically sealed into the frame and will stay clean for an indefinite time.

This sealing gives no protection against the little brown spots called 'foxing' which can appear on mount and drawing in humid conditions. It may be caused by a fungus or mould, the spores of which are trapped inside when framing the work, and await the right conditions to grow, or it may be due to specks of iron salts in the fibres. If the picture is hung in reasonably dry conditions, however, the sealing may well deter the humidity from entering the frame during those short spells of humidity we get in England from time to time. If you go away in winter and leave the house unheated, you may well find that the frame has breathed in some humidity despite the seal, which will slow the drying out process; and the frame will have to be opened up to get rid of it. But then, drawings and other graphic work should not be left in an unheated house if they are of any quality or value.

For large framed drawings, a strip of adhesive cloth tape, like that used by librarians, should be stuck along the rebate at the top edge of the frame overlapping the backboard. It gives added strength to a thin moulding if the painting is (wrongly) lifted up by the centre of the top edge.

Some points on handling picture glass

Many artists who submit drawings and graphics to exhibitions keep a stock of frames for the purpose. Works returning from a show are taken out and returned for the time being to the plan chest or folio, and others are framed up in their place for the next submission. It is usual for the picture glass to be removed and cleaned; and sometimes accidents happen and it has to be replaced. All this means that the artist handles picture glass fairly regularly.

Contrary to the bohemian myth, an artist producing immaculate prints and drawings maintains a clean and efficient studio and follows systematic procedures to maintain the spotless perfection of the white paper,

fragile mounts and expensive frames in use. I would like to discuss a few ways in which this can apply to the regular handling of glass in the studio.

When open stacking of framed water colours and drawings is employed, it is well to keep an old piece of clean strawboard or hardboard to put in front of a stack of frames leaning against a wall or in a rack, to protect the picture glass from dirt and damage and to shield the work from light, in order to minimise fading. The same piece of board can be used as a cutting base when trimming paper and mount card with a knife and straight-edge; and used in this way the board should last for several months. Ideally, a piece of strawboard should be placed between each stacked frame and its neighbour, to minimise wear and tear and possible glass breakage.

If the studio is in the country, and a long way from the glazier, it will sometimes be easier and quicker, when you break a picture glass, to cut another to size from a spare piece, or from a larger piece taken from another frame. Some artists, who feel sufficiently confident about their glass-cutting skills, may wish to lay in a stock of picture glass for all contingencies. With this in mind, it is perhaps of value to say a little about the right types of picture glass and the way to cut this beautiful but temperamental material.

When ordering glass from the glazier, tell him what it is to be used for; namely for picture framing. He will then avoid for instance, selling you horticultural glass, which is for garden frames and greenhouses and can have bubbles and other little flaws in it which do not matter in that context. Also tell the glazier the approximate size to which you usually frame your work; so that he will not give you heavy glass for little frames or glass that is too thin for heavy frames. Glass free from flaws for this purpose can range from 3 mm to 6 mm in thickness. There is available a diffuse-reflection glass for picture framing; which reduces the reflections, but I have found that it gives a slight softness or diffusion to the character of the drawing or painting; which cannot, therefore, be seen exactly as the artist created it. If pictures are well hung, reflections are not, usually, much trouble. An artist should also avoid the use of acrylic plastic, such as Perspex, for picture framing. It is useful in situations where security against accidental breakage or vandalism

is important, being strong and virtually unbreakable; but it can be scratched, and picks up dirt easily, so that a drawing is not seen through it at its best. These scratches can be removed by polishing with metal polish or car polish containing very fine abrasive, or with a buffer attachment to a power drill; but this is a troublesome necessity that is best avoided by using glass.

If you cut your own glass you will need a glass cutter, and even if you do not, it is a useful first-aid tool to get a framed work to an exhibition sending-in day on time if you have an accident and break the glass. A diamond cutter is, I think, easier to use than a wheel cutter; but is of course, more expensive. A wheel cutter which is rather like a pen with a little wheel at the point, should be held between the first and second fingers and drawn along the line of the cut in one smooth, continuous movement without varying the pressure. A T-square should be used to guide it. If the stock of the T-square is thick enough to lift the blade of the T-square slightly off the surface of the glass, place a thin piece of strawboard or plywood under the line of the cut to raise the glass a little.

To separate the glass along the line of the cut, place a straight-edge or thin wood batten under the line and press lightly on either side. A glazier will make a light, smooth stroke and snap the glass cleanly; whilst the beginner will make a stroke that does not score the surface in some parts of the line, and has to be gone over again; and when the glass is pressed over the batten, the break will wander to one side or another. It is always best, therefore, to practise on some spare glass first. With glass-cutting, I find that people either have the knack or they do not. If you do not, after all, have the knack for it, then rely on your glazier to do it for you, as it will save you a lot of wasted glass.

If a piece of glass needs trimming slightly along one edge, to a narrow width of (say) 5 or 10 mm, score the line as described above, and then hold the glass in the fingers on both sides of the cut and bend it to snap off the unwanted strip. If 'nibs' of glass remain here and there along the edge, due to faulty scoring with the glass-cutter, nibble them off with pliers. If a very narrow strip, of (say) 3 mm is to be removed, score it and nibble it off along its length with the pliers.

The newly-cut edge of the glass should then be smoothed and blunted with the oilstone or fine emery paper or glass paper on a cork block, giving special attention to the sharp corners.

It is a good idea to keep a chamois leather in the studio for cleaning glass. When not in use this should be kept dry to avoid it acquiring mould; but should be soaked carefully and softened in advance of cleaning glass.

I described earlier (page 82) how to stack framed prints and drawings face-to-face or back-to-back, rather than in sequence front-to-back, to avoid pressure on the glass.

In ordering glass from the glazier, remember that whilst art museums and art societies in their exhibition catalogues always give the dimensions of drawings and paintings with the height first followed by the width, e.g. H 30.5 cm (12 inches) W 61 cm (24 inches) a glazier does it the other way round, and gives the width first. With plain glass, this, of course, does not matter, but if, for any reason in your studio you need a piece of ribbed or patterned glass, it is important not to muddle the horizontals and verticals. It is best to make it quite clear which dimension is which in a written order.

The glazier will measure your frame, and select the right weight and type of glass according to circumstances, and cut the glass to be a good fit. It can happen, especially if the artist has made the frame, that it is not truly square; in which case the glazier can use the frame as a template and cut the glass accordingly.

To take the glass home, it should be placed in the frame, preferably with its backboard. It is highly dangerous to walk about with sheets of glass, across the pavement to the car, as a child might run into you and be injured. It is totally unacceptable to take glass sheet on to public transport unprotected. It is far safer carried in its frame. The glass is less likely to break if your car goes over a bump, if it is held in a frame in the boot of the car. If need be, a frame will carry several sheets of glass of the same size.

In the studio the sharp-edged glass will be handled repeatedly, for reframing and cleaning; and as I have stated the sharp edges should be blunted as soon as possible. The glazier will have blunted the corners with a

whetstone; and the artist should continue this process all round the edges. Then, the sheet of glass can be handled with no more risk of cut fingers than with a piece of cardboard. The blunting can be done with emery paper or glass paper, or a flat carborundum whetstone that is not too coarse. Those small sharpening stones sold at tool shops for sharpening chisels are very good for this task. Gloves can be worn against the risk of cut fingers, if they are of thick leather; but this has the drawback of being clumsy and leading to breakages.

It is vitally important that *all or none* of the sheets of glass in the studio be blunted, to prevent someone grasping a sheet thinking it is blunted only to find that it is not, and with cuts to prove it. It is equally vital to ensure that all four edges of a sheet have been blunted. Check this carefully as you work; and do not do so by lightly running a finger along the edge feeling certain that it has been done, with cut fingers to show your mistake (this may sound unlikely but it is very easily done).

The smoothing down should be done outside on a flagstoned or other smooth-surfaced floor; for it leaves a considerable amount of powdered glass, which must be swilled away – not swept; this prevents it getting into the house, on the food, or lying around to contaminate a child's toy or a dog's ball.

When handling the glass for these purposes always move in a slow, deliberate way. As each piece of glass arrives home from the glaziers and is taken out of the frame, stick a plastic label in the middle of it so that it does not become invisible when placed against the wall or on a table to provide a booby trap for someone.

Keep people away, especially children and pets, until the glass is blunted and safely stacked where you will not absently-mindedly back into it. Wipe the glass with damp rag before taking it indoors again after blunting; and throw the rag into the dustbin. Do not shake it out.

During this task, do not touch the face or wipe the eyes, where powdered glass is most undesirable; and wash the hands carefully afterwards. If in spite of these precautions in handling glass in the studio, a print or drawing gets a blood-smear on it, try enzyme detergent between clean tissues to remove it, if the nature of the work of art permits this without damage.

Pinning the backboard into a frame

It is amazing how often the obvious way to do something is the wrong way to do it. If one were to ask anyone how to tap the panel pins into the rebate at the back of a picture frame to hold the backboard in place, the reply is likely to be 'Tap it in with a small hammer' – or words to that effect. Yet, this is far from being the best way to do it.

A hammer should not be used at all for this seemingly simple task. We have to bear in mind that panel pins are thin wire objects; and, for holding backboards in the rebates of frames which are often made of very slender hardwood, the panel pins must be as thin as possible to lessen the risk of splitting the moulding.

The head of the striking tool, therefore, should be of such a form that it offers the maximum striking surface to the tiny head of the panel pin. A moment's thought will indicate how very little surface of a hammer is offered as a striking area; and how easy it is to miss the head of the panel pin altogether (striking the fingers painfully in doing so).

This apparently trivial task can easily become a frustrating and badly performed one, in consequence. The right tool for the job is a *firmer chisel*. It should be not less than the traditional one-inch size (which refers to the width of the blade).

Any size less than this is too light for the task. Most household tool-kits tend to include bevel-edged chisels, which are made for light work and bevelled to get into sharp corners. These are quite unsuitable for driving panel pins. A mortise chisel, which is straight sided like a paring chisel, is, like the latter tool, of heavy construction for bigger work. However, it is lighter at the head than a firmer chisel and has the wrong balance for striking panel pins without hitting hard, which causes the pin to bend.

The completed frame, with backboard (of plywood or hardboard) in position is placed face downwards on a flat, firm table protected by an old blanket or felt. For drawings, water colours and the like, the narrow frame-moulding needs no more than half-inch panel pins – or at the most three-quarter inch pins. These are available in thick and thin gauge, and, as stated, the thin should be used to avoid excess projection at the back of the frame.

The panel pin is placed on the backboard and the point

Figure 44 Pinning-in a backboard with a chisel.

Figure 45 Inserting a panel pin into a frame with pliers.

offered to the rebate. The chisel cutting-edge is laid flat in the backboard, as in my sketch, and the pin is struck with the side of the chisel. The edge of the chisel is bevelled for about half an inch, and it is the bevel that rests on the backboard in striking. If held at the proper angle, it gives about half an inch margin for error in striking the panel pin, compared with the round hammer head which gives no margin at all.

Additionally, the angles or arrises (the sharp junction of two adjoining surfaces) of a firmer chisel are quite clean and sharp, whilst those of a hammer-head are usually rounded or slightly bevelled, causing many mis-hits in this particular task.

An alternative way to push very small panel pins into the rebate of a frame to secure the backboard is to use a large pair of square-nosed pliers. One jaw of the pliers rests on the outside of the frame moulding and the other holds the head of the pin firm, with the pin point against the inside of the frame rebate at the intended point of entry. A firm but gentle squeeze of the pliers will drive the pin home. The pliers must be held quite square to the direction of movement, otherwise there is a danger of slipping.

This method is particularly useful with very small frames, which do not have enough space between the sides of the frame as to allow a proper backswing of a chisel when striking the pin. The process calls for really large pliers; and a lady artist with small hands might find it more difficult, especially as a fairly strong grip is needed. To prevent the pin from going too far into a very thin frame moulding, a succession of short squeezes is better than one strong one.

Some general tips on framing drawings and paintings

In pinning in the backboards of framed drawings (oil paintings rarely have backboards, although it is a very good thing if they do), always use the thinnest possible panel pins. Pins of given lengths come in different thicknesses; and some are too thick to drive home and tape over, without making an unsightly bulge. Where there is not much frame rebate to spare from accommodating the

thicknesses of the picture glass, the window mount and the back mount, together with the backboard, the pin may be driven home at a slope, and then gently tapped flat against the backboard with no risk of breaking the glass. In addition, thin pins at the back cause less damage to other frames stacked adjacent, than thick pins with obtrusive and sharp-edged heads. If the only panel pins you have to hand are rather thick, then stick a small square of brown, manilla, sticky tape over each pinhead, before taping over the edge of the backboard and rebate with the same kind of tape. If need be, stick two small pieces of paper over the pin head, before taping.

If you wish to extract panel pins from a frame to remove the backboard, pull them out with a pair of sharp-nosed electrician's pliers; gripping the pin with the tips of the jaws, and resting the pliers against the rebate, as a fulcrum to lever out the pin. If you can contrive to magnetise your pliers – both the bull-nosed pliers used for driving in the pins and the sharp-nosed ones used for extracting them – this prevents the panel pin from falling from the jaws of the pliers and dropping between the rebate and the backboard (which necessitates withdrawing all the other pins, and removing the backboard to get it out again). Try stroking your pliers with a magnet. Never try to extract or straighten panel pins, or pull out drawing pins, with a good penknife which has a bone or ivory handle. The handle will crack at the end, due to the leverage, and a good knife will be ruined.

When working on a frame, to frame up or take out a work, always place it face downwards on to a firm surface, protected by a blanket or felt. It you are striking pins sideways into the rebate, always place the side of the frame against a wall, or some other back-stop, otherwise you may spring the mitres at the corners and loosen them.

NOTES
[1] *Cf.* Ralph Mayer, *The Painter's Craft*, (Nelson, 1978).

Chapter 13

Getting your work to exhibition

How to transport unstretched canvases

Figure 46 Cardboard telescope for packing drawings.

If the artist wishes to send or transport unstretched canvas or paintings – perhaps to a framer, prior to exhibiting – every chance should be taken to save any cardboard tubes that are to hand; for rolling the canvas, painting side *outwards*, prior to wrapping and sealing. Or you can keep a supply of thin card, available from art shops, and roll this to the requisite diameter to suit the purpose; storing it flat in the meantime. If two pieces of card are rolled and 'telescoped' one within the other, a roll of adjustable length is achieved, which can be adjusted to the size of the rolled canvas. A fairly thick elastic band placed round the inner roll will prevent the telescope collapsing in transit and will not hurt the canvas; nor will it touch the paint surface which, in any case, should be rolled on the outside (to open up rather than crush any paint cracks). For thin paint a diameter of 6 cm is about right; if you paint thickly, make it 8 cm diameter. If you paint very thickly indeed, like John Bratby or Frank Auerbach, do not roll your paintings at all, but pack them flat.

A tube for a rolled painting should be adjusted to be at least 2 cm longer at each end than the rolled canvas. One thickness of card is not enough; it should be rolled on itself at least five or six times (before rolling on the canvas) to give the requisite strength. Secured with elastic bands on the outside of the canvas, and wrapped in cellophane or clingwrap against damp and dirt in transit with the ends of the cellophane tucked into the roll ends, and finally wrapped and sealed in strong brown manilla paper, it should come to no harm.

The packing and transport of your work

When the drawings or paintings are finished and framed-up, it is time to pack and transport them to the place where they are to be exhibited. If this is not far from the studio, the simplest way to do it is to put them face-to-face in the boot of the car, placed on several thicknesses of folded blanket and held firmly so that they will not shift and rub against each other during the journey. In many cases, however, you may need to send work away either by road transport, railway or air freight.

Perhaps the most important piece of art transport I did was some years ago when I flew from Holland to England with two large parcels; each containing four famous Van Gogh canvases. I sat in the front seats of the first-class compartment of a Dutch KLM airlines aeroplane, with one parcel strapped into the seat on my left and the other in the seat on my right. Because of the importance of these Dutch art treasures, I was permitted to carry them as 'passengers', so that I never had them out of my sight. I was seen on to the aeroplane and into my seat by the Dutch airport police and customs, and the first person aboard in England was a British policeman, after which I had a police escort to my destination. A month later I took them back to Holland in the same way. Before the return journey, I had supervised the packing of the paintings; and I am glad to say that they arrived quite safely.

On another occasion I arranged the transport of a Leonardo da Vinci painting through London and for 200 miles further, with a police-car escort of each of the dozen or so police areas through which it passed, being passed on from one escort to the other. Another car carried an expert restorer, a fireman and a police officer. It is not really surprising that that picture also arrived safely! I am not suggesting that the artist who has personal work to transport should go to those lengths; yet the same rule applies for safe transit – careful and detailed planning from start to finish.

For transit by car, rail, road freight or air, a framed picture should be first wrapped in polythene which is taped or stapled to itself, to keep out dust and damp. A very large, framed painting in oil should, ideally, have

the glass taken out of the frame and packed separately, unless the picture is going a long way – say, to the continent – and then it is simpler and cheaper to have a new glass cut for it on arrival. A drawing or water colour should retain its glass, for protection. This should have adhesive tape placed across the glass in a chequerboard pattern, to hold it together if it should break. If the work is very valuable, a sheet of brown paper should be pasted all over the glass to prevent scatter in the event of shattering; and this should be taken within 2 cm of the rebate of the frame – but no closer. If it is too close, there is a risk of water penetrating the frame through the rebate when damping the paper to remove it. The glass should next be covered with a thick sheet of cellulose wadding, and then with hardboard; and finally should be parcelled and taped-up with brown paper and parcel tape, covering every joint.

The materials to place ready to hand before beginning to pack it are: sisal string or curtain cord, (both non-stretch), cellulose wadding; polythene sheet; strong man-illa paper. It should be remembered that, in cold condi-tions, polythene sheet can gather condensation; so that you should take up a fold of the sheet here and there between the fingers, and punch holes with a filing punch or a leather eyelet punch, for ventilation.

For air transit, if accompanied, the work can be packed with hardboard sheets for protection and wrapped in strong corrugated cardboard or corrugated fibreboard, well tied with sisal and all joins taped with wide parcel tape. If unaccompanied, or if travelling by road or rail freight, you should consider having a wooden case made for it, as the picture may well be dropped. It should be parcelled as above and well padded in the case so that it is 'drop-proof'. Glass should not travel in the same case, unless the picture is a small oil or a medium-sized or small drawing; in which event the case should be clearly marked as carrying glass, and labelled *'fragile; do not throw down or drop'* on *every* face of the case *both* ways up in all appropriate languages. A cased example should never, if possible, weigh more than two men can comfort-ably lift. If it is bigger or heavier, it should travel in a van, into which the artist sees it loaded and secured; and should be met at the other end by someone reliable, to supervise its unloading.

If the work is to go abroad, take my advice and retain the services of reliable and well-known fine art packers and shippers, such as those mentioned in the list of suppliers and services at the end of this book. Whether going abroad by sea or air, it will have to be inspected by HM Customs and Excise; and you can arrange with the local office to have this done by a Customs Officer at the place of packing and despatch, to save it having to be unpacked in a damp and draughty customs shed on the docks or airport.

If you sell any work to a client from abroad, make it a condition of the deal that the client is responsible for the costs of delivery to his or her home country. If you state a price that will cover this, as you think, you may have a shock in the cost of the consignment going on from the airport or docks in the foreign country by their road freight, to the final destination. Recently a picture of mine that had been acquired for a foreign official collection arrived in Paris and went on from there to the destination, some 100 miles away, by ordinary road carrier – at a cost of about £100 from Paris onwards. Any letter or contract, or receipt for the transaction should state 'F.O.B.' (free on board) if you are driving the consignment to the airport or docks, or 'F.O.R. (free on rail) if you are taking it to the station, after which you will not be liable for the carriage and other costs (with an American client F.O.B. stands for both). If you are not responsible for any transit costs at all, you should state 'F.O.B. studio' and add a clear statement that you are not including transit and packing costs in the price.

A wooden case for a picture should be made of timber about 8 to 16 mm thick according to the size of the case; and should be screwed, with flat-headed, countersunk screws, and not nailed. Such a case can often be re-used; one larger side lifting off as a lid, and should be made of softwood. Any space inside between the picture and the sides should be packed with pads made of small taped parcels of crumpled newspaper of the required shape and size. A large unframed canvas should be screwed through two interior battens, as described on page 258 and the case should be lined with waterproof paper, stapled to the case. Fix a notice inside the lid asking for packing materials to be repacked and returned with the empty case and giving the return address.

If arranging the details of inland transit yourself, it is useful to consult the road or rail or inland airway offices about special freight services with through supervision and checking. These provisions change from time to time, and should be checked. For sea passage, a stronger case should be provided, with extra waterproofing inside.

The export of works of art from Britain is governed by Department of Trade regulations, Customs and Excise, the Exchange Control regulations and the like. It is best to use a fine-art shipper who knows the rules. Do not forget that, if you are sending a work abroad, say to France, for exhibition (and return if not sold) there will be duties to pay on entry, import tax and the like; and you should find out the regulations from the embassy or consulate of the country concerned beforehand. If you have sold a work of art to a recognised foreign cultural, official body, such as a public art gallery, it is always worth asking the embassy of that country if they will take it there in the official diplomatic bag.

Transit and packing of goods for foreign countries are affected in the conditions and methods not only by the nature of the goods and the type of conveyance but also by the country to which they are going. For this reason, always ask the advice of a shipper and packer with experience of that particular country.

How to pack unframed canvases for transit

If the artist is not able to supervise, or carry out, the packing of his works, he is putting them at risk. Works of art are usually fragile and irreplaceable; and deserve the most skilled packing they can get. There are two main problems in fine-art packing; one presented by the solid objects, with which I deal later, and the other presented by the flat ones such as unframed canvases. It is not possible, in a short chapter, to cover all types of art object; and I can only describe enough of the methods to avoid the worst of the possible catastrophes, and to enable the artist to ensure skilled standards of work when he is assisted in the packing or commissions a firm to do it for him.

A wooden packing case should always be used, except

for air transit where the package is accompanied at all times, as were the eight Van Gogh canvases I mentioned earlier; which is a facility not usually granted. Even the smallest picture should have a small wooden packing case; and the makers of these, if the artist cannot for any reason make the case, are to be found in the classified telephone directory. However, it is quite easy for the artist to make these when needed. For canvases up to 100 × 120 cm, a flat case, with top and bottom of strong plywood and sides of 2 cm thickness in softwood, is quite adequate. The plywood should be glued-and-pinned to one side, and not just nailed. A flat-headed, countersunk screw can be fitted every 20 cm for added strength with the screw heads just below the surface. If the edge of a screw-head protrudes because of inaccurate work, the hand of anyone lifting the case can be cut. Drill pilot holes in the sides of the case to start with and use a countersink bit in a swing brace to prepare the countersunk holes. As the screws go through plywood, fit metal cup washers over the screwholes if you do not countersink the screwholes.

For cases of this size or larger, transverse battens, two or three to a side, should be fixed, made of 2 × 5 cm softwood; and glued on under pressure. The battens should be drilled and countersunk, for screw fixing to the sides of the case. For the side that is not glued and pinned – which acts as a removable lid, these batten screws are the main fastening, supported by other screws through the plywood at 20 cm or so distance.

For cases larger than 100 × 120 cm or so, plywood is not strong enough; and the lid and bottom of the case should be made of tongue-and-groove softwood floorboarding of 2 cm thickness, with battens as described above. Softwood blocks 5 × 5 cm should be glued into the corners of the case, to take the corner screws from top and bottom, and the sides of the larger cases should be 2.5 cm thick, or, for very big cases, proportionally thicker.

Before placing any canvas or canvases into the case, it should be lined with waterproof paper laid across and along, so as to fold over and wrap the contents. The stretched canvas should rest on four pads, made as small parcels of crumpled newspaper in the manner described on page 84; with four others on top and still more round all the sides; so that the contents are held gently but

Figure 47 Packing an unframed canvas: (top) the lining of the case and the interior fixing battens; (bottom) the closed case with external, strengthening battens.

securely when the lid is screwed down. On each side of the contents – below and on top, a sheet of plywood 3 cm thick should be placed, to prevent the pads denting the stretched canvas. There is no need to pad between canvases if the case contains more than one, and, indeed, it is safer not to do so, as a pad could come adrift and slide about between two canvases.

A fairly large and valuable work should be packed alone in the case; and pads should not be relied on. Two transverse battens of 5 × 2.5 cm thickness in softwood should be screwed on to the back of the canvas stretcher and then fixed to secure blocks fitted in the bottom of the case against the sides. The canvas then travels suspended as part of the case; protected on its upper side and at the sides by being wrapped in waterproof paper before being screwed in position.

A large and clear notice should be stapled to the underside of the lid in all cases asking for the packing material to be repacked and returned with the case; if it still contains the consignment on return, to be packed as on receipt; and if empty, to contain all packing material. The owner of the case should have his or her name burned into the sides of the case; otherwise the case will go astray after use, or perhaps somebody's broken-down old packing case will be returned instead, whilst they keep your nice new one. The case may or may not be marked on each face with the words 'Valuable Pictures With Care'. The risk that a passing thief will read this, and walk off with the case, is, in my opinion, less than the risk that a porter, not knowing what is in the case, may throw it about. In all cases, whatever the mode of transit, the case should travel by registered or recorded transit, to ensure safe handling.

For sea transit, double waterproof lining and an extra-strong case are advisable; the latter particularly so, as it may have some other, very heavy, cases placed on top of it in the hold of the ship. Here again, the clear marking of the case with the nature of the contents will help to ensure careful stowage. For air transit, of course, the case must be as light as possible, commensurate with safety and security.

Even when it is unlikely that the consignment is to travel by air, it may have to be lightly packed. When I was invited, in 1982, to contribute five of my pictures to

the *Salon des Nations Exhibition* at the Centre Interna-
tional d'Art Contemporain de Paris, for which all the
transit arrangements were undertaken by the organisers,
it was one of the conditions of the invitation that the five
works were to be packed together in a single package that
had to be of cardboard, strong enough to be used again for
the return of any work unsold, and which must not be
more than 50 cm wide. They had to be delivered, at the
Unitaire Centre, Feltham, for air transit.

Whilst the packing of unframed canvases can be
thought to include those framed in the modern fashion of
a thin strip of wood pinned all round the stretcher –
which is not a frame at all in the real sense – my works
for Paris would be water-colour drawings framed under
glass, packed as I have explained above. If they were to be
oil paintings in heavier frames, they would require pack-
ing with additional reinforcement, which I will try to
describe.

The packing of oil paintings in heavier frames

An oil painting in a heavier frame may be a modern work,
in which the frame is likely to be made from a simple,
straight frame moulding such as those which I described
on page 117 might be assembled from softwood mouldings
obtainable from the timber merchant, or in the case of an
older picture of the nineteenth century or earlier, is fairly
sure to be in an ornamental frame. This can be a straight
frame with modelled and sculpted corners, in the shape of
swags and cartouches of stucco which has been gilded, or
it can be a *swept frame*, with ornamental corners, and
additional cartouches half way along each side, between
which the edge of the frame curves inwards in an elegant
sweep from point to point.

Many contemporary painters, however (the term *con-
temporary* being often used in the art world to mean work
of the twentieth century which is not progressively
modern) still like to frame their pictures in swept and
ornamental frames. Clearly, in packing such framed
works, the ornament must be protected from abrasion and
impact in transit; and even a simple frame, being heavy,
must be padded in the case, being more liable to shift

about than a light frame, when the van brakes sharply or the train has an additional carriage shunted on to it, or when the case is handled in stowage.

To avoid movement of the picture in its case, it is packed in on all sides with padding. Firstly, four pads must be made to protect the corners and to prevent the face of the frame, or its back, coming in contact with the case. For such heavy, though fragile frames, the pads should be strong, and the packer of the picture should wrap crumpled paper in strong brown paper which is strongly sealed with gummed paper strip or the scotch tape type of adhesive strip. The plastic adhesive packing tape of greater strength and width is good but not essential. It is a good idea to wrap each one in double thickness of brown paper.

The pads are made by rolling a length of crumpled paper in double-thickness brown paper and folding the ends to leave a flat, long tab at each end of the pad (see figure 5, page 84). The pad is secured to the corner of the frame by placing the centre, padded part over the frame corner at the front and securing each flat tab at the back. In a contemporary working frame it can be stapled with a staple gun, or secured by drawing pins. It would not be right to pierce an antique, swept or ornamental frame with staples or drawing pins, however, and in such a case, the pads are fixed as follows.

Each pad is folded over the frame corner as already described, but, instead of being stapled securely to the frame itself, the two overlapping end-tabs of each pad are stapled to each other. Then, with the four pads in place, strong string is tied around the frame and the four pads as shown in my drawing. Even modern, working frames, of no antiquarian value can be padded like this if the artist prefers. At the front of the frame, over the padded centres of the corner 'parcels' the string holds the pad in place. At the back, the string at each corner is crossed over itself, to prevent any slipping, and taken along the side of the frame to the adjacent corners where it passes over the pad at the front, then is twisted round itself at the back and so on until it comes round again to its starting point where it is firmly tied into a slip-knot, by which the cord is tightened with judgement to hold the pads firmly but not be so tight as to damage the pads or the frame. The slip-knot should then be tied-off by two

half-hitches, the end of the string being passed back through the second half-hitch to make untying easy by simply pulling the end; which should be tucked out of harm's way to avoid premature pulling.

The string should be non-stretch; which means either sisal packing string, or woven cord such as curtain cord. Thin, hard string which cuts the pads, and is liable to break, is no good for this purpose.

A framed painting padded like this can travel safely as it is in a car boot without any other packing other than being covered by a dust sheet; but for long-distance transit it goes in a parcel for air transit or a wooden case for rail, road or sea. In a parcel, it has a sheet of thick strawboard placed on either side, and is wrapped in double thickness of corrugated cardboard, and finally is parcelled in double thickness of brown paper, taped and tied with sisal or woven cord. Before wrapping in corrugated cardboard, a long roll of padding, like a long sausage, should be placed along the outside of each side of the frame.

For heavier packing, the painting should be laid in a flat wooden case of the kind I have described earlier, and firmly padded at all sides by further parcels of padding, so that it cannot shift about. The case may or may not be lined with waterproof waxed paper (which I recommend), and the flat lid, when screwed down should grip the corner pads between the lid and the bottom of the case.

CLEANING PICTURE GLASS

When a picture arrives at its destination it may well have accumulated dirt or packing dust on the glass. More often than I could approve, I see drawings, water colours and graphics in exhibitions, houses, and occasionally in public galleries, with dirty picture glass. Wherever a framed work of this kind is exhibited, the glass will collect a film of dirt with the passing of time. If this is allowed to accumulate, it can be quite stubborn to remove. A picture glass should be cleaned once a month at least in town, and once every three months in the country.

It is not necessary to take the work down from the wall for this purpose; yet, at the same time, it should not be left to an employee to do it; as the work can be damaged in the process if due care is not exercised.

Figure 48 Cleaning picture glass close to the moulding, with a firmer chisel wrapped in chamois leather or cloth.

The glass merely requires to be wiped with a humid chamois leather, which should not be really damp, and certainly not even slightly wet. The most stubborn part of the film of dirt is adjacent to the inner edge of the frame itself; and it is here that the greatest care must be taken. If the leather is too moist, the pressure that has necessarily to be applied can force water between the glass and the frame, which can leak through onto the edge of the mount, causing a stain.

To get into the corners, the leather should be wrapped round the handle of a paint brush (better still, wrap it round the edge of a blunt chisel), and the film of grime gently wiped away. The cleaning should be finished off with a gentle wipe with a carefully rolled cone of absorbent and clean cotton or linen fabric such as an ordinary glass-cloth, to remove any streaks.

The packing of sculptures and other three-dimensional works

A sculptor working in London is able to send for a fine-art packer's team to come along to the studio and pack his sculptures; but a sculptor or collector living in the country or one of the smaller towns of the regions may wonder where to turn for help.

With big sculptures it is not usual to make special packing cases; unless the work is going abroad. For smaller sculptures or bronzes, and for three-dimensional constructions or even something like a very large pot – a packing case is advisable. I sometimes wonder whether or not the best way to send a medium-sized carving or bronze figure would not be simply to tie a label round its neck, so that the railmen and carriers involved can see just what they are handling. The danger here is that they might, with the best will in the world, pick up the weighty object by the wrong part – an arm and a leg, perhaps – which would break off.

The best thing to do with a big sculpture or object is to telephone the nearest graveyard. Ask them for the location of your nearest monumental stonemason's yard. The stonemasons are accustomed to the daily handling of heavy but fragile sculptures, and have the skill and the equipment for transporting it. It is a simple matter to fix

a price for the stonemasons to load, transport and, if necessary, install your sculpture. In the past, I have found their charges as moderate as their efficiency was fantastic. They will have it loaded and away before everyone else has finished standing around wondering where to start.

Any old packing case will not do for smaller sculptures; it should be a special one, unless the piece is so small that it may be padded in a normally strong case with plenty of wood wool. Any piece over two feet high should have the packing case literally built around it; with battens and pads to wedge the sculpture firmly and prevent it coming loose and knocking about inside the case.

Figure 49 Packing a three-dimensional object for transit.

As no two sculptures are the same shape, the battens should be fixed in place to suit the shape of the sculpture concerned. Pads are made by parcelling wood wool in strong brown paper as described on page 260. The case should be clearly marked to show which way up it should travel; but, at the same time, the sculptor, or collector, should always try to pack the piece so that it will be firmly held, whichever way up it goes. Unless the consigner is very handy with woodworking tools, the local joiner should be called in to make the packing case out of cheap deal. There is no need to go in for more expensive knot-free wood or tongue-and-groove boarding. If waterproofing is important, the case should be lined with tar-paper.

If it is to go by rail, it should go by passenger train (if not too heavy) to avoid shunting. A heavier example should not be routed without contacting the railway people, British Road Services or any other carrier for discussion of its size and weight, otherwise they may arrive to collect it and decline to take it. British Rail or British Road Services may be prepared to supply a special container; and should be asked for details of this service, where it would save trouble.

There are special problems in sending such an item abroad. Needless to say, the consignment should be insured; and it is worth remembering, when deciding just how carefully to pack the object, that insurance premiums for transit for stone objects and similar brittle items are very much higher than for paintings and drawings; and for plasters and terra cottas they are higher still. I cannot indicate rates as they depend upon circumstances, and upon inflation among other factors.

The case should have big block-lettered address labels

firmly attached to all four sides and the top. It should also have red-lettered labels prominently stating the contents for the guidance of handlers in transit; such as 'Fragile Sculpture' or the like. Lettering should be in waterproof ink. The sides of the case should be screwed together, not nailed; and should have strong exterior cross-battens. The wood should be at least 2 cm thick, and metal screw-cups for countersunk screws should be used to minimise wear of screw-holes with repeated use.

Index